Ugliness
and
Judgment

Ugliness and Judgment

On Architecture in the Public Eye

Timothy Hyde

Princeton University Press

Princeton and Oxford

For India and Elias

Contents

Introduction

Architecture, Judgment, and Civic Aesthetics

"What an ugly building." This succinct judgment, commonly enough expressed, has in its repetition underwritten a broad critique of architecture based in large part upon a presumed differentiation between public and professional points of view, between "what people think" and "what architects think." This presumption, that architectural thinking proceeds along a path distinct from that of social thought more generally, reinforces the seemingly obvious conclusion that architecture as a social object is and ought to be subject to judgments fashioned by public figures and by social commentary. In Great Britain, where the architectural profession has during the hundreds of years of its existence certainly made efforts to engage persuasively with the public, the start of the twenty-first century was marked by some startling proposals to concede even more fully to the public the arbitration of architectural success and failure. The president of the Royal Institute of British Architects suggested the compilation of a Grade X list (so named to parallel the Grade I and Grade II lists of historic preservation) containing the "most vile" buildings of the preceding century, the "plain eyesores," the "bad," the "mediocre," the "horrendous" buildings whose demolition should be actively encouraged, according to the public consensus from which the list would derive.[1] Channel 4 seized upon this proposal as the basis for a short television series called *Demolition*, in which twelve buildings selected by viewer vote were dramatically assessed by judges as candidates for destruction. *Building Design* magazine followed this lead in 2006 by establishing the Carbuncle Cup, annually awarded to the "ugliest building" built in the United Kingdom in the preceding year, chosen from a short list of "scars, blots, and eyesores" drawn from nominations submitted by the public.[2]

Expressed through a myriad of such epithets, ugliness has attached to architectural debates in Great Britain with notable but unremembered persistence over the past centuries. It has long been cast as the decisive element of judgments large and small. The architect Sir Edwin Lutyens condemned the roof pitch of forty-five degrees as the "ugly angle"; a young and censorious William Morris declined to explore the Crystal Palace in 1851, having proclaimed it to be "wondrously ugly"; in 1793, the anonymous author of Drossiana in the *European Magazine* visited St. Paul's Cathedral and found Sir Christopher Wren's ornament "ugly and ill-judged."[3] Countless other examples lie within architectural histories, some trivial or short-lived, others influential and enduring; a few have employed the term approvingly, as a positive value within specific circumstances, but the vast majority of instances intend unambiguous derogation. Of course, opinion changes over time as one historical period reflects upon its predecessors, and unanimity of judgment is rarely if ever achieved. It is not the individual judgments, then, that are persistent, nor their validity. It is the category itself, ugliness, that has maintained a special pertinence within the social evaluation of architecture in Great Britain.

But what exactly is the nature of this pertinence? What are the roles of ugliness in architectural discourse, and what are its consequences in social debate? Invoking historical episodes of taste, style, and aesthetic judgment to better discern the social role of architecture, I pose these and another, rephrased question: not, how is architecture *subject* to societal judgment, but rather, how does architecture *participate* in societal judgment?

Judgment

The presumption that architectural thinking—the profession—and social thought—the public—exist apart from one another, at incommensurable distance, obscures the certainty that public and professional perspectives on architecture have been deeply intertwined in the evolution of a number of social practices; it elides the many circumstances through which architectural practices enjoin social thought more generally, outside of and often in advance of the decisions and events that produce individual buildings. My intention in this book is not to engage the question of ugliness as a matter of fact, offering confirmation or rebuttal of one or other particular accusation of ugliness. Nor do I propose to engage ugliness only as a matter of taste, describing instances of architecture in relation to contemporaneous opinion and mores. Instead, by abjuring the presumption that the gap between internal structures of disciplinary judgment and external modes of societal judgment is traversed only in the register of

taste, I investigate moments when architecture has contributed obliquely but concretely to the criteria and instruments of societal judgment even and especially when architecture has been construed as ugly and its social assimilation therefore resisted. Debates on ugliness, I believe, expose how architecture (not only buildings but more so the thoughts and motives and mechanisms that accompany them as architectural discourse) not simply served as an object of judgment but acted as a means for the solicitation and formulation of judgments, and how, in doing so, architecture participated in the production of devices and effects distributed through other registers of public life.

The aim of this investigation into architecture and ugliness is thus not to define ugliness in itself, but to expand contemporary debate on the instrumentality of aesthetic judgment. Though its aesthetic dimensions are foundational to the disciplinary self-understanding of architecture, and should therefore be authoritative aspects of its encounters and exchanges with social institutions, it is commonplace that criteria for judgment such as cost, practicality, or environmental impact today possess an authority as grounds for the social valuation of architecture significantly greater than that of aesthetic criteria. The interpretation of architecture in aesthetic terms very often reduces to the analysis of individual reception (by a user or a critic) or authorial intent (of an architect or a client), so that aesthetic interpretation and sociocultural analysis are set apart from one another, rendering opaque what it is that architecture does or judgment does in a given circumstance. What makes ugliness such an important category of judgment, however, is precisely its resistance to this segregation of the aesthetic register—for ugliness is properly conceived as an object's excessive entanglement with the real contingencies of social life, as a hindrance to an object's reduction to the purely aesthetic. With ugliness understood not as an aesthetic value but as a social judgment, exploring architectural ugliness brings to light an understanding of the social instrumentality of architecture, revealing its unacknowledged relationships to a variety of nonarchitectural protocols or structures in law, or science, or politics that organize social and political life.

Architectural arguments in Great Britain (the focus of this book, for reasons elaborated below) oriented around the judgment of ugliness have been conducted and received primarily in the register of style. In schematic terms, the formal codifications of neoclassicism beginning in the late eighteenth century, followed by the confrontation of the practitioners of that neoclassicism by the advocates of gothic revival; the aesthetic idiosyncrasies of the arts and crafts movement then set against the orthodoxies of both of these predecessors; then the self-conscious declarations of modernism, offered as a transcendence of style

but nevertheless subsumed within the frameworks of style; and finally, most recently, postmodernism and the latest return to neoclassicism— all these historical successions were approached and debated through frameworks of style. They were attached to other arguments, about representation, morality, technology, and other social concerns, but the aesthetic category in which they were contained, and in which they remain in debates today, was style. To the extent that style was considered to be a relative category, no longer tied to absolute values, it was paralleled in these debates by conceptions of taste, the capacity for individual discrimination and judgment of aesthetic materials. Taste and style, these have been the evaluative tools in the persistent British debates on architectural ugliness.

But again, the reader will not find in the argument that follows either affirmations or rebuttals of ugliness in the terms of taste or style. It is not my aim here to further sort stylistic classifications into opposing pairs, nor to engage with and add to the literary inventory of expressions of taste. The question here is not which architecture is ugly, but what are the consequences of judgments of ugliness in architecture. The particular object of attention is the structures of collectivity that become the medium for the translation of aesthetic judgment into other registers of social activity. Even limited to a single national context and to a historically coherent set of aesthetic debates, as in this book, societal judgment is of course made up of myriad disparate factors—customs and habits, physical environments, media, financial practices. The historical investigations in this book explore architecture's relation to societal judgment through the institutions and norms that formulate, contain, or propagate different conceptions of these factors and, by doing so, instrumentalize the aesthetic. Many of the chapters that follow reveal how architectural concerns became entangled with social questions whose resolution was pursued through legal mechanisms such as the interpretation of precedents, new common law conventions, parliamentary legislation, or legal abstractions. It was in these mechanisms that architectural thoughts and objects acted in a different register of social instrumentality, one in which aesthetic judgment was applied not only directly, as to a realized building, but indirectly through reports, opinions, and memos to the interpretation and legitimation of a broad range of social practices. Architecture thus participated in these structures, often obliquely but nevertheless with a notable consequentiality, and it is ugliness that must be granted the recognition of having been instrumental in these participations. The proof offered is not a singular or systematic aesthetic theory, nor a history of ugliness, but a series of demonstrations of the role of ugliness, and an attempt through these to outline a new understanding of architecture and ugliness, and answers to the question that directs this book: how,

through aesthetic debates on ugliness, has architecture contributed to the construction of societal judgments?

Histories and Theories of Ugliness

Despite its frequent and familiar application, the judgment of ugliness has been little examined in architectural history and theory as a rigorous category of architectural thought or experience. Especially with ugliness taken to be, as it will be here, a broad conceptual category filled with numerous cognates such as irregularity, discomfort, or impropriety, along with their many synonyms and affiliates, grasping a condition of ugliness with sufficient critical perspective to extrapolate explanatory frameworks has been a rare endeavor. Disciplines such as art history or literature that have taken up ugliness in categorical terms have, like architectural history, struggled to address a quality that seems to either dissolve into the subjective assessments of taste or, to the extent it is granted an objective existence, remain particular, attached to singular examples rather than generalities. For this reason, theoretical studies on ugliness often emphasize the mutability and imprecision of the category, which render expansive definitions superficial or vague. Either that, or such studies depend upon the subordinate relationship of ugliness to the category of beauty, a focus of much more sustained philosophical and historical attention. The relationship of the ugly and the beautiful has in fact been the pivotal concern for many aesthetic inquiries into ugliness, and while some construe the pair as opposites or as reciprocal inversions, a number of theorizations have proposed that these two aesthetic categories are independent of one another. My stance at the opening of this inquiry lies nearer the latter, refraining from seeing two rival outcomes in ugliness and beauty and speculating instead that these two aesthetic categories reference distinctively separate potentials within contested social contexts. Indeed, it should be clearly stated that ugliness is not the subject of this book but its critical tool, employed for the purpose of exploring the potentialities of aesthetic judgment in such contested social contexts.

In the middle of the nineteenth century, in a period when aesthetics was by definition directed toward the understanding of beauty, German philosopher Karl Rosenkranz published what remains the only attempt at a systematic aesthetic philosophy of ugliness. His *Aesthetics of Ugliness* was premised upon the need to examine—without displacing any prevailing orientation toward the pursuit of beauty—the actuality of ugliness. "There is no other science to which it could be assigned, and so it is right to speak of the aesthetics of ugliness. No one is amazed if biology also concerns itself with the concept of illness, ethics with that

of evil, legal science with injustice, or theology with the concept of sin."[4] His treatise outlines the permutations of the "aesthetically ugly," from the appearances of formlessness to the manifestations of incorrectness and the attributes of deformation. The list of qualities, symptoms, and synonyms of the ugly is extensive; disharmony, amorphism, disfiguration, crude, hideous, disgust, and many more words and phrases are needed to capture the multiple variations and nuances of ugliness. (In the chapters that follow ugliness will often be encountered obliquely, through analogues such as those captured by Rosenkranz's taxonomy.) While overlaid with a nineteenth-century instinct for classification and systematization, Rosenkranz's *Aesthetics of Ugliness* is assembled from particularities, from evidence and from example. He attends to the distinction between different modes of cultural production, focused upon art but addressing the possibilities of ugliness in adjacent fields. He suggests that the practical endeavors of some disciplines, such as architecture, may restrain the elasticity that produces ugliness. "Architecture, sculpture, and music are somewhat insulated against uglification by their technical means," in Rosenkranz's words, meaning that the need to resolve the demands of gravity, materiality, or economics encourages architecture toward a propriety that lies at a distance from ugliness.[5] Though Rosenkranz is thinking of the pragmatics of building, the suggestion of architecture's inescapable proximity to reality has theoretical importance, in that this proximity may also be a source of uglification.

For all the complexity of his analysis of ugliness, Rosenkranz remains bound to the primacy of the visual, with other senses subordinate even when they do make an appearance. More recent inquiries into ugliness have lessened the priority of the visual and used more expansive frameworks to capture an understanding of the consequentiality of ugliness in its social and cultural dimensions.[6] Gretchen Henderson, as the title of her book *Ugliness: A Cultural History* indicates, proposes that ugliness can be examined from the perspective of its cultural influence, in its manifest appearances in the bodies, objects, moods, and words that compose the changing constellations of culture.[7] Describing the considerable purchase that ugliness has gained upon the contemporary imagination, Henderson offers the insight that ugliness is marked by its "relational" character. She means by this term that ugliness exists as the encounter between something and its limit, or between something and its other, and more precisely as the transgression of their boundary of separation. The usefulness of Henderson's conceptualization of ugliness lies in its insistence that the ugly be understood neither as an inherent quality nor as a singular subjective response but as the changeable relation between things, between people, or between people and things that constitutes the texture of culture. Taken further, Henderson's thesis that ugliness is

a description of a relational state implies that there may be a specifically modern condition of ugliness, or perhaps even that ugliness itself is a condition of modernity; that despite its long history before modernity, it describes a particular inhabitation of the pervasive modern circumstances of differentiation and distantiation.

To the extent that Henderson engages with architectural matters, such as buildings and styles, she examines them as settings for the appearance of ugliness as these architectural objects become sites of cultural or social encounter. A theoretical exploration of ugliness centered more upon architectural thought, and certainly the most cited within architectural discourse, is Mark Cousins's extended essay on "The Ugly."[8] Cousins's approach to the question of the ugly also focusses upon the relational dimension, but with a more insistent emphasis upon the subjective or psychological perspective. While ugliness may be affiliated to architectural qualities, its manifestation and its importance is, for Cousins, as a subject's encounter with an architectural object. This encounter, he insists, cannot be subsumed within an aesthetics, whose proper study he maintains to be beauty: "If ugliness is to become an object of inquiry, this inquiry will have to be conducted outside the scope of aesthetics."[9] Ugliness exists not in the attributes of the object, but in the relation of subject and object. The present usefulness of Cousins's argument on the ugly (in addition to its location within architectural theory) lies in his assertion that ugliness should be measured not as an absence or a negative—as in a lack of beauty—but as a presence, indeed often as an excess of presence. The ugly is the architecture that looms too large before its beholder, that is out of place. "The ugly object is an object which is experienced both as being there and as something that should not be there."[10]

The architectural historian John Macarthur has also contributed to the theoretical inquiry into ugliness through his analysis of the significance of disgust, as a sensation and in its depiction in the eighteenth-century English picturesque, especially as articulated by Uvedale Price. Disgust lies at a limit, as that which is "beyond the territory of art's appropriating powers," prompted by an ugliness made intolerable by deformity.[11] Macarthur sees that the difficulty of ugliness, as an aesthetic matter, is to withdraw sufficiently from a real circumstance that would prompt disgust, to a figurative standpoint from which an object can be rendered through the art of the picturesque. The placement of ugliness between an excessive reality and a tempered aesthetic (in Macarthur's framing), the excessive presence of ugly architecture (in Cousins's framing), and the boundary transgressions of ugliness in cultural productions (in Henderson's framing) all point back toward a critical aspect of Rosenkranz's aesthetics of ugliness, toward a theoretical point upon which I rely. Rosenkranz assumes a reciprocity of ugliness and beauty,

with the ugly necessarily dependent upon the foil of beauty. Where beauty can aspire to, and can achieve, a condition of sufficiency or completeness in itself, the ugly, remaining bound to the measure of beauty, cannot. The two are not equals upon a scale; what differentiates them most sharply is that the ugly is "incapable of ... aesthetic self-reliance."[12] Rosenkranz argued that the ugly cannot proceed very far along a path toward abstraction, toward an autonomous essence, in the manner of beauty. Ugliness remains bound up with the real, the material actualities of the world, the realities of behavior and possibility that structure society.

This entanglement with reality, or, put another way, the perception that ugliness is an excess of the real, provides a theoretical key in the present argument, prompting the use of ugliness as its critical tool to address the question of architecture's participation in societal judgment. For it suggests that the inquiry into ugliness and architecture has in view two objects (one an aesthetic, the other a practice) that are defined in part by the inescapability of their ties to reality, the inability of either to be conceived as abstractions. More concretely, this insight leads to the proposition, again central here, that architectural ugliness must be explored not along a philosophical plane, but along the horizon that composes the difficult reality of architecture, which is not necessarily the material reality of buildings (though those may be included) but the realities of the norms, institutions, and standards of expectation that precede architecture. Ugliness in architecture may act perceptibly and consequentially upon these realities, and therefore it is reciprocally such actions that are foregrounded in those frequent instances when the judgment of ugliness is cast upon architecture.

A Debate on Ugliness, Reconstructed

Norms and institutions are social materials, and to see through them the consequentiality of ugliness requires a view toward a societal aesthetics—not, in other words, an aesthetic premised upon the encounter between one individual and some instance of architecture, represented in the thoughts and feelings of that individual, but rather an aesthetic that is the representation of a collective encounter. This collective encounter is what is embodied in norms and institutions. This book, by pursuing the intersection of society and aesthetics in what will be more specifically defined as a civic aesthetics, attempts to locate the inquiry into ugliness between the extremes of singularity and abstraction, with individual experience being the instance of the former and philosophical classifications an instance of the latter.[13] In terms of architectural discourse, this betweenness is positioned between the extremes of taste (as individual or collective discretion) and style (as a classification that precedes

its objects), both of which are conventional and comprehensible aesthetic categories, but neither of which produce a sufficient understanding of the consequentiality of the judgment of ugliness.

The discussions of architectural ugliness examined in this book are therefore approached as an extended debate over aesthetics, with participants in any given moment responding to one another, but responding also to historical periods that precede their own. The account of this extended debate has a broad chronological span, but not with the aim of a systematic survey of ugliness. Instead, its scope serves to produce a historical field within which aesthetic judgments, contemporaneous ones as well as those separated in time, may be juxtaposed to discern more precisely their mechanisms of judgment and the manner in which they are fashioned by and for their social contexts. Making use of a longer perspective and distinguishing the particularities of a given moment from the longer arc of an aesthetic modernity has two benefits: it brings into view instrumental effects that occur alongside or even well after the precipitating moment of an architectural project, and it sets into relief the present historical moment, in which debates on ugliness have been collapsed into a general perception of the aesthetic register as a flattened, horizontal space unbound from social causes and effects.

Though this book acknowledges the linearity of history, it is deliberately constructed from discrete historical episodes, each defined by an implicit (or, in some, an explicit) claim of ugliness and by a contextual social field such as law, morality, health, or economy. With each foregrounding aesthetic judgment within a transforming or contested circumstance, these episodes are used to reconstruct a fitful debate over architectural ugliness that has periodically entered into the social and political institutions of Great Britain or, more specifically, of England. Though fitful, this debate possesses an unremarked measure of coherence, with participants on its different stages having narrower or broader concerns yet sharing in common themes of judgment such as the propriety of persons or objects, or the calculation of social benefit, or the evaluation of novelty. It is the peculiar composite of English civil society—ceremonial institutions of state, representative governance enacted through the malleable mechanisms of constitution and common law, the endorsement of scientific advance and commercial advance alongside an established religion—that renders it a setting for an equally distinct instrumentality of the aesthetic register, and therefore the setting for the argument that follows.[14] Corollary to the composite nature of English civil society, though, is the episodic nature of the narrative presented here. Each episode, framed within its chapter, conveys particularities of an exchange between an aesthetic register and a social one in a concrete moment of historical change, an exchange that leads

toward the crystallization of new social mechanisms. It is this commonality that binds the episodes into a narrative, even as they explore different times and different corners of the constantly changing edifice of civil society.

The narrative of the book focuses upon London, but the story begins in the provincial city of Bath, in the early eighteenth century. The first chapter initiates the historical arc with aspects of the architectural career of the architect John Wood the Elder, eccentric even among an unconventional cohort of architect peers and political figures in the early eighteenth century. Responsible for the first planned improvements of the city of Bath, technical investigations of the building process, and a highly imaginative and contentious interpretation of the trilithons of Stonehenge, Wood in his career epitomized the continuity of aesthetics with three particular themes explored in the book: persona, materiality, and the institutions of civil society. Wood's son, an architect and assistant to his father, was himself a member of a peculiar eighteenth-century institution, an Ugly Club, a social club that celebrated the physical ugliness of its membership, a curious fact pursued in the chapter to expand the implications of Wood's architecture and aesthetic theories and to introduce the collective dimension of societal judgment and aesthetics. This chapter sets out the constitutive elements of the formulation of a civic aesthetics in Wood's formulation of attachments between the aesthetic dimension of architecture, and the social, historical, and economic endeavors in which he participated.

This initial chapter is followed by three grouped chapters, independent in their topics but chronologically sequential, all revolving around the significance of materiality. Chapter 2 reveals a century-long process through which judgments about ugliness linked to transforming perceptions of the industrial metropolis. It begins in the 1830s with the case of the stonework of the newly rebuilt Houses of Parliament in London. Initial worries about finding stones that would be aesthetically suitable and physically durable were drastically increased when the new stonework showed premature signs of decay. The industrial atmosphere of the city was to blame, and the recognition that this atmosphere of smog and soot produced an effect of ugliness prompted several courses of action. Some were aesthetic—new theories of architectural styles to suit a polluted atmosphere, for example; some were legislative—such as the evolution of nuisance laws to cope with the newly recognized inseparability of individual buildings in a city shaped by its atmosphere. The integral relationship of these seemingly unrelated paths of action is the primary focus of this chapter as it reveals how aesthetic debate on the ugliness of the industrial city incorporated the judgmental matters of representational regimes into those of enduring legal formulations.

Chapter 3 focuses upon the collective nature of societal judgments by addressing the forms and materiality of the contentious architectural aesthetics of brutalism. Over a thirty-year period, the uncompromising concrete forms of brutalism became the characteristic backdrop of the policies and politics of the postwar city and the welfare state. The "stonework"—poured and precast concrete—of the brutalist architecture favored by city councils and institutions confronted not simply individual subjects, but rather a collective subjectivity that had been instantiated in customs, conventions, and institutional embodiments. This chapter explores this collective subjectivity in the form of the metropolitan citizen, using the legal convention of the "man on the omnibus," or the reasonable person, to conceptualize the modern metropolis as a space of expectation and interpreting the judgment of ugliness as the disconcerting of civic spaces of collective expectation.

Chapter 4 explores the possibility that the judgment of ugliness marks out a conflict between the prerogatives of architecture and those of governing institutions. The particular case here is the controversial alteration of a seventeenth-century church designed by Sir Christopher Wren through the 1986 addition of an altar designed by Henry Moore. The perceived incongruity between the neoclassical architecture of the church and the modern form of the sculpted altar was characterized in terms of ugliness. But this chapter reveals that this judgment was only the most recent dispute about the significance of the very concept of congruity, a concept formulated in nineteenth-century debates on church architecture and recapitulated in the rise of preservation movements in the later twentieth century. Drawing together questions of materiality (the fact that the altar was made of stone was central to the debate) and institutional prerogative (much of the debate occurred within the ecclesiastical courts of the Church of England), this chapter connects the aesthetic judgment of ugliness to the conflicting intentions of preservation.

The second part of the book consists of an additional three chapters, once again independent in their topics but disposed chronologically and linked together by a common theme. This theme is personhood, in its manifestations from the individual architect to the profession to the public, elucidated through episodes that span from the late eighteenth century to the present day.

Chapter 5 reveals the origins of the commonplace assumption that aesthetic criticism may address works of architecture (and other aesthetic productions) as social objects independent from their creators. Prior to the evolution of specific aspects of English libel law, common understanding held that a work of art was the embodiment of its creator, and to improperly criticize the former was to illegally impugn the latter. Through a series of libel cases heard around the turn of the nineteenth century,

including well-publicized cases in which the architect Sir John Soane sued critics who decried the ugliness of his buildings, the modern formulation emerged whereby criticism of aesthetic matters was exempted from libel claims. The conflicted relation of libel law and aesthetic practice has, however, been periodically renewed, in James Whistler's 1877 libel suit against John Ruskin, in later concerns about the legal timidity and therefore the ineffectuality of architectural criticism, and most recently in a lawsuit brought by the architect Zaha Hadid against the architectural writer Martin Filler. This chapter describes the role of judgments of ugliness within this transformative process, and shows also how the process itself has served to consolidate concepts of an architect's persona.

Chapter 6 takes the profession of architecture as its central topic. With the parallel emergence of modern conceptions of individuality and celebrity on the one hand, and modern organizations of corporate architectural practice on the other, the concept of the architect as a corporate person has come to assume a greater and more nuanced importance. In aesthetic judgments, in legal proceedings, and in historical valuations, the person of the architect very often stands in for complicated disciplinary motives and institutional routines. This chapter begins with the conflation of the process of professionalization and the critique of the mediocrity of architecture in the late nineteenth century, and then carries this perception of the Victorian city into an analysis of the drawn-out episode of the development of the Mansion House area of London. From the 1960s to the 1990s, proposed redevelopments—first a tower designed by Mies van der Rohe, and then a smaller building designed by James Stirling—were strongly opposed by representatives of preservation groups and civic organizations who viewed the development as an unacceptable aesthetic degradation of the city. In this sequence of events and in accompanying legal inquiries, the authorial (and professional) standing of the architect served as a focal point for the judgment of aesthetic propriety, or, as opponents argued, lack of propriety.

The final chapter in the group extends the consideration of personhood to an institutional embodiment of the state, in the form of the public and also in the person of a future constitutional monarch, the Prince of Wales. For the past thirty years, Prince Charles has been an outspoken proponent of neoclassical, traditional, and vernacular architecture in both urban and rural contexts. His has been the most prominent voice in a broadly antimodernist turn in the aesthetics of architecture that commenced in the 1980s with the ugliness of a century of modern architecture as its rallying point, yet the prince himself has been insistent that his voice is a direct expression of public opinion and popular sentiment set against a professional opposition. This chapter explores the postmodern turn in England and examines some of the arguments that accompanied it as

signaling a novel stage in the construction of societal judgment. It looks at controversial civic projects such as the National Gallery extension and contentious real estate speculations such as Chelsea Barracks to discern the relationship between aesthetic judgments and the neoliberal state. By examining the extraconstitutional role played by Prince Charles along with the functional role of the public inquiry (a statutory component of the planning process in Great Britain) as a venue for disputing aesthetic judgment, the chapter reveals the way in which contemporary claims about ugliness are contributing to the refashioning of the state's participation in cultural production.

By its conclusion, the book has arrived at the present day, in the midst of strident arguments about the ugliness of architecture. These arguments, however, have a history, a long history, whose explication reveals a very different understanding of architecture's role, and potential role, in society. Once the judgment of ugliness is understood not as a simple matter of taste but as a manifestation of social and political conflict that is diffused through different modes of cultural production, it becomes possible to see that the aesthetics of architecture have a consequence beyond the compass of individual buildings and at times even entirely separate from buildings. Once the judgment of ugliness can be seen beyond the defining calculus of style, then the aesthetic sphere, construed in terms of a civic aesthetics, can also be evaluated and experienced through the mechanisms of judgment as much as through the judgments themselves. In the narrative that follows, the reader should anticipate not a summary definition of ugliness but an exploration of the consequences that follow from implicit and explicit judgments of ugliness, and the potentials that develop with these consequences. With these potentials brought into view, it may be possible—still without disregarding or endorsing the proprieties or degradations of any specific building or architectural critique—to understand ugliness as the signal of transition in moments of transformative change, as the boundary mark between the constraints of one configuration of social mechanisms and the permissions of another.

Improvement

By the end of the seventeenth century, in the wake of the Civil War and the Restoration, a new balance of political interests occupied the towns of Great Britain—not only the metropolis of London, but provincial towns as well. Even as the monarchy retained its central symbolic role and considerable effective power, the increasing strength of civil authority had its expression in the development of towns. City corporations composed of aristocratic landowners, merchants, bankers, or freemen plotted the future course of their towns with a view of the new constellation of forces that would shape the development of urban settlements in Great Britain across the course of the eighteenth century: the mercantile system of imperial might that gave new priority to roadways and ports; the industries prompting the movement and consolidation of urban populations that spurred the construction of manufactures and warehouses; the technologies of illumination, water distribution, and print communication transforming the experience of the public spaces of the city. The role of architecture changed accordingly, in both its representational and its practical dimensions. The signification of monarchy—in the major cities at least—and the church—in even the most provincial of towns—remained central elements of architectural performance, but these were joined by novel manifestations of social endeavor, such as the club or the exchange, that were instances of an emerging public domain shaped by discourse and transactions conducted in public view. In the buildings that housed these new institutions, behind the facades that fronted private interiors, and in the streets that connected them together, social life in the metropolis began to assume the now-familiar contours of modernity.

Such transformations in the towns of Great Britain, though rapid, did not occur abruptly, or decisively. Even with considerable enthusiasm for "improvements," as they were generally known, a number of factors might act as obstacles to their realization. Theories of property, which had captured the legal and social imagination in Britain, segregated private and public domains such that physical changes to those domains might not parallel exactly the changing formulations of the civic sphere. The techniques and practices of design and construction, some long established and enforced formally by guilds or informally by habit, could constrain rather than encourage novelty. In general, improvements overlapped with prior circumstances—with older buildings, streets, and customary uses—so that the one threw the other into sharp relief. Architecture itself, a material endeavor, was in some ways less malleable than the ideas of civic space that architecture was asked to instantiate, and it was in this distinction that the role and purpose of the aesthetic register of architecture came decisively into view. In this transition from prior to future civic arrangements, the aesthetics of civic spaces began to be described in terms of beauty and ugliness, terms that—while of much older lineage and long employed in architectural discourse and poetical descriptions—served now in a particular manner to define an emerging civil constitution of towns and their society, with the concept of ugliness in particular serving to denote the uncertainties, the speculations, the difficulties of that emergence.

The Disorder of Bath

When the antiquarian William Stukeley visited the provincial city of Bath on his tour of notable sites in Great Britain, his observations conveyed a measured appreciation for some of its features tempered by a disdain for the state of its streets and buildings:

> The [ground] level of the city is risen to the top of the first walls, through the negligence of the magistracy, in this and all other great towns, who suffer idle servants to throw all manner of dirt and ashes into the streets.... The small compass of the city has made the inhabitants croud up the streets to an unseemly and inconvenient narrowness: it is handsomely built, mostly of new stone, which is very white and good; a disgrace to the architects they have there. The cathedral is a beautiful pile, though small; the roof of stone well wrought; much imagery in front, but of a sorry taste.[1]

Handsomeness and beauty seem in Stukeley's view to have resided more in the material properties of the architecture of the city than in its expressive achievement. The quality of the stone embarrassed the

accomplishment of the architects who used it, and the techniques used to work the stones of the cathedral roof surpassed the artistry of the sculptures and ornaments that adorned its facade. Stukeley was aware, as most visitors would have been, that Bath was shaped by diverse intentions and by contingency as well. Its geological surroundings produced the hot springs for which the town was named, and also provided the source of the local stone that he deemed "white and good"; its governance was in the hands of a city corporation, the magistracy to whom he assigned the blame for the misbehavior of the denizens of the town; its growth over time had been constrained by the older Roman walls, producing the crowded and irregular arrangement of streets and buildings. The outward appearance of all these aspects—simply, the aesthetic effect of the city—Stukeley judged deficient, and attributed that deficiency to the architects who were "disgraced" by an admirable stone whose qualities their own inadequate efforts at design failed to complement.

Though famous already for its medicinal baths, the city's transformation into a storied center of leisure commenced with the start of the eighteenth century. (Figure 1) A royal visit by Queen Anne in 1702 and her return the following year brought the court and courtiers, and with them the attention and notice of other well-to-do persons who gave Bath its place on the itinerary of fashionable destinations. The town became part of the winter tour, an attraction first and most famously for its baths and their supposed curative powers, but soon also for its entertainments, its elaborate balls, gambling, and gossip. Over the span of less than two decades at the beginning of the century, Bath attained an almost unrivaled popularity, highly favored by the fashionable set for the excitement of its social scene, which in comparison to London or other settings was unguarded and permissive.[2] The success of this new attraction—a leisured urbanity—was due in part to the calculated efforts of Beau Nash, who, appointed by the city corporation as the master of ceremonies in 1705, governed the social life of the town for more than fifty years.[3] Wealthy visitors arriving for months-long stays came with the expectation of a enjoyable and satisfying residence. It was the job of the master of ceremonies to provide this guarantee. Nash recorded each visitor of suitable social standing as a member of "the Company," a subscription list whose members could attend the entertainments held in the assembly rooms, be escorted to the baths, and be managed in every aspect of their social lives by the master of ceremonies.

While Nash administered the social life of the town's visitors, the mayor and the Bath Corporation governed its citizens and its economic and material condition. The thirty members of the corporation included representatives from the many trades that composed the commercial life of the town, and their primary concern was to perpetuate its economic

Figure 1. The walled medieval city of Bath occupied the roughly circular shape seen at the center of this 1776 plan. The new streets and blocks of fashionable houses expanded north and west in the eighteenth century, including elements such as Queen Square, the Circus, and the Royal Crescent, all seen in the upper left quadrant of the plan.
A New and Correct Plan of the City of Bath, sold by W. Frederick and W. Taylor Booksellers (1776).

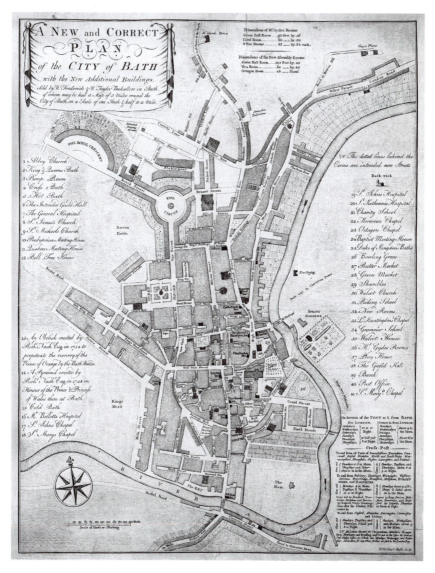

growth and vitality. To these fiscal ends, the corporation pursued a number of improvements, beginning with legislation such as a tax levy to pay for ten lights to be constructed in anticipation of Queen Anne's visit, or the enactment a few years later of turnpike and paving acts to rebuild the roads leading into Bath and to pay for their upkeep. Improvements to the infrastructure of the town were accompanied by improvements to its maintenance, with further legislation ordering a regimen of street cleaning and a regular watch to protect its citizens. By 1766, the corporation had determined that new and more expansive legislation was needed in order to "have the streets etc. paved by a pound Rate, to be cleaned by a daily scavenger, and to have the power of directing all matters relative to the paving, cleansing, enlightening & watching the streets etc."[4] Such extensive concern for improvement reflected not only the foresight of corporation members who took a longer view toward the town's future growth and vitality, but also the concern of corporation members that the town in its present state did not provide an adequate physical setting for the civic institutions and behaviors that it housed.

Infrastructural and managerial improvements did much to answer these two aims, but more important for the latter concern was the appearance of the town, an appearance decisively determined by its public and private buildings. The architect who seized upon this aspect of improvement and organized much of his career around it was John Wood the Elder, a precocious provincial architect who practiced extensively and influentially in Bath during the second quarter of the eighteenth century.[5] In 1727, when Wood arrived in Bath and took up residence, he brought with him, by his account, designs to carry out grand transformations: "I proposed to make a grand Place of Assembly, to be called the Royal Forum of Bath; another Place, no less magnificent, for the Exhibition of Sports, to be called the Grand Circus; and a third Place, of equal State with either of the former, for the Practice of medicinal Exercises, to be called the Imperial Gymnasium of the City."[6] Any one of these would have intervened in the small compass of the town at a spectacular scale; together they would have imposed an artificial magnificence to rival cities of historical imagination. But Bath had immediate need of improvement at a much smaller and more humble scale. The quality of its houses did not match the quality of the newly arriving visitors, and its "little, dirty, dark, narrow Passages" made the perambulations of those visitors uncomfortable and at times unsafe.[7]

Wood was particularly appalled by the architecture of the town's central attraction, the baths. The entry rooms of the King's Bath "seemed more fit to fill the Bathers with the Horrors of Death, than to raise their Ideas of the Efficacy of the Hot Waters"; the Queen's Bath was even worse, for "a Man no sooner descends into the Bath, than he finds himself

sunk into a Pit of Deformity; if irregular Walls incrusted with Dirt and Nastiness, and these standing beneath irregular buildings, may be so called."[8] Wood believed that the appearance and the physical state of the baths endangered their occupants. The haphazard arrangement of forms and the decayed surfaces of the walls and floors, the darkness of the interiors and the dankness of their air, demanded, in his view, urgent remedy. The architecture of the baths was, after all, the architecture of the central civic amenity of the town, upon which its future vitality depended: "The Wretched and dangerous Condition of what made the Staple Commodity of the City I was about improving … made me lose no Opportunity, by Observation or Enquiry, to form a Design for making the Baths as Commodious as possible for the Benefit of the present Age."[9] Wood's proposals to improve the baths were not pursued by the city corporation, but Wood had articulated the process of improvement in architectural terms and had in fact already started work on other commissions that would foreshadow the sweeping transformation of the city during the Georgian period.

A contract with the Duke of Chandos to rebuild St. John's Hospital afforded Wood the chance to design and construct adjacent houses. Soon after, he began work on his own scheme for what would become Queen Square, four neoclassical facades facing each other across a square and unifying separate building plots behind. Constructed in what was then an open field just beyond the city wall, Wood's design for Queen Square inaugurated a period of speculative building through which Bath expanded beyond its "small compass" and took on the more orderly and regular arrangements of neoclassical plans—straight streets, consistent proportions, and ornamentation. This architecture would properly house the Company over the course of the eighteenth century, with more commodious interiors, more elegant exteriors, and urban settings that reflected the standing of the citizens and visitors who traversed them. Wood's notable legacy in Bath would eventually include, along with Queen Square, the King's Circus, and the Royal Crescent, projects conceived and initiated by Wood and completed by his son, John Wood the Younger, after his father's death in 1754. (see Figure 1) Though these works in Bath would be his most enduring, he also completed a few significant buildings outside the city, including the exchanges in Bristol and in Liverpool, which contributed to the civic improvement of those important mercantile centers.

Wood's thirty-year career in Bath was not without conflicts—his disputes with clients arose from diverse reasons, from the architect's tardiness to strong disagreements over the architect's designs, and the Duke of Chandos memorably chastised Wood for his inability to properly engineer the drains: "the Water-Closets smelling so abominably whenever the Wind sets one way, 'tis a sure sign that it is the Effect of

your Ignorance."[10] (Figure 2) The significance of the arc of Wood's career lies not in the tally of successes and failures, however, but, insofar as it pertains to the issue of civic aesthetics, in the narrative of improvement along which it is structured. Wood published his lengthy and detailed account *Essay towards a Description of Bath* first in 1742 and in a much revised version in 1749.[11] In the four parts of the book, Wood attempted to provide his reader an understanding of the city of Bath from multiple perspectives, the first part discussing the setting and environs of the town through the lens of natural science, the second giving an elaborate (and largely fanciful) story of its founding followed by a political history, the third—architectural in its focus—describing the physical qualities of the town, its buildings, and its streets, and the fourth presenting its legal and regulatory apparatus of bylaws and statutes. The composite of these four was a narrative of improvement, tempered by repeated assertions of a glorious ancient past subsequently lost, but nevertheless insistent in its demonstration of the effort by Wood and his contemporaries to realize a newly magnificent civic realm within their provincial city.

Throughout the text of his *Essay*, Wood provided his reader architectural indices of improvement—tiled roofs to replace thatched ones, small and ineffective glass replaced by sash windows, taller buildings, and "Ornaments to adorn the outside of them, even to Profuseness."[12] Such details had already been weighted with significance, for in the opening lines of his preface, Wood presented the transformation of Bath in explicitly architectural—and explicitly aesthetic—terms:

> About the year 1727, the Boards of the Dining Rooms and most other Floors were made of a Brown Colour with soot and small Beer to hide the Dirt, as well as their own Imperfections; and if the Walls of any of the Rooms were covered with Wainscot, it was such as was mean and never Painted.... As the new Buildings advanced, Carpets were introduced to cover the Floors, though Laid with the finest clean Deals, or Dutch Oak Boards; the rooms were all Wainscoted and Painted in a costly and handsome manner.... To make a just Comparison between the publick Accommodations of Bath at this time, and one and twenty Years back, the best Chambers for Gentlemen were then just what the Garrets for Servants now are.[13]

Calculated in aesthetic terms, the transformation effected was an increase in beauty and a corresponding decrease in ugliness. Imperfections and dirt concealed by the brown coloration of soot and beer were unmistakable examples of a prior ugliness that was removed or rectified by more perfectly milled lumber and carpets of pleasing color. This aesthetic improvement of architectural circumstances was mirrored by a parallel improvement of social circumstances. Where in the seventeenth

century "all kinds of Disorders were grown to their highest Pitch in Bath; insomuch that the Streets and publick Ways of the City were become like so many Dunghills, Slaughter-Houses, and Pig-Styes," now Wood could point out "a handsome Pavement … with large flat Stones, for the Company to walk upon."[14] The unconstrained social habits of the earlier time slowly gave way to the social behaviors regulated by the statutes and by-laws of the town, which were in turn reflected in the well-ordered appearance of new architectural settings.

As they walked upon such a handsome pavement, the manner of the Company would be accordingly elegant and orderly, obedient to eleven articles of conduct agreed to by members of the Company upon subscribing to its privileges. These articles defined niceties of social etiquette, though in any given season, of course, disorderliness was as likely to be caused by fashionable members as by thieves or prostitutes. Similarly, instances of decay, meanness, or disproportion certainly persisted in the architecture of the city, old or newly built. Ugliness was not vanquished by beauty, but its valuation had taken on a particular significance that extended beyond a singular example. Wood's intent was, unquestionably, to foster an increase in beauty, but this architectural priority reveals social specificities such as difference, lowliness, expedience, or apathy, being assigned to ugliness. Aesthetics was formulated as mode of inquiry at this same moment, and though Wood himself could not have invoked either the word or the philosophical concept, the surrounding context of British intellectual inquiry was very much concerned with questions of judgment, sensation, taste, and experience.[15]

The challenging question of collective judgment, of societal consensus around the evaluation of beauty or ugliness, was pursued at this time by David Hume. Examining the social manifestation of taste, Hume proposed that beauty and ugliness were not inherent properties of things, but rather were the idea or feeling produced in a person by those things. To designate a street as ugly or a building as beautiful was to describe a sentiment or a responsive emotion. Such sentiments or emotions were integral in themselves, not subject to proof or disposition outside of subjective experience. But they mirrored sensations produced by the reality of objects of experience.

> When a building seems clumsy and tottering to the eye, it is ugly and disagreeable; tho' we be fully assur'd of the solidity of the workmanship. 'Tis a kind of fear, which causes this sentiment of disapprobation; but the passion is not the same with that which we feel, when oblig'd to stand under a wall, that we really think tottering and insecure. The *seeming tendencies* of objects affect the mind: And the emotions they excite are of a like species with those, which proceed from the *real consequences* of objects, but their feeling is different.… The imagination adheres to the *general* views of things, and distinguishes the feelings they produce, from those which arise from our particular and momentary situation.[16]

According to Hume, sentiments had a social dimension, gathered together under a standard of taste, or a set of judgments accumulated over time by discriminating persons, not in isolation but as participants in changing social situations. Hume's thought inflects the significance of Wood's account of the city of Bath and of his architectural ambitions and accomplishments, for it allows an understanding of ugliness as a social judgment uncoupled from the properties of the architecture against which that judgment is registered, and reinstated instead as a social consensus of that architecture's "seeming tendencies." Purposeful, instrumental, bound up with intention and foresight, and as such, this consensus manifests not only architectural but also institutional and political concerns, opening the possibility of the reciprocal engagement of aesthetic properties and social consequences.

Architecture and the Neolithic Past

With the configuration of neoclassical buildings and artfully composed places like Queen Square, the North and South Parades, and the King's Circus, John Wood the Elder supplemented the town's rising prominence with a suitable civic appearance. Elegance achieved through the well-crafted ornamentation of columns, window surrounds, architraves, and

the like, along with consistency derived from the uniformity of the local freestone and the orthodoxy of Wood's geometric figures, made the architecture of the town a proper setting for the affairs of the fashionable set who visited for the winter season, as well as for the ambitions of the city corporation and the wealthy merchants and tradesmen responsible for its governance. The physical appearance of the town, constituted by the material, style, and facades of its architecture, provided only part of its aesthetic value. Equally important for Wood was the representational or symbolic significance of the architecture, and this significance depended in no small measure upon its historical resonance. The historical and theoretical tradition of classical architecture was well established in Great Britain by the close of the seventeenth century. Sir Henry Wotton's treatise on the *Elements of Architecture*, published in 1624, and the works of Inigo Jones and Sir Christopher Wren, along with other writings and buildings, had introduced the principles of classicism attributed to the ancient source, Vitruvius's treatise *De architectura*.

Wood, however, proposed a very different lineage of architectural authority. In the spring of 1741, he published *The Origin of Building; or, The Plagiarism of the Heathens Detected*, a treatise of evident architectural concern, as indicated by its title, but just as much a history of cultural inheritance, in which Wood attempted to establish for architecture a divine source. The Temple of Solomon—in Wood's day a presumptive historical reality—already served as an idealized architectural origin, but Wood aimed to make this origin more proximate to his own historical position and to displace Vitruvius from his authoritative position within architectural theorizations. The result was an account of restless imagination, tortured argumentation, and often inscrutable associational thinking. After a summary comparison of quotations from Vitruvius to sayings attributed to Moses, the author advised his reader, "we purpose, in the following Sheets ... to weigh and consider, the Origin, Progress, and Perfection of Building, so as to make an Account thereof consistent with Sacred History, with the Confession of the Antients, with the Course of great Events in all Parts of the World."[17] *The Origin of Building* does not exclude Vitruvius, or his categorical descriptions of the architectural orders, but these appear almost as postscript, in the fifth and final book that follows the four that assertively present and justify the argument for a more ancient origin. The classical architecture of Rome and the Greek architecture that preceded it are in Wood's view mere derivation rather than source and contained distortions and misappropriations of idealized forms and systems of design. His aim, in contrast, was to correctly align historical and aesthetic development, so that their coincidence was also the legitimation of one by the other.

In the final book, in a brief chapter, Wood took a further leap, bringing the argument of *The Origin of Building* closer to his time and place. Pointing to the evidence of architectural remains in Britain—"all the remarkable great Stones which lie flat on the Ground, as well as the Heaps made of several small Stones; or the single Pillars, Lines, Circles, Triangles, and Squares, composed of erect Stones"—that preceded the period of Roman occupation, Wood opened the possibility of a connection between the earliest stages of architecture and the standing stones located close by his own town of Bath.[18] Three remarkable sites—Stanton Drew, Avebury, and Stonehenge—stood within a day's ride of the town, and these remains of a lithic architecture of such "Art and infinite Labour" in Wood's view must certainly "bespeak a Parent of more Antiquity than the Romans."[19]

Wood constructed a speculative lineage for these remains in the second book of his *Essay towards a Description of Bath*, one based upon an elaborate and fanciful account of the founding of the city of Bath. The foundational legend of the city, which already in the eighteenth century was coming to be regarded as fable but to which Wood himself ardently subscribed, had it that the famous hot springs were first encountered by King Bladud, a Celtic prince whose disfigurement by leprosy caused him to retreat from his kingdom to live as a swineherd. After seeing his pigs wallow in the hot springs and subsequently be cured of their sores, he bathed in the water and discovered his own leprosy cured. Bladud founded a city upon this site, raising a temple with perpetual fires; centuries later the Romans raised their own temple at the site they called Aqua Sulis, and several centuries after that the medieval town developed, still centered upon the medicinal baths. With contortions of chronology and with opportunistic use of ancient and contemporary sources, Wood proposed to his readers that the inheritance of divine architecture had been brought to Britain by King Bladud himself. According to Wood's account, Bladud had traveled to "the South Eastern Part of Europe," where he "became a Disciple, a Collegue, and even a Master" of the philosopher Pythagoras, encountering through him the influences of Zoroaster's Persia and the philosophical advances of Greece and conveying in return "his knowledge of the Magical Art."[20] Returning to Britain after the fall of Troy, Bladud founded a vast city with Bath as the "Metropolitan Seat of the British Druids" and a center of healing, and Stanton Drew, the "University of the British Druids," as its center of learning.[21] Wood construed the standing stones of Stanton Drew as an embodied cosmology, declaring it to be "a Model of the Pythagorean System of the Planetary World," with its dimensions fitted to those of the Solomonic past and anchored by twin temples of the sun and the moon.[22] Stonehenge was similarly a seat of learning, modeled after Stanton Drew, and therefore also descended

from the divine inspiration of architecture, uncorrupted by and not indebted to Vitruvius or Roman architecture.

The fantastical nature of Wood's historical reasoning was sharply contrasted by the scrupulous empiricism of his study of the lithic monuments themselves. In the summer of 1740, Wood ventured his first study of the nearby antiquities, drawing sketches of the stones at Stanton Drew. These earned him the patronage of Edward Harley, second Earl of Oxford, which enabled Wood to undertake more deliberate surveys. These he carried out at the end of the same summer, first at Stanton Drew and then at Stonehenge. (Figure 3) His study of Stanton Drew was

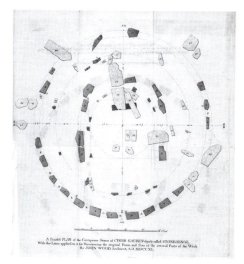

Figure 3. John Wood's survey of the existing stones at Stonehenge with concentric circular lines showing his speculation on the original geometry of the monument. From John Wood, *Choir Gaure, Vulgarly Called Stonehenge, on Salisbury Plain, Described, Restored, and Explained* (Oxford: J. Leake, 1747).

the basis for the chapters in the *Essay towards a Description of Bath*, while the work on Stonehenge Wood published in 1747 as *Choir Gaure, Vulgarly Called Stonehenge, on Salisbury Plain, Described, Restored, and Explained*. With the latter publication, Wood joined a debate over the origins and significance of the megaliths that extended from Inigo Jones's posthumously published survey and reconstruction, which he carried out for King James I in 1620, to the contrary arguments put forward by William Stukeley in 1740.[23] The axes of dispute were the authorship of the stone monuments—Roman according to Jones and Druidic according to Stukeley—and therefore their significance, pagan but imperial in Jones's account and proto-Christian and trinitarian in Stukeley's. Wood argued for their Druidic attribution, but with the origin of their architectural arrangement traceable, like that of Stanton Drew, to the divine architectural source of the Temple of Solomon.

But while Wood may have found himself in agreement with some parts of the accounts offered by other interpreters, he was quite clear that none was acceptable in full: "though many have undertaken to Describe the Ruins of Stonehenge; to Restore those Ruins to their antient State; and, in general, to Explain the whole Work; Yet it is not Stonehenge that they have Described, Restored, or Explained to us, but a Work that never

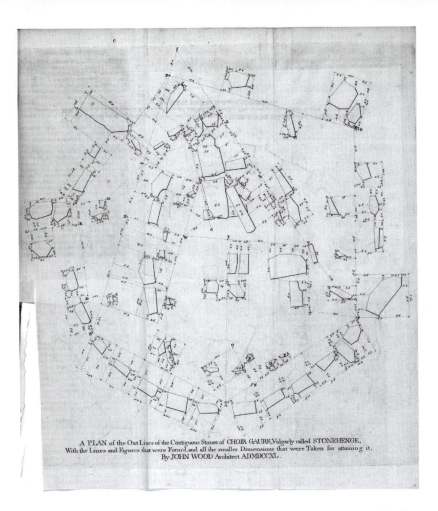

A PLAN of the Out Lines of the Contiguous Stones of CHOIR GAURE, Vulgarly called STONEHENGE, With the Lines and Figures that were Form'd, and all the smaller Dimensions that were Taken for attaining it. By JOHN WOOD Architect ADMDCCXL.

existed unless in their own Imaginations!"[24] Wood also pointedly disagreed with Stukeley's assertion that a minutely accurate survey of the stones was impossible, and sought to refute it with the accomplishment of his own. Though his historical interpretation remained fantastical, Wood in his measurement and survey achieved a remarked fidelity to the physical reality of Stonehenge. Over the course of a few days, Wood set survey stakes around the site in arrangements of lines and polygonal figures in order to calculate with unprecedented precision the position and orientation of the stones. (Figure 4) Over dozens of pages of his text, he rehearsed for his reader each of these survey lines and angles and noted, in additional scrupulousness, that he had left his survey stakes in place, driven down flush with the ground, should any person wish to check his measurements for error.[25] The contribution of Wood's survey lay in this

precision, as it provides still a knowledge of the disposition of the site as it lay in the eighteenth century.

The survey's precision has a further significance, unremarked but relevant in the context of the emergence of a civic aesthetics: Wood's precision arose in relation to his encounter with the irregularity of the stones themselves. Not only the overall arrangement but the shapes of the individual stones were understood to be deformations from some prior, more regular state. Though Wood disputed both Jones's and Stukeley's overly geometric reconstructions, he too imagined a more orderly form to have been the original condition. Yet he urged his reader to understand that even the prior Stonehenge was imperfect in this regard, conceding that "Perhaps Your Lordship will be surprized at the great Irregularity which appears in almost all the Pillars of the Work," but suggesting that an understanding of the difficulty of working such large stones set upon the ground, and of the effect of weather and vandalism over centuries changing those stones "from more regular Forms into the Shapes we now see them, it will very much abate our Ideas of Irregularity in the present Position of them."[26] In an illustration of his technique for accurately ascertaining the profile of the stones, Wood shows the stones placed within rectangular frames, which he marked at the site with survey stakes and used as a norm to measure the offset dimensions of the existing stone. (Figure 5) This illustration evokes the erosion of the surfaces over time while also establishing a theoretical proximity of the regular and the irregular. Not simply the original state of the stone in contrast to its present condition, but a simultaneous proximity, in Wood's perspective, of an irregularity that is

Figures 4 (opposite) and 5. John Wood's illustration of his survey technique showing the rectilinear forms and measurements used to derive the outlines of the irregular stones at Stonehenge. From John Wood, *Choir Gaure, Vulgarly Called Stonehenge, on Salisbury Plain, Described, Restored, and Explained* (Oxford: J. Leake, 1747).

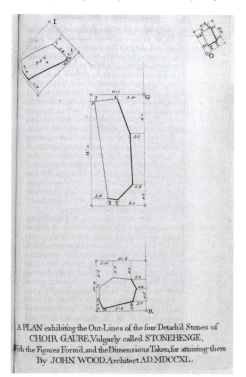

A PLAN exhibiting the Out-Lines of the four Detach'd Stones of CHOIR GAURE, Vulgarly called STONEHENGE, with the Figures Form'd, and the Dimensions Taken for attaining them By JOHN WOOD Architect AD.MDCCXL.

contained by and within a regularity; in more directly aesthetic terms, an ugliness encased within beauty.

"The Body of Stonehenge, thus Restored to its perfect State, cant be conceived otherwise than as a most Beautiful, as well as a most Magnificent Structure."[27] For Wood, as for Jones and Stukeley, the aesthetic presence of Stonehenge in its ruined state was a physical index for a prior presence that could be resummoned only through imagination and through techniques of representation. Wood disagreed with the others as to the arrangement and form of this prior presence, proposing a much less elaborate geometry to resolve the evidence of the stones as he found them into a coherent pattern of concentric rings. His restoration differs not only in its form but, most decisively, in Wood's accompanying claim that his plan of Stonehenge in its perfect state represents the "State intended by the Architect of the Work" even though the monument was never actually realized in this form.[28] The "Design was so far from being compleated, that I have many reasons to think the first Builders of Stonehenge did not Perfect so much as any one single part of the whole Fabrick," argued Wood, attributing the incompleteness of the monument not to contingency or accident, but proposing instead that it had been "purposely left unfinished."[29] For Wood, then, Stonehenge existed in three states: the one he encountered during his survey; the ideal one planned by its architect; and a third, incomplete state between these two. It is Wood's capacity to conceive of incompleteness as a positive condition that issues the most radical insight into the aesthetic presence of Stonehenge, for this conception collapses the otherwise sharp distinction between perfected form and ruined condition. Though Wood himself did not use the word "ugliness," it is implicitly framed through his argument, not attached to the deformity of the ruin as a negation of beauty, but instead possessed of an instrumental, deliberate capacity, in the willful incompleteness of Stonehenge.

Wood arrived at his threefold view of Stonehenge only through the unique composite of an unconstrained historical imagination and a highly constrained technique of representation. It was through Wood's encounter with Stonehenge as a reality that a framework for ugliness came into view. Wood's conclusions were conditioned by the materiality and the actuality of the stones: their size, their weight, their surfaces. The irregularity of their abraded surfaces was made comprehensible, calculable, and representable by Wood's survey points, lines, and measures. Wood's undertaking to imagine the actual process used for the almost unimaginable labor of lifting the immense stones into place led him toward his reflections on incompleteness. His contemplation of the aesthetics of the stones was based not just upon a painterly view of Stonehenge in its setting, but also, and seemingly more, upon a close if speculative analysis

of the color, crystallization, and geologic source of the stones.[30] The sum of these different grapplings with the lithic actuality of Stonehenge was a representation that attempted to contain the excessive reality of the monument, an excessive reality that would itself be characteristic of an emerging conception of ugliness. With its careful study of the irregularity of the stones, and the decision to think historically about incompleteness, Wood's investigation of Stonehenge introduced a substantively novel perspective on what would be two other constitutive dimensions of the aesthetic of ugliness: irregularity and incompleteness. Though the eccentricity of his theories often prompts their segregation, this novel perspective was not unrelated to the social and civic intentions of Wood's own architectural work, for the aim of his historical efforts was to establish and legitimate a British origin to which that work might be bound. In fashioning a conceptual understanding of irregularity, incompleteness, and implacable materiality, Wood fashioned also a framework for the coexistence of ugliness and civic aesthetics.

The Stones of Bath

The opening chapters of the *Essay towards a Description of Bath* demonstrated both Wood's interest in the local geology and that his knowledge of it was current with recent scientific thinking: "Experience hath sufficiently demonstrated that the Body of the City of Bath stands upon a hard Clay and Marl, of a bluish Colour, with Stratas of Rock," while under the soil of the vales outside the city walls, "the Stratas of Rock intermixed with the Clay and Marl soon become a kind of Marble, called Lyas; … These Rocks increase in their Progress westward; and the Beds of Gravel, as well as the Veins of Coal, increase likewise; the latter to such a high Degree, that large Quantities are now raised and sold within three Miles of the hot Fountains in the Heart of the City."[31] These seams of coal, then beginning to assume their commanding economic importance, were not the only mineral resource of specific economic value; for an architect like Wood, the strata nearby the town contained a more vital resource—freestone. A type of limestone, freestone was a desirable building material because it could be cut in any direction and therefore used for architectural profiles or details, and it was admired also for the color and texture of its surfaces; the aesthetic quality of the stone, in other words, lay both in its visual appearance and in the shapes into which it could be contrived.

The local freestone, also known as Bath stone, would become familiar as the typical architectural surface of Georgian Bath, but the stone was little used in London, due in large part to the protectionism of local masons and architects in the metropolis who denigrated its appearance and

durability. Wood and his compatriots actively fostered its recognition, with Wood trying to convince the Duke of Chandos to use the stone for a new house in London.[32] On another occasion, his advocacy was more public and more cunning, as Wood recounted in boastful anecdote: "The Introduction of the Free Stone into London met with great Opposition; some of the Opponents maliciously comparing it to Cheshire Cheese, liable to breed Maggots that would soon Devour it; and the late Mr. Colen Campbell, as Architect, together with the late Messeurs Hawksmoor and James ... were so prejudiced against it ... they Represented it as a Material unable to bear any Weight, of a Coarse Texture, bad Colour, and almost as Dear as Portland Stone for a Publick Work in or near London."[33] Wood intervened, attending a public meeting for the selection of stone for Greenwich Hospital and having a mason provide samples of Bath stone and Portland stone; Campbell, strong critic of Bath stone, promptly mistook the one for the other, exposing his partiality and also demonstrating the high aesthetic and material quality of the stone from Bath.

Ralph Allen, a prominent civic leader and entrepreneur who had a near monopoly on local quarries in Bath, chose to make his new estate an architectural display of the quality of Bath stone. Wood produced several designs "wherein the Orders of Architecture were to shine forth in all their glory," before Allen settled on what they deemed a more humble approach. The humility is relative, for the building executed over a number of years, including periods of estrangement between Wood and Allen, was a commanding neo-Palladian structure of considerable scale and elegance. While work proceeded on the house, the grounds of Prior Park, as the estate was named, were embellished by a garden laid out by Alexander Pope, an acquaintance of Allen who was then elaborating the aesthetic principles of naturalistic landscapes and poetical allusion that would develop into the picturesque movement. (Figure 6) The house faced a lawn perspectively framed upon its central axis, but to one side Pope designed a wilderness of woods, paths, watercourses, and poetic elements such as a grotto of rustic stone. The very aspects that Wood had reckoned with at Stonehenge, irregularity, incompleteness, and material presence, Pope employed as attributes of aesthetic purpose.[34] Prior Park was further embellished by a very different kind of feature—a railway that connected Allen's stone quarries, located just beyond the estate, with warehouses and docks on the river Avon from which the stone could be delivered to Bath or other sites by barge. The system possessed an ingenious simplicity: carriages filled with stone could be guided down from the quarry holding large cut blocks or pieces of rubble stone; gravity powered the descent, controlled by a braking mechanism, and the empty carriages were drawn back to the quarry by horses.

Figure 6. An engraving of Prior Park shows Alexander Pope's forest wilderness, containing the grotto, between the house and the railway featured prominently at lower right. Anthony Walker, *Prior Park, the Seat of Ralph Allen Esq. near Bath | Prior Parc, la Residence de Raoul Allen Ecuyer pres le Bath* (1752).

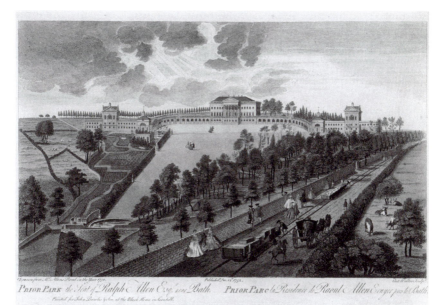

Prior Park the Seat of Ralph Allen Esq. near Bath. Prior Parc la Residence d' Raoul Allen Esquyer pres le Bath.

The means devised by Allen to deliver stone from his quarries to his warehouses had an economic expedience, but also had a decisive role in the constitution of the civic aesthetic that Wood sought to introduce into Bath. When Wood began his career there, he found that the local masons adhered to a peculiar sequence of work. After blocks of stone were raised out of the neighboring quarries, they were worked by masons designated free masons, who were entitled to carve the freestone into the dressed blocks that would be used as architectural facings. These dressed stones were transported from the quarry into the city and there set into place by rough masons, the masons who worked rubble and common stones and who were entitled to raise walls at the building site. Wood criticized this organization of work for its deleterious effects upon the resulting architecture. Because of the cumbersome and incautious transportation required to bring already finished blocks to the building site, the "sharp Edges and Corners of the Stones are generally broke" by the time they are delivered; and thus the architectural works of Bath "lose that Neatness in the Joints between the Stones, and that Sharpness in the

Edges of the Mouldings, which they ought to have; and which People, accustomed to good Work in other Places, first look for here."[35] The civic character of Bath, dependent for its expression upon the precision and sharp delineations of form and ornamentation in its architecture, had been compromised by the customary processes of quarry work and masonry. Allen's railway alleviated this problem: masons could be stationed in the warehouses by the river or at the quarry, allowing for a different distribution of work upon the stones, and dressed or unfinished blocks could be delivered with greater facility and less chance of damage due to the less rugged mode of transport. (Figure 7) In addition, Wood claimed credit for introducing the use of "the Lever, the Pulley, and the Windlass" by masons on building sites in Bath. Before he recruited laborers from other parts of Britain familiar with such contrivances, the locals had "made use of no other Method to hoist up their heavy Stones, than that of dragging them up, with small Ropes, against the sides of a Ladder," with all the consequential damage that entailed.[36]

The necessity of technologies such as the railway or cranes at his building sites was the provision of more precise translation of stones from their place of origin underground to their destinations aboveground in the civic apparatus of architecture that Wood was projecting for Bath. Wood's concern for the correlation of the material of architecture with its aesthetic consequences was not merely pragmatic, not only an attention to construction or physical appearance, but a speculation upon symbolic dimensions as well. One of the early chapters of the *Essay towards a Description of Bath* confirms this emphasis, with a passage in which Wood offers a seemingly digressive description of a local coal-works:

> The Hovel for working one of the Pits is exceedingly remarkable, as it lately represented a covered Monopterick Temple, with a Porticoe before it. The former shelters the Windlass, the latter sheltered the Mouth of the Pit; and one was raised upon a Quadrangular Basis, while the other appears elevated upon a circular Foundation; a Figure naturally described by the Revolution of the Windlass.
>
> The Diameter of this Figure is just four and thirty Feet, and the Periphery is composed of six and twenty insulate Posts, of about seven Feet six Inches high, sustaining a Conical Roof terminating in a Point and covered with Thatch: Mere Accident produced the whole Structure; and if the Convenience for which it was built was of a more eminent Kind, the Edifice would most undoubtedly excite the Curiosity of Multitudes to go to the Place where it stands to view and admire it … as a Structure of the same Kind with the Delphick Temple after it was covered with a spherical Roof by Theodorus, the Phocean Architect.[37]

Wood included no illustration, but the structure he described was not uncommon above the pitheads that were appearing in increasing numbers in Somerset. In its simple form, this structure would have had a windlass, a raised circular drum turned by horsepower to wind and unwind a rope, next to a wooden framework with mounted pulleys guiding the hoisting rope down and up the mineshaft to the caverns below. The structure that Wood described was more elaborate: the windlass was sheltered by a thatched roof conical in form and supported by twenty-six columns; the mouth of the pit was "sheltered," implying a roof and substantial supports. Though Wood conceded that the appearance of the structure resulted from "mere accident," he asked his reader to see this

Figure 7. Masonry and architectural details rendered in Bath stone in the buildings of the King's Circus.

mechanical device as housed not in a "hovel," but in a monopteric temple with a portico, as grand in its architectural presence as the temple at Delphi.

Wood's moment of architectural contemplation, insignificant in the larger narrative of *Essay towards a Description of Bath* and therefore overlooked in assessments of that text, brings into view two aspects of his architectural work that bear upon questions of civic aesthetics. The first of these, straightforwardly enough, is the attention that Wood paid to the geological surroundings of the town that he aimed to improve, surroundings upon which the materiality and therefore the aesthetics of his architecture directly depended. The second is Wood's preoccupation with the devising and codification of a civic architecture, that is, an architecture of collective purpose that represented and encouraged the activities and discourse of communities of citizens. Such an architecture did not consist only of the traditional symbols of monarchy, state, or church. In the same years Wood surveyed neolithic monuments and assembled his history of the origins of architecture, he designed and built the Bristol

Exchange, itself a monument to the mercantile importance of that city.[38] In the description of the coal-works, Wood conjured an appropriately civic architecture for an economic engine that did not yet have an adequate architectural representation. The expedient assembly that sheltered the windlass and pulley was mere hovel, but the working of the coal seam below was an activity of economic importance that merited a far more deliberate and accomplished architecture; in short, a civic aesthetics.

Ugliness and the Citizen

The complexity of architectural ugliness in the emerging formulations of civic aesthetics consisted of the changeable valences of the social and aesthetic valuation of ugliness. Wood's efforts to refute the degraded reputation of Bath stone and to secure a means for its use free of imperfections, along with his campaign to improve and rectify the disorderly and decayed state of the town, point to a desire to elide the instances of architectural ugliness. Certainly, Wood aimed to bring beauty into existence, but Wood's other contributions to architectural thinking raise different perspectives, concerned less with the undecidability of ugliness than with the possibility that architectural ugliness had (and would continue to have) a social function. This function may be the effect of a single building, but Wood's architectural productions—drawings, buildings, writings, managements—suggest that elements of architectural ugliness participate in more diffuse or more distributed ways as well. The presence, in Wood's professional work, of stones as historical markers and stones as economic instruments indicates this social distribution. His survey and analysis of Stonehenge not only accounted for but assigned merit to two characteristics—irregularity and incompleteness—that were, in parallel contexts of his work, factors of ugliness. To the material aspect of social function, Wood's life adds a further factor, that of personification, or the role of the person within the social distribution of architectural ugliness. The many idiosyncrasies of John Wood the Elder do much to suggest the importance of embodiment, but it was actually the son to whom he gave his architectural legacy, John Wood the Younger, who participated in a most curious and telling social context: the Ugly Face Club of Liverpool.

In 1751, while supervising the construction of the Liverpool Exchange on behalf of his father, Wood the Younger joined a social club that gathered together men purported to be of unfavorable visage. (Figure 8) This "Honorable and Facetious Society of Ugly Faces" was undoubtedly premised upon the conviviality of its fortnightly meetings, and did not advance any aim other than congenial fellowship. Nevertheless, it maintained clearly stated standards of admission for any prospective member, who would have to possess "something odd, remarkable, Drol

or out of the way in his Phiz, as in the length, breadth, narrowness, or in his complexion, the cast of his eyes, or make of his mouth, lips, chin, &c."[39] Other bodily features, regardless of whether they would be regarded as deformities, were not to be taken into consideration. Only the face of the candidate was subject to judgment, and certain of its attributes could be viewed preferentially. For example, "a

Figure 8. Advertisement for the Ugly Face Club of Liverpool on the occasion of an anniversary in 1806.

large Mouth, thin Jaws, Blubber Lips, little goggyling or squinting Eyes [were] esteemed considerable qualifications in a candidate," as was a "large Carbuncle Potatoe Nose."[40] The membership at one point voted to purchase five pictures of ugly faces, presumably to give some emphasis to the decor of the rooms in which they met and some objective standing to the issue around which they organized themselves.

By the time Wood the Younger was elected to membership in 1751, the Ugly Face Club had been in existence for at least eight years, with departing members clearly being replaced by others eager to join. Surprising though it may now seem, the club was not all that unusual and was by no means the first of its kind. Forty years earlier, the *Spectator* claimed to have received a letter giving notice of the existence of an "ill-favoured Fraternity" at Oxford that had "assumed the name of the Ugly Club."[41] An ensuing exchange of letters over several issues extended an offer— which was accepted—for the *Spectator* to join as a member, as well as an assertion from another correspondent that priority of invention ought to be given to a "Club Of Ugly Faces [that] was instituted originally at Cambridge in the merry Reign of King Charles II."[42] Though these earlier clubs may or may not have existed, the idea of ugly clubs certainly existed by the beginning of the eighteenth century, among the innumerable social clubs, large and small, that had sprung into existence over the preceding decades. The phenomenon of the social club—a gathering of men with shared interest, profession, or conviction for the purpose of fellowship and discourse—arose following the Restoration with institutions such as the Civil Club.[43] During the eighteenth century, these clubs became vital venues for a new type of participation in public life that could be pursued by men (and some women) in a variety of professions and social stations. They were spaces of conversation and debate, spaces of collective attention.

Though the Ugly Face Club of Liverpool was only one of many hundreds of clubs, it would have been one of the few to focus its membership upon an aesthetic particular: ugliness. The evidence for the club's existence is a nineteenth-century reprint of its minute books for a ten-year period, but the only evidence of the purported ugliness of its members would lie in the lists of members' names and qualifications contained in those minutes. All of these textual descriptions, following the facetious intention of the club itself, attempted short but lurid accounts of each member's features, with the record for Wood the Younger, entered on July 22, 1751, giving special attention to his profession: "A stone colour'd Complexion. A Dimple in his Attick Story. The Pillasters of his face fluted, Tortoise ey'd, a prominent Nose, Wild Grin, and face altogether resembling a badger, and finer tho' smaller, than Sir Chris'hr Wren or Inego Jones's."[44] The equation between architecture and the appearance of the body was already deeply embedded in architectural discourse, and its repetition here would have been unremarkable but for the fact that its application was to testify to ugliness and that it was not proof of ugliness but rather the instrument by which ugliness could be measured. The lines are brief (though they would seem to have been given more thought than those describing other members) and can carry only the burden of suggestion. But they do indeed suggest the role that architecture might be conceived to perform: not to be ugly but to enable the definition of ugliness toward particular ends.

In the case of the Ugly Face Club, that end is a collectivity of social experience, which was the purpose of the club itself. It was one element within the larger constellation of institutions, habits, and enterprises that made up the emerging modern civic sphere. In important mercantile cities like Liverpool and Bristol, or in a provincial town such as Bath, the elements of civic life were being fitted together with architectural settings such as the two Exchanges, or the Square and Parades in Bath. The Ugly Face Club, and Wood the Younger's place and characterization within it, supply a way to conceptualize the role of ugliness that will be pursued in the successive episodes of this book. It endows the aesthetic with a purposeful rather than reflective position; in other words, the aesthetic describes not the encounter with an object of contemplation but the performance of a social role. In this sense, ugliness contains a deliberateness, an intention, or a cause outside of itself. Though the visages of the club's members are natural endowments, they are made ugly through the bylaws and minute records of the club, through institutional protocols that assign the authority and standards of judgment. This type of ugliness acts as a public attribute, in that it is judged and remarked in a collective setting, here a convivial social exchange but more generally as a mode of exchange between the participants, individual or institutional, of civic

life. Understood in this light, ugliness possesses an instrumentality, a capacity to enter into and to affect the routines of society.

The episodes in the chapters that follow have metropolitan London rather than provincial Bath as their setting, and manifestations of collective endeavor and a civic realm are correspondingly less narrowly defined. They are decisively present nonetheless, as are the instrumental mediations of the aesthetic revealed in the four sections of this account of Wood: the social, the historical, the economic, and the civic. The very strangeness of John Wood the Elder's efforts to forge a public architecture in Bath, and also the fascinating strangeness of Wood himself, thus bring into view a broader and more complex conception of the ugly than one delimited by questions of style and taste. Though both style and taste enter into the conception of ugliness, they are not the decisive mechanisms of judgment as ugliness becomes entangled with the speculations upon distant history, the management of building materials, or the reformation of social behaviors. In the work and writing of John Wood the Elder, one can find the example and evidence of the new significance of architectural ugliness in eighteenth-century Britain as, in architectural stones and in architectural personae, ugliness emerged as an instrument of political and social transformation.

Stones

Chapter 2
Nuisance

Observers have employed a range of measures and shifting registers to assess the ugliness of the city of London over the centuries of its recorded existence. The vast number of these judgments have no doubt been ephemeral, passing from various degrees of intense feeling into the unrecorded experience of the city. Many such judgments, though, have been marked upon some type of historical record, visual, textual, or material, that produced a link between aesthetic experience, judgment, and the physical composition of the city itself. One such record is the rolls of the Assize of Nuisance, the medieval legal body delegated to adjudicate a specific category of conflicts between neighbors: nuisance. As formulated in the thirteenth and fourteenth centuries, the category of nuisance referred to encroachments upon the proper use and enjoyment of one freehold property by a neighboring property. Not every instance of neighborly misconduct was in legal terms a nuisance; some might be annoying but permissible, others might be criminal and prosecutable. Nuisances were a civil matter, and, as heard and judged in the Assize of Buildings, they had a physical, architectural manifestation, consisting of encroachment over property lines, or dispersal of drainage outside of a lot, or misappropriation of party walls.[1]

In June 1333, the Assize heard a complaint whose conflation of architectural arrangement and visual repulsion makes it stand out among the litany of complaints within the rolls:

325. Andrew de Aubrey and Joan his wife complain that whereas they possess an easement in the use of a cess-pit common to their tenement and those of Thomas Heyron and Joan relict of John de Armenters, and the same was

enclosed by a party-wall (*pariete*) and roofed with joists and boards (*bordis*), so that the seats (*cedilia*) of the privies of the pls. and the others could not be seen, Joan de Armenters and William de Thorneye have removed the party-wall (*clausturam*) and roof so that the extremities of those sitting upon the seats can be seen, a thing which is abominable and altogether intolerable. Judgment, after the site has been viewed, that the defs. roof and enclose the cess-pit as it was before, under the penalty prescribed by the law and custom of the City in such cases.[2]

The records of the Assize contain no further detail or comment, so much is left to the imagination. But the relationship between two aspects of urban circumstance is clearly established. The privy was enclosed by a wall of brick or stone and a wooden roof, creating a private interior shielded from general or public view. The wall was held in common between two neighbors, a shared party wall to which each had a legal right and over which each had a say in terms of its use, appearance, and upkeep. The cesspit below the privy was also held jointly, a typical arrangement in medieval London. But for an uncertain motive, one of the neighboring parties (the defendants, Joan de Armenters and William de Thorneye) removed the party wall and the roof, exposing to view anyone using the privy and thus creating an "abominable and altogether intolerable" circumstance or, in short, ugliness.

The Assize granted judgment in favor of the plaintiff, requiring that the wall and roof be restored. In this case, as in other less dramatic cases heard at each assize, assessments were made concerning specifically physical attributes and architectural relationships of properties. Party walls were a recurrent concern. The Assize of Buildings stipulated rules for their shared construction and possession—the requisite criteria were that each property owner gave one and a half feet of land in order to construct a three-foot-wide stone wall sixteen feet in height. Apertures and window openings were also a point of contention and therefore of legal regulation, with the Assize ruling that an owner could not create an opening overlooking or looking into a neighbor's house unless that opening was more than sixteen feet above the ground. The very same plaintiff and defendant from the case of the exposed privy appeared before the Assize with their roles reversed, to address a dispute about an aperture:

326. As regards the aperture which the same Andrew and Joan his wife made in their room over the cellar of John de Armenters, now held by William de Thorneye, through which his private business (*secreta*) can be seen by those in the room above, and concerning which Joan de Armenters and the above-named William have made complaint, it is adjudged by the mayor and aldermen that it be blocked up.[3]

Such nuisances appear with great frequency in the rolls of the Assize, which was compelled to visit the sites in question, oftentimes with masons and carpenters in tow to help with measurements and expert assessments of causes and effects.

Architecture thus became the central medium for the judgment of nuisance in London. Though the judgments were responsive, reacting to situations already set in place, the Assize also assembled prospective codifications of architecture intended, in part, to delimit the possibilities of nuisance at a future moment.[4] Such codifications also aimed to improve the city more generally, curtailing its risks and prompting it toward more congenial states of coexistence. Overhangs and similar encroachments of beams or rafters upon public ways were proscribed, for example. Fire was a paramount risk, of course, to which the Assize responded with a directive that stone or brick be used for all party walls in the city. While enforced inconsistently, this directive nevertheless placed an emphasis on a particular materiality—that of masonry—which was to become responsible for an increasing scope of judgments within the city, first the judgment of nuisance in its medieval form, and subsequently in modern forms of nuisance. Stone and brick became in this process an instrument for negotiation and a register of the reciprocities of the city. (Figure 9)

Even for a city with buildings made of brick and stone, fire remained a threat, exacerbated by the number of wooden buildings, or brick buildings with thatch roofs, that persisted alongside and despite the regulatory structure of the city. In September 1666, the risk was realized as the Great Fire of London burned over the course of two days, reducing thousands of buildings to ash and rubble across the full extent of the City and even in areas beyond its walls. The rebuilding that followed consisted of separate endeavors: an administrative regime of surveys and ordinances; economic investments in rebuilding and in speculative development; and campaigns for the improvement of the appearance and arrangement of the city. The first of these endeavors was realized through a new parliamentary Act for the Rebuilding of the City of London, which established more precise provisions for new buildings in the city. One of the most important pertained to materials: "And in reguard the building with Bricke is not onely more comely and durable but alsoe more safe against future perills of Fire Be it further enacted by and with the Authoritie aforesaid That all the outsides of all Buildings in and about the said Citty be henceforth made of Bricke or Stone or of Bricke and Stone together."[5] Construction of doors, windows, and roofs as well as the positioning of framing within the structure and near chimneys were all accounted for in the articles of the act.

Standards or grades of house were specified also, each relating to an accompanying character of street such as "streets of note" or "high or

Figure 9. A view across the rooftops of Southwark toward the City of London shows the density of individual properties and party walls in the seventeenth century. Detail of Wenceslaus Hollar, *London, the Long View* (1647).

principal streets." These stipulations reflected the aim, also expressed in the act, to achieve a higher degree of order and regularity within the city.[6] Surveying practices would play a part, but the outcome depended upon an architectural consequence, upon the projection of more consistency and propriety among individual building facades and along streets. This architectural consequence was pursued more emphatically in the several proposals for rebuilding the city put forward by leading figures such as Sir Christopher Wren, John Evelyn, and others in the aftermath of the fire. These unrealized designs addressed the plan of the city as a whole, rather than its individual buildings, and sought to take advantage of the destruction to rebuild London with an orderly character and greater magnificence in its public architecture. A century later, they remained in view as an alternative to the uncoordinated and economically motivated growth of speculative developments across the northern edges of the city. The architect John Gwynn referred to the seventeenth-century proposals

Figure 10. A pickpocket, a tripe seller, a gin shop, a dyer, and various objects and liquids falling to the street from windows above are among the nuisances shown unfolding beneath the dome of St. Paul's Cathedral. George Cruikshank, *Grievances of London* (1812). Published as the frontispiece in *Metropolitan Grievances; or, A Serio-comic Glance at Minor Mischiefs in London and Its Vicinity* (1812).

in the text for his own *London and Westminster Improved*, published in 1766. Gwynn opened his treatise with a discourse on "Publick Magnificence," and then continued by way of a denunciation of the disorderly results of a century of private building and development. If London before the Great Fire had been "totally inelegant, inconvenient, and unhealthy," one hundred years later it remained so.[7] He identified the primacy of private property—the same factor that had brought the Assize of Nuisance into being—as the cause. The "mean, interested, and selfish views of private property" had produced an urban fabric marred by deformity and "absurdity upon absurdity."[8]

Many of his contemporaries shared Gwynn's view of London, noticing and emphasizing different ugly details in their disdain. For the architect, it was the irregularity of the buildings, for another it might be the unruly crowds overflowing every street, for another the stench and darkness of fog. Each offense might be susceptible to a particular remedy, and some of these remedies took architectural form. (Figure 10) But it was not architecture as a cure for the ugliness of the city that had the most resonant effect, for that obtained only as a matter of taste; it was in the role architecture had played in the Assize of Nuisance that a different significance of judgments of ugliness was established. The confluence of nuisance law, the masonry wall, and the visual experience of the city—the view of the abominable and altogether intolerable—forged a different understanding of the city itself.

Durability and the Houses of Parliament

It was another fire, in October 1834, that opened the way toward this different conception of the city and its monumental palaces, a fire that destroyed only one building, but that one most important: the Houses of Parliament. In March 1836, the four commissioners appointed to choose a winning design in the competition to rebuild the Houses of Parliament

were summoned to explain their decision to the Select Committee overseeing the works. Appointed the previous year—only months after the fire and after public debate on how a suitable, economical accommodation for the Parliament might best be assured—the Select Committee was responsible for confirming that the design of the new building would fulfill its detailed programmatic requirements and be appropriately elegant in appearance. The members of Parliament

Figure 11. The Houses of Parliament in the late stages of construction. Roger Fenton, *Houses of Parliament from Lambeth Palace* (1857).

and lords on the committee began the hearing by asking if the winning scheme—plan No. 64, a design in gothic style that had been submitted by the architect Charles Barry—had been preferred because of its merit according to these standards. Were the internal arrangements superior to other plans, and was the external architecture more beautiful? This was indeed the case in the opinion of the commissioners. Though they found it difficult to convey exactly how the aspects of the chosen design would offer a superior embodiment of the stature and aspirations of the nation, they were firm in their conviction that it would do so, while still answering to every practical demand in its use.[9] (Figure 11)

After discussion had proceeded along these lines, Joseph Hume, MP, interjected with a different question: "You spoke of the style and beauty of the gothic; have the Commissioners considered the effect of air and weather on all exterior ornaments of that kind?"[10] "No, certainly not," was the reply from Charles Hanbury Tracy, chair of the commissioners and an MP himself; "that must depend greatly on the material; the selection of the stone, the quality of the stone."[11] Hume pursued the point, noting that other comparably ornamented buildings in London had proved susceptible to decay, and asking whether or not the gothic style should be preferred to another style in regard to its likely permanence. Tracy answered again that such permanence would depend upon the stone used for the building. Hume posed his next question quite directly: "Did not durability form an element in the choice of the plan for building both Houses of Parliament?"[12] Tracy responded defensively, pointing out to Hume that the gothic style had been specified as a requirement for competition entries by decision of the Select Committee (of which both

he and Hume were members) and that a concern for the durability of any given style ought to have been placed then; no blame should lie with the four commissioners for the absence of inquiry into durability in their considerations.[13] Hume rephrased his question in a more conciliatory fashion, asking instead whether durability ought now to be considered by the Select Committee in its own deliberations, a suggestion with which Tracy readily agreed.

No expertise on the matter of stone was immediately available during the hearing—the commissioners having been chosen precisely because they had a deep knowledge of architecture without the presumed biases of professional standing, and the MPs and lords equally possessed of only superficial knowledge. The consideration that Hume encouraged was thus pursued in terms of the visible properties of the respective styles that had been solicited in the competition, Gothic or Elizabethan. Perhaps the decision to require entries to adopt one of these styles was misguided, given the self-evident fact that the "plainer the building, the less ornamented it is, the less liable it is to be injured by the weather"; and yet the prevalence of the Gothic as the "creation of the severer climates of Europe" suggested that it was "not ill-calculated to endure the weather." The decisive consideration was the stone, and with "proper care and attention paid in the selection" it would be possible to build a durable edifice in the style preferred, rather than have the style dictated in advance by a visual deduction of its possible durability.[14]

The committee moved on to other questions, about internal arrangements, prospective views, and probable costs, before Sir Robert Peel (prime minister at the time) returned to the question of the stone, stating that if the Select Committee chose the design the commissioners had preferred then it was crucial that a stone be selected that was "best suited for that particular style of architecture."[15] And when Charles Barry himself appeared before the same Select Committee the following month to provide details and estimates for his design, Joseph Hume was not the only MP to raise the issue of durability with the architect. "Do you think that the surface of the buildings will be subject to constant decay?" asked Sir Robert Peel. He did not, Barry replied, though much would depend upon the quality of stone.[16] More than the commissioners who had preceded him before the Select Committee, the architect could claim some measure of expertise in the matter of stone and its durability, and could explain that uncertainty about the matter of durability was the consequence of a range of factors. He pointed out that durability would need to be considered alongside other qualities: "What may be a durable stone, may be a stone which will harbour the filth and smoke of the London atmosphere; I should say that siliceous stone was not so likely to imbibe the filth of the London atmosphere as the lime-stone and some of the oolites."[17]

What Barry described as the "filth of the London atmosphere" was the pervasive cloud of smoke and soot that enveloped the metropolis, the recurring thick fog known as the "London particular" that carried the granular deposits of thousands of city chimneys.[18] The buildings of the city confronted not only the weather, not only the predictable annual climatic cycles of warmth and cold, and the equally predictable coursing of effacing rains across their surfaces, but also the specific circumstance of London's atmosphere. Nearly two centuries earlier, in his *Fumifugium* of 1661, John Evelyn had deplored that "this Glorious and Antient City ... Should wrap her stately head in Clowds of Smoake and Sulphur, so full of Stink and Darknesse."[19] The "Hellish and dismall Cloud" offended the physical health of the city's inhabitants; against the aesthetic dignity of the city's buildings it was an "Enemy to their Lustre and Beauty."[20] The cause of this airborne pollution was the combustion of sea coal, in domestic fires to some extent, but more so in the forges and furnaces of smithies, breweries, dyers, and lime burners, in the city and its rapidly growing urban environs. Even as the use of other fuels with more efficient combustion was encouraged, the atmosphere of the city continued to absorb the consequence of an ever-increasing population and an ever-rising number of manufactures. The size of these factories expanded as well, and by 1800 the polluted air of the metropolis was severely worse than the conditions that Evelyn had deplored.[21]

Knowledge did not keep pace with consequence in the comprehension of this atmosphere. Technological innovation brought improvements to the combustive efficiencies of the city's industries, but scientific insights into the physiological and material effects of the smoke they produced remained vague. While experience and anecdote gave clear suggestion of its deleterious effects, the causal connection between smoke-laden air and illness had not yet been definitively proven. Indeed, the theory of miasma still largely prevailed, maintaining a broad consensus that the bad air responsible for disease occurred naturally, produced by decomposition. In urban settings, concentrations of miasma would be expected to occur in proximity to effluence of sewage or graveyards or other sites of decaying matter. Smoke, in the view of miasma theory, offered relief and even protection from the contaminations of noxious vapors and therefore ought, at least to some degree, to be favored rather than mitigated. Limited (and largely ineffective) measures to mitigate the emission of smoke in London and its environs had been introduced even before Evelyn's day, but such legislation only slowly gathered efficacy during the course of the nineteenth century as an increasing understanding of the physiological effects of polluted air began to motivate a more dedicated

Figure 12. London County Council survey photograph ca. 1900 documenting the decay of stonework at Westminster Abbey.

political demand for regulation of smoke.[22] (Figure 12)

Scientific understanding of the material consequences of smoke also lagged. In 1713, just fifty years after Evelyn's lament, Sir Christopher Wren observed that on some surfaces of Westminster Abbey, "the Stone is decayed four inches deep, and falls of [*sic*] perpetually in great scales," a decay he attributed to an "unhappy Choice of Materials" poorly matched to the demands imposed upon them by prevailing climate and atmosphere.[23] With the rapid growth of industrial activity, in factories and also in steam-driven transportation, the city's buildings were coated outside and in with layers of soot that rose from chimneys exhausting thousands of coal fires and furnaces, from thousands of buildings and engines. Evident to any inhabitant or visitor, these accumulating layers of soot blackened the polychromatic surfaces of stonework, and smothered the articulations of ornamental carvings.[24] In addition to causing this obvious aesthetic degradation, the London atmosphere was also suspected of hastening the physical degradation of buildings. Unlike the erosion of surfaces due to the natural course of time, and also unlike the contrived ruins in picturesque gardens, this premature degradation was judged aesthetically unseemly. Reviving the London prejudice toward Bath stone that John Wood had tried to overcome, the architect Alfred Bartholomew, for example, disparaged in visceral aesthetic terms the appearance of St. Bartholomew's Hospital, built less than a century earlier: "the Hospital, is coarse, gloomy and disgusting in appearance ... and its whole surface is frowning, swarthed, blained, excoriated, peeling, and decomposed."[25]

Like Wren a century earlier, Bartholomew and other architects and builders at the outset of the nineteenth century depended upon unsystematic empirical observations to conclude that the quality of a given stone determined its longevity in the city; some types of stone had remained undamaged over long periods enveloped in the city's smoke, while others

decayed rapidly. When Charles Barry debated with the Select Committee the matter of the durability of the new Houses of Parliament, the opinions that he offered, while expert, were founded upon understandings such as these, necessarily imprecise understandings of the relation between the city and its buildings. Similarly imprecise were various assignments of responsibility that surrounded the project—those of cause and effect in the case of nonhuman elements such as soot, but also the responsibilities construed between persons such as experts and laymen or indeed between one body of experts and another. The still vague nature of such relational structures, and their corresponding categories such as agency or authority, was in large part the focus of attempts within adjacent but not yet coordinated scientific and legal and aesthetic efforts to bring clarity to material and immaterial relationships. The occluding atmosphere of the London particular was the very substance that would bring the correspondence of these efforts into view, as the aesthetic dimensions of the new Houses of Parliament, its style, appearance, and ornamentation, were to be safeguarded from the ugliness of decay by the application of scientific and legal protocols.

Fit and Proper Materials

During the Select Committee deliberations over the design for the new Houses of Parliament, as it became clear from the witnesses' presentations that so much would depend upon the proper selection of stone for the building, the attention of some committee members turned to the question of how exactly that selection might be made. Who would choose the stone and upon what criteria? Certainly the architect must be largely responsible for the decision, but even with the palpable authority conveyed by Charles Barry, the evidence of the hearing suggested that there was no clear body of expertise upon which to base a decision, only an accumulation of empirical assessments. Sir Robert Peel proposed to his colleagues that a more systematic study might be undertaken "by some public department of the Government" in order to ascertain "the comparative advantage of taking particular kinds of stone, and as to the effect of a London atmosphere upon those classes of stone."[26] This study would employ as its principal vein of evidence the facts of the physical presence of historical architecture itself, the durability or lack of durability of existing buildings such as those referenced by witnesses in the hearing, but analyzed in a systematic and most importantly a comparative method: "Supposing professional men were instructed to make a minute inquiry into the state of the most exposed parts of St. Paul's Cathedral; into the state of the towers of Westminster Abbey; into the state of Henry the Seventh's chapel; were to ascertain the quarries from which stones

used in those buildings respectively were taken, and to make a Report to the Treasury upon the effect which the smoke and air of London had upon those several structures, do you not think that some very valuable conclusions might be drawn with respect to the probable advantage of selecting any particular stone for this intended structure, and for future buildings connected with public objects?"[27]

Peel's colleagues agreed and the Select Committee appointed four men to undertake such a study and then to advise on the selection of stone for the Houses of Parliament. The architect Charles Barry was one of the four, joined by a well-known architectural sculptor, Charles Harriot Smith, and two prominent geologists, William Smith and Sir Henry de la Beche.[28] The composition of this advisory group might be seen to reflect a parallelism of professional and scientific knowledge. Often enough conflated, these two modes were embedded with the contrast between practical and theoretical knowledge, or the empirical understanding derived from purposeful craft and that derived from disinterested observation. For Barry and for Harriot Smith, stone was the raw material of building and of architectural ornamentation; for William Smith and Henry de la Beche, stone was evidence of vast scales of time and the physical processes of nature. Both perspectives rested upon a nuanced and expansive knowledge of stone, but then revealed the further state of uncertainty that existed between the priorities of knowledge and action. The prerogatives of architect and sculptor differed, for example, and the two geologists were certainly participants in an unsettled and contentious field.[29] The aesthetic perspective was maintained, though now conflated not only with that of science, but with its uncertainties compounded by those of the adjacent discipline.

The group embarked in August 1838 on a three-month tour with a lengthy itinerary that would have them inspect several dozen quarries around Britain and examine nearly a hundred historic buildings in rural areas and in large towns. From August until October, the four men visited the selected quarries to assess the aesthetic, physical, and economic suitability of different types of stone that might be used, and scrutinized the series of historic buildings in order to verify the likely durability of different types of stones. At each building the men recorded observations of any visible decay or corrosion of surfaces, noting their age, orientation, and exposure. They collected sample specimens of stone from each quarry, recording characteristics such as color, composition, bedding, and available dimensions. (Realizing that their survey would not be comprehensive, they also accepted samples from quarries that they were not able to visit.) Upon the conclusion of their tour, the group consulted with John Frederic Daniell, professor of chemistry at King's College, London, who (along with professor of experimental philosophy

Charles Wheatstone) assisted them to ascertain the composition of the various samples they obtained.

At the conclusion of this lengthy investigative process in March 1839, the group reported to the Select Committee their recommendation that magnesian limestone from a quarry in Derbyshire be used for the building. They prefaced this conclusion with a summary of considerations. For example, economic constraints in the rebuilding of the Houses of Parliament had excluded consideration of "granites, porphyries, and other stone of similar character, on account of the enormous expense of converting it to building purposes in decorative edifices."[30] Similarly, the appearance of the stone had been evaluated taking into account the urban setting of the new building: "Colour is of more importance in the selection of a stone for a building to be situated in a populous and smoky town than for one to be placed in an open country."[31] Durability, though, was the pivotal concern in their assessments, a criterion for which the group sought, by means of observation and experiment, "incontestable and striking evidence."[32] As for the causes of the decomposition of stonework, these they could propose only in general terms as being "chemical and mechanical" (where "mechanical" referred to the expansions and contractions caused by variation of temperature). Exposure to weather determined the mechanical cause, the chemical cause would produce "a change in entire matter" of the stones, and the atmosphere of the smoky town would be expected to produce greater decomposition in stonework than the atmosphere of the open country. Though this differential process of transmutation was unaccounted, they were able to describe its circular nature: "These effects are reciprocal, chemical action rendering the stone liable to be more easily affected by mechanical action, which latter, by constantly presenting new surfaces, accelerates the disintegrating effects of the former."[33]

If the explanation of causes remained indistinct, their report did offer much more detailed assertions about the compositional characteristics that would give resistance against these causes. Relying upon the correlation of their field observations with Daniell's conclusions about the microscopic properties of stone, they concluded that, with respect to limestones, "their decomposition depends ... upon the mode in which their component parts are aggregated, those which are the most crystalline being found to be the most durable, while those which partake least of that character suffer most from exposure to atmospheric influences."[34] A more rather than less crystalline composition being desirable, they then followed Daniell's assertion that among the various samples of limestone, those that possessed a roughly equivalent proportion of carbonate of lime and carbonate of magnesia were the more crystalline. Chemical composition may or may not have been the decisive factor, but significantly it

was now elevated as a criterion to the same level of importance as the much more familiar considerations of cost and appearance, assuming, in a sense, the prerogative of the aesthetic outcome. In concluding its report, the group of four advisors admitted that several different types of stone seemed to meet these considerations to satisfactory degrees; but based upon their scrutiny of evidence of durability (which came first in their listing of criteria), cost, and appearance (which was listed last), they proposed that magnesian limestone from the Derbyshire quarry of Bolsover Moor or from its immediate environs was the "most fit and proper material to be employed in the proposed new Houses of Parliament."[35] With this decision approved, the construction of the Houses of Parliament could commence with the questions about durability and the atmosphere of London seemingly addressed.

Atmospheres of Decay

On May 4, 1852, the assembled members of the Manchester Literary and Philosophical Society listened to a talk by Dr. Angus Smith, a chemist in that city. Smith read a paper "On the Air and Rain of Manchester," which aimed to demonstrate that the air, and specifically polluted air, could be subjected to chemical analysis. That polluted air (impure air in the then common terminology) existed was not in question; it had been both experienced and described for centuries. But, Smith argued, little objective evidence existed of the physical difference "betwixt good air of the finest mountain side, and the worst air … of the infected dens of large towns, so well described in various forms, of late years, to the public."[36] Yet this difference was palpable to the senses, he continued, "as if the eye had obtained a mysterious power of seeing what was scarcely capable of being proved within the domain of substance, and the smell had a power of observing what was more an influence than a positive thing."[37] Smith suggested that the air, and especially the air of towns, produced two sensible effects, one perceptible by the "ordinary senses"—sight and smell in particular, but also touch—and the other felt by what he called the "chemical senses," the physiological reaction to exposure that would become known by illness or similar degradation of optimum health. This categorization and its indication of measurable effects suggested in turn that the air, or atmosphere, of towns like Manchester and London could be brought under scrutiny and made known as a substance.

Oxygen and nitrogen had already been identified as constituent elements of air, but analyses of the full range of other possible contents remained limited and uncertain. By turning his experimental techniques to the city in which he lived, Angus Smith could begin from the commonsensical knowledge that the air was laden with substance, specifically the

particulate matter of coal smoke that was as obvious in this industrial city as it was in London. To investigate—to make visible and evidentiary—the seemingly intangible matter of air, he examined not the air itself, but the rain that fell upon the city, and this rain, he discovered, contained easily measurable quantities of sulfuric acid. These quantities decreased in samples taken further from the town, in the more pure country air, leading Smith to conclude that the smoke of the city's furnaces and forges was creating an atmospheric condition that he referred to as acid rain. In the next few years, his accumulated experimental data were sufficient for him to present a more detailed account to the Chemical Society, which was published with the title "On the Air of Towns."[38] Here, Smith confirmed finding substantive difference between the atmosphere of open country and that of the city. His experimental results could be (and subsequently were) supplemented by studies of other areas of Great Britain, enabling the possibility, in theory, of an atmospheric map making visible its invisible enclosure of air. Smith's data, in tabular form, were in any case sufficient as the basis for a new knowledge that affected stones: "It has often been observed that the stones and bricks of buildings … crumble more readily in large towns where much coal is burnt than elsewhere. Although this is not sufficient to prove an evil of the highest magnitude, it is still worthy of observation, first as a fact, and next as affecting the value of property. I was led to attribute this effect to the slow but constant action of acid rain."[39] The sulfuric acid precipitated out of the atmosphere as rain coated the buildings of a city, and left as residue the acid that would be insinuated into vulnerable stonework, decomposing its elemental structure and causing the decay of its exterior surfaces.

Angus Smith's novel observations of acid rain and his conclusions about its consequences had an immediate relevance in London. Within a decade of the start of construction and with the building works not yet fully complete, indications of decay began to appear in some of the stonework of the new Houses of Parliament. By the end of the 1850s, evidence of serious deterioration was widespread enough to compel some remedial course of action, and in 1861 a new committee was formed to "inquire into the decay of stone of the New Palace of Westminster and into the best means of preserving the Stone from further injury."[40] The membership of this panel included noted architects of the day—William Tite, the president of the Royal Institute of British Architects, Sidney Smirke, George Gilbert Scott, Matthew Digby Wyatt. They were joined by several chemists, including August Wilhelm von Hofmann, the director of the Royal College of Chemistry, and geologists, none more prominent than Roderick Murchison, then between terms as president of the Royal Geographical Society. The two geologists who had been responsible for the original survey and selection of stone, William Smith and Henry de

la Beche, had both died, as had, only the year before, the architect Charles Barry; Charles Harriot Smith, the only one of the four commissioners still alive, was appointed to the new committee and asked to give detailed accounts of the process that he and his colleagues had undertaken.[41]

The committee also called upon some three dozen witnesses, from builders to scientists, and heard testimony that identified two causes for the premature decay of the stones. The first, a mechanical cause, originated in the transposition of stones from the quarry, where stones would have lain in a natural bed, to the building, where individual stones were then set in positions perpendicular to their natural bed. This translation, the committee was informed, could make certain pieces of stone more liable to fracture or decay as they carried loading within the overall structure. Though this knowledge was commonly held by masons and architects, careful supervision at both quarry and building site was required to forestall any improper translation of stone, or the use of compromised stone, and this level of supervision had not been provided during the initial stages of construction at the Houses of Parliament. The failure lay in procedure of work rather than any incapacity of the conventions of architectural thought and aesthetic imagination.

The same could not be said for the second cause of decay, a chemical cause, which originated in the exposure of the stones to the atmosphere of the city. The balanced proportions of lime and magnesia and the "crystalline character" of magnesian limestone had been determining factors in its original selection, being qualities expected to provide resistance to weathering by limiting the absorptive capacities of the surfaces. But the subsequent investigation, being held twenty-three years after the stone had been chosen, had access to recent experiments in what had been coined "chemical climatology," experiments that revealed the crucial factor of acidic atmospheric effects. The chemists on the committee referred to Angus Smith and his experiments in Manchester as well as other recent analyses undertaken to examine how the chemical composition of different types of stones was affected by atmospheric conditions.[42] This gathering scientific knowledge made clear the significance of acids, carbonic and sulfuric, newly recognized as possessing a strong corrosive capacity to which the stone being used in the Houses of Parliament was in fact highly susceptible, precisely because of the carbonates of lime and magnesia of which its crystalline structure was composed—the very same criteria so favorably regarded twenty years earlier.

The stone used in the Houses of Parliament, so the chemists concluded, was "amenable to all the sources of disintegration which we have above enumerated," including a mechanical process of fracture caused by water entering into the stone and freezing, but also and especially to the effects of acids present "in the air of towns."[43] With this understanding of the

problem, the committee also considered testimony regarding possible remedial treatments for the stonework already damaged as well as stones not yet affected. These remedial treatments consisted of various coatings applied over or absorbed into the stonework to provide either temporary or permanent preservative effects. A small number of these treatments had been tested on damaged portions of the Houses of Parliament prior to the convening of the committee in 1861. The inventors of these treatments were therefore invited to present the results; other treatments put forward were new inventions, not yet tested in the field. Some of the proposed solutions the advising chemists derided as "obviously erroneous, such as ... ridding the building of the principle of decay by fermentation."[44] Others of the proposed solutions might, they believed, be effective, but the examiners could not evaluate them conclusively because experimental evidence did not yet exist to support or undermine their claimed efficacy. The chemists suggested therefore that "it might be advisable to apply to portions of the New Houses of Parliament actually undergoing decay, certain processes selected as representatives ... in order that their merits might be submitted to the only conclusive tests, those of actual application, and protracted exposure to the corrosive influence of a London atmosphere."[45] The full committee agreed, though with a reluctance presumably caused by frustration with the lack of any immediate solution, and recommended this attenuated course of action to the government with a "confident expectation that a remedy will soon be found to arrest or control the decay."[46]

The frustration of the committee overseeing the construction of the Houses of Parliament resulted from the novel experience of a temporally extended process of constructing and sustaining architecture within the changeable circumstances of its surrounding atmosphere. The new Houses of Parliament would be turned into a site of material experimentation aimed at devising new mediations between building and atmosphere. This maintenance (for that would be the term for this new regimen) would consist not only of practices of cleaning, repair, and replacement to accompany the ordinary use of the building, but a theoretical understanding as well of the materiality of stones as the medium for interaction between architecture as a purposeful aesthetic intent and the city as an apparatus and an atmosphere. Decay in itself was not a novel aesthetic category, but the familiar recognition of the decay of stone as the inevitable process of exposure to time and the still fashionable recognition of ruins as aesthetic devices were now supplemented by an awareness of the decay of stones as a contingent process of exposure to the atmosphere of modernization itself. Just as the cultivation of ruins in picturesque gardens was at root an aesthetic of ugliness, of positive valuation, so too was the novel concept of maintenance an

aesthetic of ugliness, though of negative valuation insofar as it aimed to remediate the possibility of ugliness. But where ruins and the natural decay of stones had always been encountered most directly in the register of visuality, maintenance was accessible or knowable through a range of mediating registers, visuality only one possible form of discernment and likely to evidence only effects and not causalities. In his experiments, Angus Smith examined rain in order to attain an understanding of that which produced the visibly impure quality of air; Frederick Ransome, describing to the committee his own experiments on the application of preservative solutions to specimens of stones, explained how he added color to "make perceptible" the relative depth to which the solutions were absorbed by the stone.[47] In the emerging concept of maintenance, visuality and the aesthetic register more generally provided not conclusions but prompts toward the larger structures of causation that surrounded the decaying stones of the Houses of Parliament.

Legislation and Remediation

Through the latter half of the nineteenth century, the metropolis remained a soot-filled place, the caked and blackened surfaces of its buildings prompting a regular stream of articles in professional journals on relevant topics ranging from new combustion technologies to new formulas for artificial stones. The atmosphere—and the need to compensate for its effects—spurred the use of both, with advances made in interior ventilation paralleled by the innovative use of architectural materials such as terra-cotta that offered practical regimens of maintenance.[48] Novel compensatory aesthetic regimens were recommended as well, to shape an architecture immersed in the "gloomy pall by which the smoke demon obscured [the sun]." This phrase was spoken by Alfred Waterhouse, prominent both as an architect and a member of the Smoke Abatement Society, who advised an audience of students that a "varied sky-line with gables, dormer windows, high-pitched roofs, massive chimney-stacks, and other exceptional features" would be better than "mere surface decoration" in the metropolitan atmosphere.[49] For surfacing material, Waterhouse recommended terra-cotta as being "admirably fitted, from its peculiar smoke-resisting qualities, for use in the architecture of our great cities in the present day, when we found all our best building-stone more or less yielding to the acids which were generated with the smoke."[50] Here though was a remarkable circularity: clay and coal, both drawn from pits in the earth, with the one (clay fired as terra-cotta) used to prevent the deleterious effects of the other (coal burned in the furnaces of the city). This relationship was noted by Waterhouse, among others, though he did not note the further circularity that the potteries

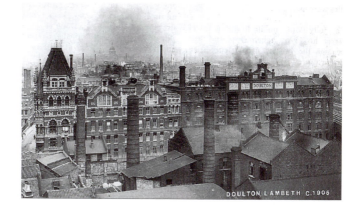

that produced the clay to guard against the damages of coal smoke were themselves producers of that smoke in the London air. Across the river from the Houses of Parliament, in Lambeth, could be found the kilns and chimneys of one of the largest such producers, Doulton Potteries. What had been a small factory in 1815 when the Doulton company was founded had grown in size as the company met the soaring demand for glazed pipes for metropolitan sewers, tiles for building work, and china for domestic interiors. (Figure 13)

In 1893, the Lambeth Vestry entered legal proceedings against Doulton, arguing that smoke from the potteries was damaging Lambeth Palace, causing the visible decay of its exterior stonework. The suit fell under the common law category of nuisance, which had developed in complexity from its medieval origins in the London Assize of Buildings, but remained in essence an activity or structure of one property that adversely affected another property by preventing the use or enjoyment to which the owner of the latter property was entitled. By the close of the eighteenth century, categories of harm potentially arising from nuisance included atmospheric dimensions such as light and air, which could, for example, be rendered a nuisance by offensive odors. In the case of the Dolton pottery, the nuisance would be that the production of excessive, harmful smoke on the one property was causing the physical deterioration of stonework on the other. But the magistrate ruled in Doulton's favor, determining that the company had made efforts to abate the smoke from its chimneys, which was sufficient to answer its legal liability. A few years later, with decay and local pollution still very much evident, the vestry considered renewed legal action, but was dissuaded by the argument that the pottery had continued to expend money on improvements

and therefore would once again be found not liable under nuisance law. This judgment, which was less a finding that no nuisance existed than that the defendant was not liable, rested upon the distinctive evolution of nuisance law in regard to atmospheric pollution during the course of the nineteenth century.[51]

During the first half of the century a steadily increasing number of scientists, government officials, and interested observers came to regard smoke as a hazard to public health, in its direct effects upon persons by hindering respiration and occluding sunlight, and in its indirect effects, as for example upon agricultural production, as a root cause of atmospheric deterioration. Many consequently sought to have smoke emissions brought under more forceful legislative scrutiny, advocating legal regulation of the emission of smoke as a solution to mitigate the atmospheric effects of industrial development.[52] There were few precedents for such a comprehensive regulatory structure, only highly localized policies or rules to control the burning of certain fuels or to mitigate quantities of smoke. But in 1821, following upon the findings of select committees convened to gather facts on the subject of smoke prevention, Parliament passed the Smoke Prohibition Act.[53] With the entire nation as its scope of application, the 1821 act asserted the government's interest in promoting smoke abatement practices in rapidly developing industries. But the new law did not mandate smoke reduction; rather, it was designed to give greater strength to the existing framework of nuisance law by enabling judges to award costs to be paid to plaintiffs in successful nuisance suits. What might have seemed a minor change in fact aimed at the primary difficulty faced by injured landowners, which was the prohibitive cost of litigation. The new law also stipulated that judges might impose abatement requirements upon defendants found liable, suggesting that the goal of smoke reduction might be met incrementally, through a gradual encouragement of corrective measures adopted by smoke producers.[54]

Data and scientific understanding were only gradually being compiled that might lend greater precision or efficacy to a parliamentary act. The passage of the 1821 act preceded by two decades, for example, Angus Smith's experiments on the acidity of rain. Advocacy continued and additional parliamentary committees gathered evidence from local officials, industrialists, and scientists on the practicality and effectiveness of smoke abatement techniques. In 1846, Henry de la Beche and Lyon Playfair, under commission from Parliament, submitted a *Report upon the Means of Obviating the Evils Arising from the Smoke Occasioned by Factories and Other Works Situated in Large Towns.*[55] Their report summarized the current understanding of techniques of smoke abatement and served as the partial basis for further efforts at legislation, including the 1853 Metropolitan Smoke Abatement Act, the first legislation to require the

suppression of smoke within London.[56] Yet here, as in the initial stages of the selection of stone for the Houses of Parliament, knowledge and action did not coincide precisely. Angus Smith introduced his 1859 paper "On the Air of Towns" with a critical reflection on the legislative process: "it seems to me a most unfortunate oversight that whilst laws have been made with relation to the impurity of the atmosphere arising from many causes, neither those who made the laws nor those who administer them have ever taken pains to find out what it really was against which they combated."[57] Regulations concerning smoke continued to be inserted into public health legislation, culminating in the 1875 Public Health Act and the smoke prevention articles included among its broader provisions to improve the salubrity of Victorian Britain. With this developing framework of legislation, the instruments of law accompanied the potentials of the chemically composed surface as mediations between buildings and atmosphere. Architectural appearance was thus embedded with the juridical and scientific implications, so that an ugliness that had been confined to an aesthetic understanding might now be known also in its legal and scientific dimensions.

Under the statutory regime that emerged, smoke abatement was assigned as a responsibility in advance of any specific event; smoke was addressed preventively rather than retrospectively as in the case of nuisance law. When manufacturers such as Doulton made practical improvements to their furnaces, they fulfilled their responsibility under statutory law and mitigated their liability even though smoke would still flow from their chimneys. Local authorities could impose fines for days on which too much "black smoke" was emitted, but the possibility of eliminating coal smoke from the city was indefinitely forestalled by these new legal provisions for managing an equilibrium of the city and its architectural objects. This translation from the common law approach of nuisance to the statutory approach of abatement, and its revelation of the crucial analytical difficulty of causation, had a particular consequentiality for architecture. Under the former framework of nuisance law, the relation between architecture and its environment was conceived as specific and localized. A particular cause of damage to a building could be identified—spatially located—and remedied; this framework corresponded to an understanding of the city as a collection of discrete properties. But over the course of the nineteenth century, the circumstances of architectural decay due to polluted atmospheres made fully evident that the effects of damage were not directly linked to their causes in the manner envisioned by nuisance law. Buildings in the city suffered significant deterioration as a result of the contact of stonework and air. But by whom had these buildings been damaged? By the effects of smoke, certainly, but smoke originating from whose chimney? Cause and effect were distributed,

generalized, their correlation often indeterminate; this framework would correspond to an understanding of the city as a structuring of mutable processes binding its architectural objects. Viewed through judgments of ugliness, these objects came into view less as discrete, singular events than as contiguous elements of a material and atmospheric system.

Evidence of Ugliness

Persuaded against pursuing legal remedy a second time, the Lambeth Vestry instead petitioned the London County Council (LCC) to investigate the problem of the destructive effects of smoke upon historical buildings such as Lambeth Palace. The LCC, whose formation in 1899 acknowledged the need to govern the metropolis as a complex arrangement of interrelated parts, responded by assigning its many district officers to a broad survey. Each officer was directed to examine the exteriors of historic buildings—churches, primarily, but also significant civic buildings—within his district and to observe the effects of weathering upon the stonework. These observations were recorded in charts provided by the LCC with entries noting the building, its date, the type of stone, and its current condition. The charts were in turn compiled into a full survey on "Weathering of Buildings," with inspections of nearly one hundred buildings confirming that stonework in significant states of deterioration was to be found all around the city, and not particularly more so in one area than another.[58] The ugliness of architecture—of architecture in these novel and unanticipated, and therefore seemingly improper, states of decay—made visible the scope of the atmospheric problem, though it did not offer a straightforward resolution under the terms of nuisance. The chief officer of the LCC's Public Control Department who had commissioned the survey confirmed in his annual report of 1901 that an examination of the decayed stonework at Lambeth Palace could not be distinguished in its characteristics from decayed stonework found elsewhere in the city and that an attribution of the specific damage to the neighboring Doulton pottery could not be drawn.[59]

Through and throughout the transactions of action and knowledge on the matter of atmosphere, a constellation of visual modes enveloped the architecture of nineteenth-century London.[60] While these evidentiary modes supplied (at least provisionally if not substantively) coherence to disparate or difficult to discern elements of the city and its atmosphere, they challenged the conventional registration of the coherence of architecture in terms of style or in terms of the discrete extent of the architectural object. (Figure 14) Individual architects had by the latter part of the nineteenth century realized the implications of the metropolitan atmosphere and its consequential alteration of a prior, static

conception of the relationship between stone and air, between aesthetic judgment and material understanding. By inquiring about resilience of the typical elements of a given style when situated in the London air, MP Joseph Hume had in 1836 joined the question of style to the issue of durability, and had linked the aesthetic and the material in a new equation that confronted architects during the decades that followed. The realities of the atmosphere prompted experiments in both aspects of the new equation. Alfred Waterhouse, for example, anticipated the inevitable accumulation of soot in choosing less refined and almost monochromatic schemes of ornamentation; Halsey Ricardo, by contrast, responded with refinement of ornamentation and the interjection of strong color.[61] Both took full advantage of the corrosion-resistant properties of terra-cotta and faience manufactured by smoke-producing potteries such as Doulton, and to accompany their buildings, and other architecture of the city, there emerged a constant, and expensive, regimen of cleaning, coating, whitewashing, repainting, repointing, and repairing: a routine of maintenance.[62]

Figure 14. A view of Temple Bar, Strand in thick fog.

Any one of these changes or techniques might be modest in itself, but taken as a larger composite these recalibrations of the coherence and extent of architecture suggest the dissolution of prior criteria of architectural comprehension and the precipitation of new ones out of the ugly buildings and the foggy atmosphere of the nineteenth century. As the novel forms of decay caused by chemical transformation prompted novel judgments of ugliness, the pursuits of remedy and remediation coalesced as a novel aesthetic of ugliness—but not in the sense that ugliness was the intention or the result, not in the sense merely of ugly buildings. The social mechanisms of legislation and maintenance and design constituted an aesthetic of ugliness insofar as they were mechanisms for the negotiation between aesthetic and political and economic registers, mechanisms for the negotiation of the ever more distributed nuisances of London.

Irritation

On January 15, 1959, a procession of a few dozen mourners appropriately clad in funereal clothing made its way along Lombard Street in London. Pallbearers, led by a woman holding a floral wreath, carried a coffin upon their shoulders. The coffin was empty, but not silent—it bore an inscription saying "RIP Here Lyeth British Architecture." The wreath, too, offered a remembrance, though not of a past architecture but of an architecture not yet built, with a text and a photograph identifying the deceased as the new headquarters building for Barclays Bank, whose cornerstone was to be laid that very day. (Figure 15) Having arrived at the site of the new building where the stone-laying ceremony was shortly to take place, the mourners laid the coffin upon the pavement and, with suitable sobriety, placed flowers upon its top. Eulogies followed, though these in perhaps somewhat less ritual form, because the funeral itself was a statement of protest. One mourner proclaimed that the proposed Barclays building was "abysmally ugly, little better than a stone slab in a mortuary"; another carried a sign that declared "The City Is Ugly Enough Already."[1]

A funeral is a manifestation of collective affect. The gathered mourners all have their individual emotions, their degrees of sorrow, regret, or relief; but together they represent grief, an inarticulable feeling that in being reflected between the mourners becomes the collective affect of a funeral. The ritualized elements of the funeral, such as black clothes, wreathes of flowers, the procession of the coffin, and words of remembrance, are the representational elements of this affect that give it a material presentation, that evidence its existence. Even a mock funeral such as the one that proceeded along Lombard Street achieves the semblance of collective affect by answering the expectation of representational elements.

Figure 15. Lombard Street in the City of London, with the Barclays Bank headquarters building on the right.

The affect of the mock funeral would have been a semblance insofar as the mourners did not actually experience the shared disorientation of grief or individual emotions of sorrow, but its potential for collective affect persisted nevertheless because *some* expression was being made and directed toward an object as a shared judgment.

The mourners gathered in January 1959 were members of Anti-Ugly Action, a group founded a few months earlier by students at the Royal College of Art to protest what they saw as a prevailing mediocrity in new architecture in London and Britain more generally.[2] The funeral procession was the group's third "operation" directed at a recently completed or newly planned commercial building. Each operation was conducted as an affective performance. The first operation, for example, included banners,

a bugler, and a drummer, and slogans chalked upon the sidewalk in front of a series of offending buildings, and the fourth operation would make use of eighteenth-century costumes to mock traditionalist architecture. In the procession down Lombard Street, the ceremonial interment of architecture conveyed the obvious expression of decline and decay, while also providing a theatrical counterpoint to the official ceremony of the laying of the cornerstone, which was wittily recast as a tombstone. The group's mocking performance had a serious motive, however, which was to direct a critique broad enough to indict a generality of architecture, rather than just a few specific buildings. The self-designation as Anti-Ugly drew an equation between ugliness and a level of mediocrity, of poor quality, that according to the group was not contingent upon style. While it is evident that members of the group advocated for modernist architecture—placing emphasis upon the belief that architecture must reflect its contemporary moment—they insisted that theirs was not a critique premised upon presumptions about stylistic propriety.

The boom of postwar building through the 1950s produced a transformation of the fabric of British cities. In London, the scale, the facades, and the material of new office blocks, many of them speculative buildings, altered the experience of the citizens walking and working in the city. While many of these buildings were vouchsafed by their architects and their owners in terms of modernist principles of function, cost, and technological advancement, the members of Anti-Ugly Action set different terms for their critique. Theirs was an unabashedly aesthetic critique, rather than a moral or material one. It was the appearance of these buildings, their outward appearance from the street, that was at issue, and not, they said, predetermined objections over style. In other words, though the Barclays Bank headquarters might have been singled out for the disproportion of its neoclassical dress, with the enormous scale of the building crudely attenuating its smaller details along Lombard Street, a bad modern building would be subject equally to anti-ugly sentiment as a bad traditionalist building such as the one they had ironically interred. Whether or not the members of Anti-Ugly Action fully achieved this agnosticism, their protests did articulate their judgment explicitly in terms of quality rather than in always-prevalent terms of style.

The new constitution of quality as a measure for the judgment of ugliness had a particular implication: it oriented the group's aesthetic advocacy toward an attention to average rather than exception. The buildings singled out for protest were only specific elements within a broader class that Anti-Ugly Action derided as "architectural stodge."[3] By marking out that class in such a fashion—as stodge—Anti-Ugly Action bridged from the particularities of style to the generality of quality and opened the possibility of speaking of a widespread standard of architecture in postwar

Britain. The architectural critic Ian Nairn (who addressed the members of Anti-Ugly Action in a lecture just after the group was founded) described Bowater House, a commercial development alongside Hyde Park that Anti-Ugly Action had approved, in telling terms: "A curate's Egg. Walls with a good deal of trouble taken over the materials and proportion, yet a roofline (not entirely the architect's) which is *laissez-faire* at its worst. A hulking shape from the park, yet an exciting experience to walk under.... This perhaps should be the average. Alas, it is far above it."[4] In other words, a building with some merit, but nevertheless quite mediocre. This level of architectural accomplishment, according to Nairn, could be acceptable as an "average" standard.

The broader concept of an average, invoked colloquially by Nairn in 1964, had already gained a well-established pedigree in social representations from the nineteenth century onward.[5] The rise of statistical information and its acceptance as an accurate rendition of the vast contingencies of social life made it possible to define a seemingly coherent norm out of a collection of differentiated points of data. Crime, physiology, prices, disease, income, weather—any such collation of facts might be sorted and graphed to bring into view frequencies and regularities, to define the average. A current of visualization and visual assessment ran through many of these processes, as Audrey Jaffe has suggested: "Nineteenth-century strategies of quantification and measurement often arranged diverse natural and social phenomena, including details of physical appearance and the information about character those details revealed, on theoretical scales, with individual elements positioned for the purpose of comparison around an imaginary mid-point: a composite or average devised to anchor the system."[6] The concept of the average was applied not only to events such as weather or to abstractions such as prices, but also to social interactions and ultimately to persons. The average man exemplified norms of skill, circumstance, and behavior, revealing, in relief as it were, the aberrant extent of social qualities such as intelligence, impoverishment, or criminality. The average man also embodied an aesthetic standard, both in his own nondescript physical appearance and in his normative evaluation of the world around him. The average man who made his entrance onto the pavements of the city in the early nineteenth century became known as the man in the street, who was by the twentieth century understood to represent a norm of opinion and evaluation.[7] His outward appearance or innate character was of less concern than his opinion, his feelings, and his thoughts.

The man in the street is a collective subject who stands for a commonality of experience rather than individuated, incommensurable experience; he is, moreover, an urban subject, for his street is the crowded sidewalk and busy thoroughfare of the city.[8] The man in the street, through the

representation of his presumptive feelings and thoughts, provides an expression of collective affect, a sensibility that arises from and responds to the surrounding urban environment, not passively but in an oscillation of acceptance and assertion.[9] This collective affect, which because the man in the street is after all a fictional norm may not be the affective experience of any one actual person, may be provoked by any of the myriad registers of the city, its architecture certainly among them. The collective affect of the funeral procession along Lombard Street belongs in this category. Because the event was a mock funeral, its affect was not the cumulative feeling of individual mourners, but the shared impatience expressed by the slogan "The City Is Ugly Enough Already"; and this shared impatience was itself a response not to exceptionally ugly buildings, but to the awareness that ugliness was the architectural average of London. Even as the procession made its way down Lombard Street a different architectural conception of the average had begun to emerge, one that attempted an altered arrangement of the concerns of the man in the street.

A Metropolitan Architecture

The 1951 Festival of Britain, conceived as a centenary celebration of the Great Exhibition of 1851, evolved into a postwar celebration of the British nation and a stylized British way of life. Its pavilions, exhibits, and performances were instruments for the fashioning of a collective national audience, with the centerpiece of the Royal Festival Hall constructed as a permanent cultural center amid the temporary structures of the festival. Even as the festival grounds were being prepared, attention was given to the future development of its newly cleared and now very public grounds along the south bank of the Thames in the center of London. To what uses should this site be dedicated, and what future public audience might it address? These were the questions posed to the London County Council (LCC) by concerned journalists and professionals. Unsolicited proposals offered in the pages of the *Architectural Review* included monumental plans for boulevards and civic buildings as well as schemes that sought to insert a density of quotidian public activity with an assemblage of leisure and work programs. A 1949 sketch offered by Gordon Cullen, famous as one of the journal's proponents of the neo-picturesque Townscape movement, shows a dense cascade of volumes and colorful surfaces tumbling down toward the river's edge.[10] The audience was, one presumes, a public taking its leisure with casual attention to visual interest.

In 1953, the Town Planning Division of the LCC formalized an outline for the future development of the South Bank site all around the existing Royal Festival Hall, with a plan that included a conference center placed northeast of the hall in a tapered block. The taper was the formal

Figure 16. In the 1961 site plan for the new South Bank Arts Centre, the articulated forms of the concert hall (labeled CH) and the art gallery (AG) contrasted with the simplicity of the Royal Festival Hall (RFH). The site of the new Shell Centre, then under construction, is indicated at the top of the drawing. London County Council Architects' Department.

indication of a radial arrangement, hinged at the rear of the site, that would retroactively fix the Festival Hall within a new geometric plan. Over the next several years, the overall scheme was revised, largely in response to programmatic changes that included the replacement of the conference center with a concert hall and an art gallery; and in 1961—two years after the Lombard Street funeral procession—the Architects' Department of the LCC published its new, detailed proposal for the complex, which had now assumed a very different appearance.[11] (Figure 16) While the Royal Festival Hall building had belatedly adopted the linear forms and referential conceits typical of prewar modernism, the new complex was a cluster of irregular forms that disregarded compositional geometries and ignored existing configurations implied by the site. Three volumes contained the programmatic spaces: two concert halls, the Queen Elizabeth Hall facing the river with the Purcell Room behind, and one art gallery, the Hayward Gallery, at the back of the site. Above street level, a deck loosely wrapped the concert halls and gallery; a pedestrian who descended onto the deck from Waterloo Bridge or climbed up to it from below could circumnavigate along a rambling route up and down stairs and along constantly widening or narrowing paths. (Figure 17) Much of the lower level was given over to car and service access and

Figure 17. An axonometric drawing of the South Bank Arts Centre shows the irregular forms and circuitous paths of the walkways surrounding the concert halls and the art gallery. The pedestrian stair to Waterloo Bridge can be seen at the far left. London County Council Architects' Department.

to a large undercroft opening toward the river. Originally intended to be faced with Portland stone (which despite John Wood's efforts became the ubiquitous stone of London buildings), but eventually constructed with precast and cast-in-place concrete, the building would rise a few stories higher than the bridge, but would be smaller than and subordinate to the Festival Hall.

Construction of this remarkable urban concoction proceeded ahead, but no sooner had the first phase of the South Bank Arts Centre opened in 1967 than a *Daily Mail* survey nominated it as "Britain's Ugliest Building."[12] This epithet—ugly—has attached to the complex with remarkable consistency over the past four decades, supplemented by a supporting cast of adjectives like surly, bunker-like, barbaric, dank (according to the architect Richard [now Lord] Rogers), bleak (so said the imposing architectural historian Sir Nikolaus Pevsner). Even advocates have tended to offer quite temperate praise, with one, for example, expressing hope that over time the design would "assert itself and make people learn to like what at first was unfamiliar and hateful."[13] In a 1968 review of the building, the critic Charles Jencks acknowledged the preponderance of hostile reactions—"One man's meat is another man's poison," he wrote—but countered them with a challenge: "All this criticism which has occurred, while understandable, is slightly beside the point. [The building] was

probably intended to be conventionally ugly. So while the critics may have reacted in the right way, they have drawn the wrong conclusions. It is rather as if the critic reacted correctly to a gargoyle, a grotesque or a Francis Bacon only to reject them as unbeautiful."[14] Jencks provokes a different question beyond the superficial judgment of taste as to whether or not the building is ugly; the question instead is this: What might be the correct conclusions to be drawn from the ugliness of this architecture? And therefore what conclusions might be drawn from architectural ugliness more generally, as an aesthetic or experiential quality, and also as a social condition? The question brings forward into view the respondent to the architecture, the person who encounters the ugly architecture, and the transaction between that person and those persons of the architectural process—architects, builders, civil servants, critics—who brought the building into existence.

The final design of the South Bank Arts Centre was the work of the Department of Architecture and Civic Design of the Greater London Council (GLC), the geographically expanded successor to the LCC. The LCC and, from 1965, the GLC constituted a level of government between local representation as provided by the councils of individual boroughs and national governance as embodied by Parliament. It was a directly elected body; each London constituency elected one member of Parliament and two councilors to the LCC. Representation of the metropolitan citizen, whose interests but also whose manner of inhabiting the civic sphere were presumed to be distinct from those of citizens in the more bounded social environments of towns or villages, had a managerial cast indebted to the nineteenth-century concern for the average. The councilors of the LCC typically had professional or administrative backgrounds, and under their authority a series of professionally managed departments took charge of public services in the greater metropolis, services such as Education and Health. The LCC supervised a Town Planning Division and an Architects' Department (subsequently the Department of Architecture and Civic Design) which during and after the war facilitated plans for the coordinated reconstruction of the city and sought to provide housing and new educational and health facilities, and to develop cultural centers in London.

These departments were large in both staff and portfolio, functioning essentially as corporate offices with a hierarchy of administrators, designers, and technical specialists. Sir Leslie Martin (architect of the Royal Festival Hall) was appointed chief architect of the department in 1953 and hired the two assistants, Norman Engleback and John Attenborough, who would continue to lead the South Bank project after Martin departed in 1956 to assume the chair of architecture at Cambridge University. Martin's successor, Hubert Bennett, though unsupportive of

the design that emerged under Engleback's direction, was unable to press an alternative scheme. In the context of the postwar welfare state and its expansion of government roles, the Architects' Department of the LCC was simultaneously an environment of civil service and of architectural experimentation, with three thousand employees but many of them grouped into studios working independently upon their projects. Within Engleback's group were three young architects who could claim credit for the new design being in Jencks's words "conventionally ugly": Warren Chalk, Dennis Crompton, and Ron Herron, who by the time Queen Elizabeth inaugurated the building in 1968 would be very well known as members of Archigram.[15]

Within the networks of architectural discourse, Archigram was disseminating a radical critique of the conventions of modernism, advocating a more urgent embrace of technological change to accompany the social transformations of those years. While the polemics of Archigram did not circulate widely beyond architectural circles, they were paralleled by another architectural movement to which the South Bank Arts Centre was bound that had begun to attain considerable prominence. The New Brutalism, as it was known, was elucidated and for a time evangelized by the critic Reyner Banham, whose essays for architectural journals and criticism for wider circulating magazines gave attention to the emergence of a distinctive architectural attitude that proposed the value of a more direct, unmediated confrontation between a building and its occupant. The New Brutalism quickly became associated with the characteristic materiality of concrete, and with correspondingly heavy massing and more crudely articulated forms. Myriad strands of architectural experimentation extended outward from the New Brutalism, geographically as it was adapted in some form on every inhabited continent, and stylistically as it continued to serve as a signifier of urban, institutional architecture. For its early advocates, the New Brutalism was to be understood not, or not only, as an aesthetic, but as an ethic, and therefore an interjection of the person of the architect into the appearance of the architecture. For Banham, three traits in particular were to be emphasized, each with aesthetic and ethical implications: the use of materials "as found"—meaning unadulterated by finishes or treatments beyond their process of manufacture—the constitution of structure as a clearly understood relationship of parts, and the production of an affecting "image"; these three traits, he argued, were the constitutive properties of the architectural *je-m'en-foutisme* or "bloody-mindedness" of New Brutalism.[16] It is hardly remarkable to suggest that the ugliness of the South Bank Arts Centre is precipitated by its brutalist approach— the adjective "ugly" is never far from any brutalist building—but the metropolitan intention of this building in particular points toward an

Figure 18. The board-marked concrete surfaces, precast panels, and heavy, cantilevered forms are all visible in the view toward the Hayward Gallery as seen from the upper-level court of the Queen Elizabeth Hall. The concrete surface at the right of the photograph is the parapet of the bridge connecting the upper levels of the concert venues and the gallery. Greater London Council, Department of Architecture & Civic Design, South Bank Arts Centre (1968).

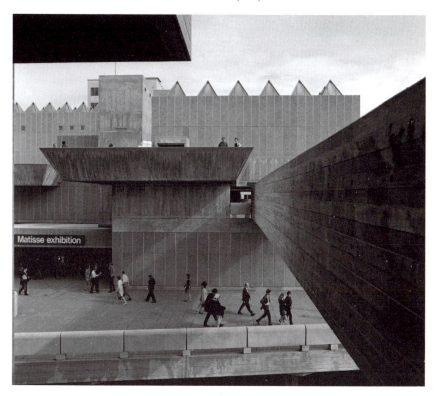

understanding of ugliness as something other than a companion term for appearance.

The Pile and the Puddle

Banham predicted that the Architects' Department "will find its most obvious monument in the only major example of the quasi-fortified/neo-antheap/more crumbly-aesthetic manner in the country, the extension to the Royal Festival Hall, now raising its mini-Ziggurats over the parapet of Waterloo bridge."[17] (Figure 18) If the shape and appearance of

the South Bank Arts Centre are to be considered as the constitutive aspects of its ugliness, subject to analysis or interpretation, then a more productive approach than the rubrics of style may be to take Banham's hint and understand the architecture as a manner and an approach, and perhaps to regard the architecture less as the consolidation of conventional traits of ugliness than as an insufficiency of not-ugliness. An encounter with the rambling architecture of the South Bank Arts Centre readily incited the verdict of ugliness, Jencks proposed, because "there is no underlying coherence, no visual logic which helps to explain the functional logic.... [The programmatic spaces] hide behind a confusing, hostile pile of jagged in-situ sludge."[18] Warren Chalk, the architect responsible for the complex walkways, explained that "the original basic concept was to produce an anonymous pile, subservient to a series of pedestrian walkways, a sort of Mappin Terrace for people instead of goats."[19] An artificial mountain landscape built at the London Zoo in 1914, Mappin Terrace was an early experimental use of reinforced concrete; it was a purposeful and considered design of form, purposeful but not precise (as evidenced by the fact that it has since served as habitat for a variety of animals). There is an echo of the humorous and positive appropriation of ugliness by the Ugly Club of Liverpool in Chalk's offhand likening of a shapeless mound of concrete to his newly designed civic architecture, but his aesthetic claim was serious. Like Mappin Terrace, the pile at South Bank was fashioned for use and for occupation without the aim of a precise compositional whole, or a precise form.

Individual parts of the complex did have highly specific criteria. For example, interior spaces had requirements for egress, and the concert halls had acoustical imperatives with ramifications for the selection of finishes and the regulation of air flow through the ductwork. But outside on the decks, people were to be free to circulate, to enter or bypass the venues, their movements accommodated with contours rather than geometric determination. The resulting asymmetries, the shifts and skips in levels, and the ubiquitous spatial expansions and contractions tolerate so much variation that any prospective continuities of configuration dissolve. The massing of the complex, decomposed into two heaps, similarly refuses to reveal causations, hierarchies, or relevancies. (Figure 19) Viewed looking across a street toward the Hayward Gallery, the parts fend for themselves or compete with one another, separately invoke concerns for technology, human occupants, or environment; not only the three programmatic centers, but also their smaller components, the staircases, curved and straight, serrated skylights, extruded balconies, and individual walls. No a priori logic generated the differentiated forms, nor does a totalizing or harmonizing framework of alignments harness them a posteriori. The overtly visible but indeterminate form results from the accumulation of

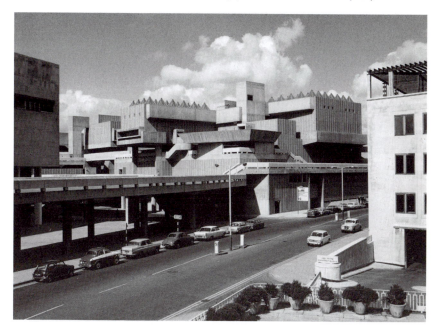

Figure 19. A pile of concrete forms, the mass of the South Bank Arts Centre as seen from Belvedere Road looking toward the Hayward Gallery, with the Queen Elizabeth Hall beyond. Greater London Council, Department of Architecture & Civic Design, South Bank Arts Centre (1968).

incremental decisions, each of which alters the configuration to which it has been added without tending toward any precisely fixed end. The architecture is in fact a pile, just as Chalk—taking advantage of the double sense of the word as both a heap and a building of some distinct size and pedigree—claimed it was intended to be.

Suspended in a process of formation, of constant increase or decrease, a pile is always a lack or insufficiency of form. In the pile alongside the Thames, no fixed relation to site, no hierarchy of movement, no interdependency of structure, and no imposed geometric order has determined a fixed arrangement of parts. This indeterminacy, like the mountainous shape of Mappin Terrace, enables possibilities without prescribing (or proscribing) further contingencies. It is difficult to recognize that the pile is not a transient stage prior to some future completion, but the actualization of indeterminacy. Consider, however, that throughout the 1950s and well into the 1960s the physical state of London was inescapably defined by the projects of reconstruction. A pertinent illustration comes from a series of paintings of London building sites by Frank Auerbach.

Figure 20. Frank Auerbach, *The Shell Building Site* (1959). Oil on board, 122 x 154 cm.

(Figure 20) One of the paintings, *The Shell Building Site*—painted like others with a technique of a thick, coarsely worked surface in a muddied palette—shows the construction of the Shell Centre, an office complex built immediately behind the South Bank site; revealed in it is the superimposition, over a raw, formless state of excavation works, of an emerging architectural order seen in pilings, girders, or cabling. To Auerbach, these appeared as simultaneous events, the one coexistent with the other, identifying incompleteness in a positive sense as a moment in which potentials had not been forestalled, in which change and differentiation were preserved.

Since its opening in the late 1960s, other architects, commissioned or not, have not hesitated in imagining changes to the South Bank Arts Centre. In 1979, *Architectural Review* published a proposal to fill in the "dark, wasted areas" of voids and overhangs at the complex with glazed enclosures, in effect smoothing out the irregular contours of the original buildings, so that the complex might be "transformed from its rock-like isolation."[20] In a 1984 consultancy, architect Cedric Price suggested a less complicated but perhaps equally forceful strategy to unify the complex by painting it and the Festival Hall a uniform color, "London Cream." The next year, architect Sir Terry Farrell proposed encasing the existing complex inside a new, larger building with a closer resemblance to the Festival Hall; later versions of the scheme proposed demolishing the halls

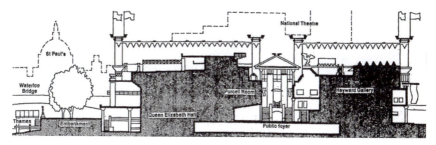

Figure 21. Sir Terry Farrell's 1985 proposal for the renovation of the South Bank Arts Centre. The sectional view shows the two concert halls and the art gallery contained inside a new superstructure and linked by a new formal entrance and foyer.

and gallery rather than containing them. (Figure 21) By 1992, a petition for listing had been rejected by Secretary of State Michael Heseltine, and a 1994 competition solicited larger-scale interventions that would redress the deficiencies of the brutalist buildings without disturbing the presumptively complete form of the adjacent Royal Festival Hall. Two of the finalists, the architectural firms Michael Hopkins and Partners and Richard Rogers Partnership, proposed the same strategy: a roof over the South Bank Arts Centre. For Hopkins, the roof would be one of the firm's characteristic tents, eight pylons stretching a bowed fabric roof across the Queen Elizabeth Hall and the Hayward Gallery.[21] The new profile would give the Royal Festival Hall a fraternal twin, with the original shape of the arts complex disguised beneath a more uniform shell, and with the concrete of the original building shadowed under the lighter, more supple material above. Rogers also sought to reconcile the arts complex with the Festival Hall by revealing the one and concealing the other. He proposed to spread an enormous glazed roof across the site, a glass wave rising up from the base of the Festival Hall and sweeping over the Hayward Gallery and the Queen Elizabeth Hall, submerging them inside what was immediately dubbed a new Crystal Palace. (Figure 22) The corrective intention of the design was evidenced by the smooth, sweeping roof's enshrouding of the disorderly pieces of the original complex.

While these corrections, ameliorations, and compensations for the original design's perceived lack of form went unrealized, the most recent attempt has proceeded closer to fruition. In 2013, what is now the Southbank Centre announced a major refurbishment of the concert halls and gallery and the addition of new spaces for rehearsal facilities and public functions. (Figure 23) The architecture firm Feilden Clegg Bradley Studios released models and renderings that showed two new glass volumes raised above the original concrete mass, one a rectangular bar running

Irritation

Figure 22. The Richard Rogers Partnership 1994 proposal to place a curving glass and steel roof over the South Bank Arts Centre. The Hayward Gallery would protrude through the roof toward the rear of the site, and a seam in the curve of the roof would make the Queen Elizabeth Hall visible from the river.

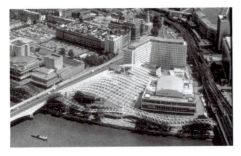

Figure 23. The initial proposal by Feilden Clegg Bradley Studios for the redevelopment of the South Bank Arts Centre, in which two new volumes would be added to the existing concrete pile. The plans for redevelopment have since changed significantly and the design concept amended.

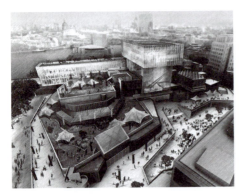

behind the concert hall parallel to Waterloo Bridge, and the other an elevated box perched above the gap between the halls and the gallery. Below the deck walkways, the undercroft was also to be enclosed and claimed as interior for the complex. Modified in response to its reception from professional and public audiences, the design is currently proceeding with a different scope, with the refurbishment of the halls the first priority.[22] The scheme itself adopts something of the logic of the original structure, choosing to add to the pile a few more volumetric additions, rather than to conceal and smooth the pile itself. These additions, however, are themselves sharply defined and prismatic, less indulgent toward uncertainties of form; and they are clad in glass, whose varied colors in reflection would present a sharp contrast to the uniform grayness of the concrete upon which they sit.

The materials employed in all of these proposed remedies—Rogers's smooth glass wave or Hopkins's taut plastic skin or FCB Studios' glass prisms—counter the brutalist architecture just as much as each design's respective consolidations of form. All of the proposals have sought to transform the exterior space into interior to make the terraces and connections between the buildings habitable, useful for cafes or shops, but these are not only programmatic changes; they would alter the balance of exterior and interior, changing the complex from an architecture whose external surfaces are the primary factor of encounter to an architecture of enclosure, protecting inhabitants from the rain, and of varied surfaces, themselves

protected from the contingencies of weather. It was one of Banham's exemplary traits of brutalism that materials be employed "as found," unalloyed and unadulterated materials displayed in architectural form. In the South Bank Arts Centre, precast concrete panels and poured concrete surfaces surround any visitor. Roofs, walls, and columns cast as one piece assert the structural primacy of the material, while board markings or the grain of aggregate on individual surfaces give direct emphasis to its sensible qualities. (see Figure 18) Many critics of the architecture have singled out for particular comment the pervasive concrete: its drab grayness in the weak light, its coarse texture, its inhospitable coolness, and, inevitably, its appearance when it rains.

The atmosphere that shaped the experience and understanding of nineteenth-century London had a continued effect upon the city of the twentieth century. A sympathetic reviewer in 1967 offered a prophetic warning: "For the visual excitement of turning a roof into a wall without changing material or finish, and without tiresome drips or the petty intervention of a gutter, one has to accept a bedraggled look on a rainy day, possibly resulting in permanent staining."[23] Such stains upon its concrete surface—which the architecture does incur and even encourage with its lack of any transitional detail along its edges—produce an additional dimension of ugliness separate from that produced by the pile's lack of form. These stains are as pervasive as the concrete they mark, occurring in the damp streaks along vertical edges and in the residual puddles scattered across horizontal planes. Weathering has not been the only cause of the stained surfaces; the undercroft, long since appropriated by skateboarders and other urban constituencies, has been covered in graffiti layered over the concrete surface. (Figure 24) The marks of rainwater and graffiti need not be distinguished from one another on account of provenance. Both are stains, and not in any presumptively negative sense, but insofar as both are what the architectural theorist Mark Cousins, in his focused reflection upon the concept of the ugly, calls the characteristic of an excess: "A stain must be cleansed. Is this because the stain is ugly? The stain is not an aesthetic issue as such. It is a question of something that should not be there and so must be removed. The constitutive experience is therefore of an object which should not be there; in this way it is a condition of ugliness."[24]

Even if less intentional than the lack of form, this second dimension, this excess out of place, is very much a part of what Jencks called the intentional ugliness of the architecture. Cousins's assertion that the stain "is not an aesthetic issue as such" does not imply a separation or segregation of ugliness and the aesthetic register, but instead underscores the relational character of ugliness, that ugliness is neither absolute nor essence, but is a relational circumstance. So to what end is the intentional ugliness

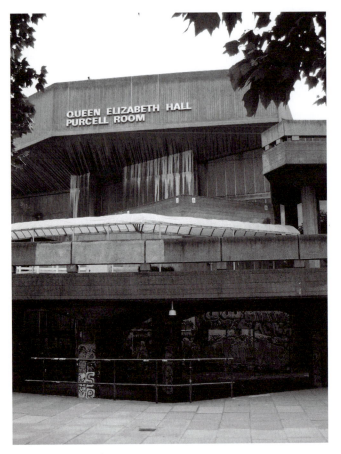

of the South Bank Arts Centre directed, and what kind of response does it warrant? For some experience was clearly anticipated by the accommodation or solicitation of stains. The New Brutalism "requires that the building should be an immediately apprehensible visual entity, and that the form grasped by the eye should be confirmed by the experience of the building in use"; but Banham further elaborated that while classical aesthetics would presume the value of this apprehension to be pleasure in regard to something beautiful, for New Brutalism its value might accrue in "*quod visum perturbat*—that which seen, affects the emotions," with pleasure, displeasure, or, pointedly, an admixture of the two.[25]

The values of visual apprehension and visual entities were at this same time being adduced (in very different fashion than Banham) by the historian Nikolaus Pevsner, who was then a leading advocate for the "Visual Planning" of urban settings, or what was also known as Townscape. Drawing forthrightly upon the legacy of the picturesque movement, Townscape gave attention to the dynamic experience of the city and above all to vision, which would, in Pevsner's conception, serve to coordinate the individual person with the highly varied urban environment.[26] In place of the modernist plan, Pevsner was advocating that the modernist promenade or movement be construed as the decisive instrument of configuration. A visitor to the South Bank Arts Centre might be surprised by its indeterminate form in much the same way as a visitor to Prior Park would be surprised by the changeable nature of Alexander Pope's wilderness. Except that the subjectivity invoked by Pevsner and other practitioners of the neo-picturesque was not that of the subject addressed by the ugliness of the South Bank Arts Centre; nor was his ideal of a calibrated concatenation of diverse forms the aim of the consolidated singularities of its ugly architecture. Writing the entry on the South Bank Arts Centre for his authoritative *Buildings of England* series, Pevsner conceded that its walkways produced "a thrilling experience, if the weather is fine and you are at leisure. But," he challenged, "what if it rains, what if you are late, what if you find steps a strain?" Then the nearest comparison to the walkways' "bleak effect [would be] Piranesi's *Carceri*."[27] Pevsner's critique reveals that the first two conditions of ugliness at the South Bank Arts Centre—its irresolution of form and the appearance of the stain—join with a third aspect of ugliness: the discomfiting sense of an architecture without empathy. The encounter between person and architecture is all roughness: the coarse concrete surfaces that are both tactile and injurious; the rambling terraces that solicit chance encounters but foil planned itineraries; the distortions of scale and orientation that defy commensuration; and the unsettling disarticulation of the architecture into parts and fragments. Where Townscape might have sought to employ these devices to produce a pleasurable confusion to be absorbed visually, the ugliness of the South Bank Arts Centre consists of an intrusive, situated dissonance.

This dissonance results not merely from infelicities of function, from the building not adequately serving its programmatic demands, or from insufficiencies of symbolic or associational legibility. It manifests from a third register of ugliness, not within the shape or material of architecture, but that consists of the relation between the architecture and the person

who encounters it. When Mark Cousins suggested that the ugly object is an object out of place, he argued that it is not the disturbance of the original object that constitutes ugliness, but rather that the ugly object, by looming too large, by already exceeding its own bounds, threatens the sovereign subject. The ugly is that which is neither contained within itself nor capable of being contained by something outside itself, and as a disproportionality between architecture and a person, ugliness prevents the proper definition of boundaries, or of what should be separate and intact exteriorities.[28] Ugliness compels disgust, as rendered in all of its actions and metaphors of repulsion, a self-preserving repulsion, whether in the form of vomiting, turning away, or crushing something underfoot, that sharply and immediately distances a person from the ugly object. Yet, however hostile some criticism of the South Bank Arts Centre has been, its ugly architecture does not prompt violent disgust manifested in physical nausea. The bleakness that Pevsner sensed, the oft-disparaged streaked concrete surfaces, the difficulty felt in navigating through the decks—these accumulate in the perception that the building is not sufficiently accommodating to its human users. All these elements prompt degrees of what is obviously displeasure, and though disgust would be found at the extreme of a spectrum of displeasure, ugliness has a more subtle key, one that prompts an affect more akin to irritation.

Where the urgency of disgust compels an unmistakably urgent withdrawal, the nagging affect of irritation emerges from a relentless proximity. The ugliness of this architecture irritates because of proximity, because it produces the sense of a mistaken, though not threatening, conflation of architecture and person. Unlike emotions, affects do not narrate the experience of a singular, coherent subject, but displace that experience into a separate, encompassing, collective mood. Affects are the relation between consciousness and circumstance, but detached from individual persons. Consequently, affects are more diffuse than emotions; they are vague, not unlike a pile or a stain. An ugly feeling (the expression is from the literary critic Sianne Ngai) such as envy or anxiety is induced by the lingering proximity of its source, condensing the interlaced factors of a given situation rather than apportioning them like the sharp emotions of disgust or anger. An ugly feeling emerges without precise causation from the perpetuation of the layered stimuli of a given situation, and the ugly feeling provoked by the South Bank Arts Centre thus summarizes the several and different instigations of a felt antipathy into a generalized but vivid mood: irritation. And while the active manner of disgust would provoke a violent overcoming of its objective cause through flight or fight, the passive manner of an ugly feeling like irritation could be extinguished only by a complete transformation of the situation from which that feeling emerges. Examples of such

transformations might include almost any of the alterations proposed over the past three decades as fixes to the complex, but in the absence of transformation, irritation persists as a simultaneous pulling-together and pushing-apart of the person and the architecture.

The person who experienced this irritation in this way was not the solitary individual, not Nikolaus Pevsner as he skirted puddles to navigate his way through labyrinthine passages, nor simply individual "laymen" who, as one critic suggested, "do not take kindly to this kind of 'architect's architecture.'"[29] For the architecture addressed a metropolitan body politic, the body politic that the London County Council itself represented—not only represented but in fact constituted, since that body politic had no prior historical, social, or geographic source of consolidation. The individual incarnation of this metropolitan body politic would have been the famous "man in the street," who had appeared in the anti-ugly demonstrations of the late 1950s, or the "man at the back of the omnibus," the surrogate for a standard of reasonableness in English common law. The average man and the reasonable man are historically intertwined; indeed, they were contemporaries in a sense—with the average man presented to the world by Adolph Quetelet in 1835 and the reasonable man making his first public appearance in 1837 in the case of *Vaughan v. Menlove*.[30] Both figures enact a translation between collective matters of concern and individual, and otherwise irreducible, experience. They summarize a larger constellation of persons inhabiting the metropolitan realm into embodiments that express a norm against which the experience or intention of those persons can be understood, and they condense the individual discernments, opinions, and tastes of those persons into personifications of the qualities of consensus and reasonableness. (Figure 25)

Crucially, the man on the omnibus is a standard of reasonableness whose social function is not to provide summary judgment but to define a measurement of expectation—not a decision about a given situation but a calculation as to how that situation ought to be perceived. The man on the omnibus, in English common law, figures a sequence of probable choices and outcomes, or to put it more generally, a course of anticipation through a given situation; the man on the omnibus "would have anticipated that. . . ." The temporal orientation that he brings, therefore, is not in-the-present-ness but in-the-future or more precisely a future anteriority, a drawing of the future expectation into the decisive context of the present. It is the man on the omnibus who experiences irritation at South Bank, and that irritation (which, again, is an affect detached from individual persons) is therefore the collective affect experienced by the metropolitan body politic. The man on the omnibus experiences that irritation through the deferrals

Figure 25. The reasonable man, with a perfectly furled umbrella in hand, and other metropolitan citizens on the walkway in front of the Hayward Gallery. Greater London Council, Department of Architecture & Civic Design, South Bank Arts Centre (1968).

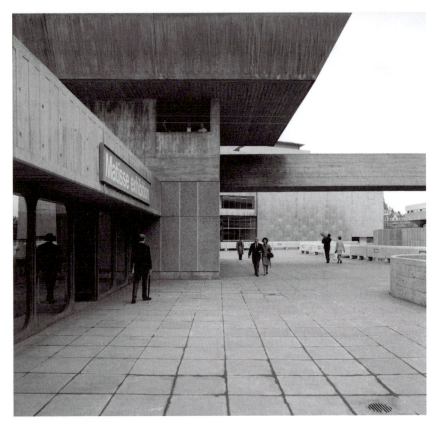

of this ugly architecture, because of its deliberate disconcerting of the certainties of the future anterior. This disconcertion occurs through a particular valence that has already been characterized as an aspect of the architectural ugliness of the South Bank Arts Centre: the valence of ordinariness. Even before the 1837 case of *Vaughan v. Menlove* gave clear description to the idea of reasonable anticipation, common law had employed notional figures that answered the need for collective embodiment; one such figure was coined in the early eighteenth century as the "person of ordinary capacity." The 1837 case imagined "a man of ordinary prudence," drawing the understanding of reasonableness together with an idea of ordinariness. With its display of unadulterated

materiality, and its willingness to eschew the organizational priority of program or geometric form, the architecture of the South Bank Arts Centre placed its emphasis instead upon a notion of ordinariness. It was a commonplace that the New Brutalism was a relentless acceptance of ordinariness. But the consequence of the collective affect it produces is that one ordinariness (that of the architecture) disconcerts another ordinariness (that of the man on the omnibus).

Deliberate Acts of Burlesque

Neither reasonableness nor irritation is historically fixed, and the ugliness of the South Bank Arts Centre is not merely a perpetuation of a metropolitan condition cast in place five decades ago. In his 1968 review, Charles Jencks predicted that the South Bank Arts Centre, unlike other contemporaneous architectural projects, would create an architectural setting "where one can imagine deliberate acts of burlesque," an analytical perception that has proved prescient.[31] Often these have been seemingly contained within the programmatic extents of the complex, in gallery exhibitions and concerts whose avant-garde intentions were accommodated by the architecture, but which also took advantage of its solicitation of further disconcertion of the metropolitan body politic.[32] One of the first concerts performed in the newly inaugurated Queen Elizabeth Hall was Pink Floyd's *Games for May*. On May 12, 1967, the band presented its gathered audience with the first experience of surround sound projected from a quadraphonic speaker system. (Figure 26) With sound effects—footsteps, bird sounds, and Roger Waters's unsettling laughter—distributed back and forth across the hall by the control of a single joystick, and with additional effects such as an artificial sunrise, giant soap bubbles, and a gong sounded by thrown potatoes, the concert's high-volume musical burlesque would have surprised even an ardent fan. The *Financial Times* praised the show as the "noisiest and prettiest display ever seen on the South Bank," and a reviewer for the *International Times* (a leading underground newspaper) agreed, noting the effect in spatial terms: "The choice of the Queen Elizabeth Hall for the Games of May event was really good thinking, for it was a genuine twentieth-century chamber music concert. [The performance] moved right into the hall and into the realm of involvement." From the radically novel perspective represented by Pink Floyd and their musical experimentation, the architecture itself was, in the critic's view, rather ordinary: "On the whole, it was good to see the strength of a hip show holding its own in such a museum like and square environment."[33]

In its capacity to synthesize different dimensions of vagueness—the irregular form, the stained surface, the irritating affect—ugliness produces

Figure 26. Pink Floyd rehearses for *Games for May*, performed in the Queen Elizabeth Hall on May 12, 1967.

a consequence that is available to such appropriations, to deliberate acts of burlesque. Even though the review of *Games for May* chose to see the music and architecture—or perhaps more accurately to see Pink Floyd and the GLC—in sharp contrast to one another, it is more the case that the performance had adjudged and seized upon a potentiality in the ugliness of the architecture. In 2008, the Hayward Gallery celebrated its fortieth anniversary with *Psycho Buildings*, an exhibition about the peculiar relationship between people and architecture.[34] The Hayward building has, on its uppermost level, three sculpture terraces whose steeply angled parapets add to the overall restlessness of the forms of the South Bank Arts Centre. Though actually extensions of the gallery's interior space, they imply that the lower pedestrian deck that forms an irregular surround at the entry level continues into, through, and out of the buildings at the upper level. During the *Psycho Buildings* exhibition, the trapezoidal terrace on the southeastern corner was the site of an improbable installation by the artists' collective Gelitin: a boating pond. *Normally, Proceeding and Unrestricted with without Title* (a convolution of a nautical definition used in accident logs) consisted of three plywood boats, a floating jetty, and a pond created by filling the entire pan of the terrace up to the top edge of the surrounding parapet. (Figure 27) The jetty, a willfully ugly contraption, was jerry-built from scrap and listed unexpectedly. The boats were similarly ugly, inverted pyramidal shapes in which two people sat facing each other, one pulling at a pair of shortened oars, with two empty five-gallon water jugs as stabilizers. Clumsy but seaworthy, they could be propelled around the pond with reasonable facility. The depth of the pond wasn't much more than a meter, but the black lining of the

Figure 27. Gelitin, *Normally, Proceeding and Unrestricted with without Title*, Hayward Gallery, London (2008). Photo collage by Gelitin, with background composed of partial views of the Shell Centre.

terrace and the reflections on the surface made it impossible to judge, and with the water up to the parapet edge an exaggeration of dimension gave a sensation of more serious nautical endeavor, one conducted fifteen meters above the ground.

Resonances with the original expedience of the Hayward design were readily found: the rickety jetty hammered together from bits made use of the "as-found" approach, for example, and the resulting wooden pile was as formally incoherent but as functionally capable as the surrounding concrete pile. The boats, too, were case studies in expedience. Simple plywood forms without graceful lines but with workable oarlocks and requisite stability to go where directed. And to create the pond itself, the formula couldn't be simpler. Take one existing terrace, plug the existing

drainage holes, fill with water. But it is this easy only once one has taken note of the actual parapets of the Hayward terraces, typically brutalist in their monolithic cast but distinctive in the raked slant that gives them the shape of trays or basins. Gelitin thereby produced what the exhibition pamphlet described as the "incongruity of [a] pastoral idyll suspended high above the ground and nestling against The Hayward's concrete Brutalism."[35] Superimposed upon the architecture, the boating pond became another puddle, larger and more purposeful but not separate from the other atmospheric manifestations of the architecture. The surface of the water both echoed and contradicted the board-formed concrete of the parapet. The smoothness it created differed from the smoothness of the roof enclosures that had once been proposed as correctives; not a wave now, but a puddle embedded within the ugliness of the architecture. At the outer edge of the terrace, the seeping stain of water would now result from the overflow of the pond, rather than rainfall, so that the stain, that which still does not belong, is nevertheless fully part of a legible performance of ugliness.

In his 1984 *Report on South Bank*, an analysis of the deficiencies and the potentials of the complex, Cedric Price concluded that "this unique area—half water, half land—must be available for massive human individual & collective endeavour, skill, delight and imagination. It must be more than a city lung—it must encourage its users to help generate its vast potential for human use.... If it can do even more than distort time and place for human dignity, understanding & delight (which is what the British Museum does) then it must do so by providing an opportunity for activities and aspirations—for both individuals and the crowd—hitherto thought impossible."[36] Both *Games for May* and *Normally, Proceeding*, by performing such impossibilities, revealed that positive category of experience that ugliness enables, a state of misalignment or disconcert between two respective domains—architecture and the body politic. A condition of friction that does not rise to the state of conflict, the passive affect of irritation never rises into disgust and a consequent resolution (through some necessary escape from or removal of the object of disgust). Instead, irritation produces a curious state of equilibrium, insofar as neither the embodiment that registers the friction nor the context in which that friction occurs may have a greater claim to propriety—to being in the right place—than the other. Perhaps the terrace always was a boating pond after all? Or perhaps the undercroft was a village green? This was the clever hypothesis of campaigners seeking to protect the undercroft as a skatepark once the most recent plan for improvements was announced; they petitioned to have the space recognized as a community space under the Commons Act 2006, designed to protect communal civic spaces such as village greens.[37] Two ordinary (and, it should be noted, nonurban)

spaces, a boating pond and a village green, occupy the same space and time as the other ordinariness of the deliberately ugly architecture of the South Bank Arts Centre.

In yet another burlesque, the man on the omnibus, that metropolitan subject of routine and expectation, encounters the architecture of the South Bank Arts Centre in the scenes of the music video for "Red Letter Day" by the Pet Shop Boys.[38] (Figure 28) The staged encounters, organized as the queues that shape much of daily urban life, give visual expression to a fragmentary narrative. With each irritable judgment of the ugliness of the architecture, the collective metropolitan subject expresses a misalignment of expectation and circumstance, but through the scenes of the extended queue winding through the architecture, as through the short-lived boating pond on its balcony and the decades-old village green in its undercroft, a novel calibration of average and exception comes into view. The average man is not met with an average architecture, but neither is the exceptional architecture met with an exceptional person. John Wood had aimed, two centuries earlier, to align an improved behavior of the Company with improved sidewalks and facades, the orderliness of the one to reinforce the other. On the south bank of the Thames, the metropolitan subject and the metropolitan architecture are brought together toward a different civic end, not a resolved order achieved by beauty, but a novel indeterminacy enabled by ugliness. By soliciting and giving substance to the affective experience of irritation, the deliberately ugly architecture transforms the individual judgment of complaint and dislike into the collective judgment of dissatisfaction and changing expectation.

Incongruity

"Taste is the smiling surface of a lake whose depths are great, impenetrable and cold," wrote the architectural historian Sir John Summerson. "At unpredictable moments the waters divide, the smooth surface vanishes and the depths are revealed. But only for a moment and the storm leaves nothing but ripples on the fresh, icy surface."[1] Summerson offered this metaphor as his conclusion to an essay on William Butterfield, the nineteenth-century architect whose work had seemed (and continues to seem) more impervious to sympathetic understanding than the work of his Victorian contemporaries. "People of taste screw up their faces at the architecture of William Butterfield," Summerson conceded, but he believed the key to understanding was to inquire more deeply into the deliberate ugliness of Butterfield's architecture.[2] With characteristically awkward proportions, irregular composition, discordant colors, and a generalized coarseness, all of Butterfield's works (churches for the most part) were "to a greater or lesser degree ugly."[3] This ugliness, though, was in Summerson's view purposeful, part of a "singular attraction on the part of some painters, architects, and writers towards ugliness" in the middle decades of the nineteenth century; an attraction prompted by nothing less than a desire to overthrow the restrictions of taste that surrounded them. "The truth is that these people wanted, needed, craved ugliness."[4]

The sympathetic understanding of Butterfield's ugly architecture required not an affinity of taste, then, but a recognition of the temporal situation of his architecture, the recognition of an opposition between one historical setting and another that preceded and threatened to overshadow it.

Just imagine yourself living in late Georgian London—yes, *living* in it, not just reading about it or enjoying the melancholy of its time-washed fragments. Imagine a city in which every street is a Gower Street, in which the "great" buildings are by smooth Mr. Wilkins, dull Mr. Smirke or facetious Mr. Nash. Imagine the unbearable oppressiveness of a landscape in which such architecture represents the emotional ceiling.... Across the hideous streets, the flaccid stucco, the flimsy railings and the six or seven million chimney-pots [the young architect] sees the vision of an architecture which is hard, muscular, fearless, contemptuous alike of the drawing-room and the drawing-board—which is full of everything the architecture around him negates.[5]

This ugliness is full of motive, an assertion of the future of possibility against the enclosures of an encompassing past; not, though, in the modernist sense of novelty—for Butterfield was one of those scrupulous gothic revivalists—but in the sense of opening a seam in a civic fabric that had covered society for too long. Such a challenge could be pursued in diverse materials of culture, in any of the arts and in political economy as well, but Summerson identified a role for architecture in giving visceral "hammerblows against 'taste.'"[6] It might be argued, and not incorrectly, that much of this exchange of blows Summerson described was transacted in the register of style, the advocates of gothic revival challenging those of neoclassicism, and then the revivalists quarreling among themselves over the minute particularities of historicist form and decoration. Yet it is important to see also that style has been linked, in his examination of Butterfield, to temporality—as Summerson challenges his reader to think of actually living in the earlier period—and that what appear as contestations of style are also a perceived incommensurability of temporal change, of one historical period succeeding another.

Of course, Summerson had his own historical context, writing about Butterfield in London in 1945, having spent the late years of the war surveying monuments and bomb damage and assembling lists for the preservation and restoration of architectural heritage that would be an important step in the century-long development of contemporary ideas and practices of preservation. (Figure 29) Summerson had already contributed to the deeper historical understanding of the architecture of the Georgian period and with his thoughts on Butterfield was beginning to do the same, with equal sympathy, for the architecture of the Victorian period.[7] The question he posed about Butterfield had much less to do with the advocacy of style than with the question of temporal distance, and the question of architecture's role in expanding or compressing that distance. As he surveyed the reality of London, his surroundings the

Figure 29. Rubble and bomb-damaged buildings in the City of London, seen through the doorway of St. Stephen Walbrook.

contingent ugliness of ruined buildings, bombed churches, and vacant lots of rubble, the deliberate ugliness of Butterfield, in the challenge of deciphering its ugliness, possessed a potential to bring to light the particularities of change—stylistic change but also changing judgment.

In looking at Summerson examining a nineteenth-century architect's likely view of Georgian predecessors, a reader enters into a similar position of historical distancing. But does ugliness still possess the same capacity—the capacity to repel a dull Mr. Smirke or to attract an intense Mr. Butterfield or to enlighten a thoughtful Mr. Summerson—within the resulting architectural temporality? Without taking recourse to philosophical assertions of a will-to-art, or a spirit of the age, one might still acknowledge that any historical period appears as a constellation of characteristics, materials, and valuations that correspond with one another. This correspondence, when examined as a historical object viewed in the register of aesthetic judgment, appears as a consistency; a consistency that certainly may belie fracture and difference in the social or economic configurations that accompany it, but a consistency

nevertheless. The question posed by such consistencies is twofold: first, whether they arise only as a matter of perspective, from employing the register of aesthetic judgment as the initial framework of analysis; and second, how such consistencies shape the intersection or coincidence of historical moments that lie at a remove from one another. When a single architectural circumstance bridges different historical contexts, when its possible starting points offer little outward resemblance, then, accustomed as we are to seeing the stylistic traits that make their respective appearances consistent in themselves and therefore utterly unalike, style becomes an uncertain analytical instrument, especially when the judgment of ugliness is involved.

The Case of St. Stephen Walbrook

The city of London, spread as it is across centuries of historical change still evident as fragments within its contemporary material presence, contains innumerable such circumstances. In order to trace one such episode of stylistic commensuration, in the church of St. Stephen Walbrook, one can begin in the twentieth century, in the 1960s, as London emerged from postwar reconstruction, or three hundred years earlier, in the seventeenth-century London that rose after the Great Fire. The London of Carnaby Street and the Beatles, or the London of St. Paul's Cathedral and King Charles II. Both were moments of rebuilding and reinvention: the earlier following not just the physical ruin of the Great Fire, but the catalyst and catharsis of the Civil War, regicide, and the Restoration of the monarchy; the later moment preceded by the total destruction of the Second World War, with the relief of victory accompanied by physical ruin soon followed by the erosion of social certainties. The events that compose the present story of St. Stephen Walbrook insist upon the coincidence of these two historical beginnings, their coexistence as historical sensibilities and their coexistence in physical forms. St. Stephen Walbrook, a small parish church in London, was one of the ancient City churches quickly rebuilt after the Great Fire, and, both then and now, enclosed by dense surroundings. Then, these surroundings were small houses, masonry to abide by the regulations of the Assize, residences and places of commerce; now these surroundings include the Rothschild Bank building by OMA, Bloomberg Place by Norman (now Lord) Foster, and other commercial structures constructed after the war. The church remains in place, a remnant and a persistence.

Sir Christopher Wren designed St. Stephen Walbrook; its central furnishing, the altar, was sculpted by Henry Moore. (Figure 30) The foundation stone of the building was laid in 1672; the stone altar was carved three hundred years later, 1972. It was the difference between the church and altar

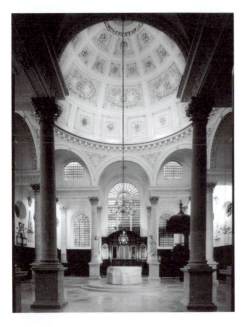

Figure 30. The interior of Christopher Wren's St. Stephen Walbrook, viewed from the nave, with the altar sculpted by Henry Moore at the center of the crossing below the dome.

that was at issue in an intricate debate about the altar and the church that commenced in the 1960s and culminated in the 1980s. Familiar and simplistic terms of contrast were put forward—neoclassical and modern, personified by Wren and Moore, or architecture and art, or refined and primitive, or even beauty and ugliness—and polarities such as these and the problematic demarcations they suggest became instrumental terms, with their instrumentality dependent upon the attachment of aesthetic judgment to other registers. The architectural events at the church were subsumed within a broader, encompassing postmodernity, with its presumed distancing or decoupling of aesthetic production and aesthetic materials from their prior cultural groundings, so that the processes of attachment become critical events in themselves, actions of displacement of aesthetic modes of judgment into parallel registers—in this instance, into legal and theological judgments. How do such displacements of the aesthetic negotiate the consistencies of the coincident historical moments in which they occur, and how are such displacements signaled, even enabled, by judgments of ugliness?

Christopher Wren's design for St. Stephen Walbrook accorded with the prevailing liturgical practices of the Anglican church of the 1670s and accorded also with the social conventions of the parishioners who attended it. It was an auditory church, meaning a single contiguous space in which the liturgy and the sermonizing of the reverend would be audible to all the congregation. The size and arrangement of the auditory, in Wren's view, must allow "all to hear the Service, and both to hear distinctly, and see the Preacher."[8] The proportion might vary, he allowed, "but to build more room, than that every person may conveniently hear and see, is to create Noise and Confusion."[9] With acoustic dissonance and visual disruption architecturally minimized, the focus of religious attention could be directed toward the pulpit from which the sermon

would be delivered, and which was raised well above the parishioners seated in the rows of box pews. (Figure 31) Box pews, a typical furnishing of Anglican churches in that period, were individual compartments with seats enclosed by tall paneling that made parishioners all but invisible to one another while still permitting a view of the pulpit. Less visible from the pews, and also less present in liturgical terms, was the altar, set within a shallow reveal at the far end that signified the chancel. A rival focus of parishioner's attention would have been the dome, the first such dome to be constructed in London and a precursor for Wren's later accomplishment at St. Paul's. This dome expanded the space that was kept compact in plan in order to satisfy the auditory requirement, and though relatively light in weight, it still required a significant structural support that would not obstruct views or hearing. Wren's solution was to set triads of columns beneath pendentives to bring the circumference of the dome into concordance with a cruciform arrangement in the lower part of the church to produce

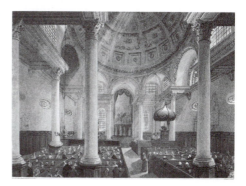

Figure 31. An early nineteenth-century view of the interior of St. Stephen Walbrook shows the congregation seated in box pews, and the reverend sermonizing from the pulpit. Illustration by Thomas Rowlandson and Augustus Pugin for *The Microcosm of London* (London: Rudolph Ackermann, 1808–10).

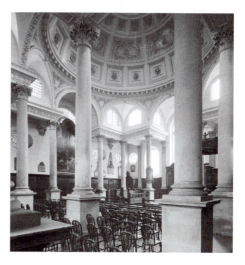

Figure 32. The interior of St. Stephen Walbrook in 1957 with chairs arranged to face the altar in the chancel. At the center of the image can be seen Wren's skillful solution for the transition from dome to the cruciform arrangement of columns.

a unified arrangement of parts. (Figure 32) These aesthetic solutions were inseparable from their social intention and consequence, with the unified arrangement the aesthetic corollary of the social effect of communal congregation.

Figure 33. Lucinda Douglas-Menzies, *Edward Chad Varah* (1988). Bromide print.

By 1967, three centuries further along and the year in which the idea of the new stone altar was conceived, the liturgical practices of the Anglican church had changed in significant ways. Communion was held much more frequently—weekly rather than three or four times a year as in Wren's day—which reinforced the communal, congregational basis of the Anglican church. The proximity of parishioners and reverend was thus emphasized, and no longer just visual or auditory, but now an intimate spatial and emotional proximity as well. In many Anglican churches, the altar was moved out of the chancel, closer to the center of the congregational body. Box pews, which had often been owned or rented by individual families, had been replaced in the nineteenth century with seats or benches. Such changes paralleled social transformations; the slow erosion of class privilege, for example, contributed to the removal of box pews. And of course London in the late twentieth century was a very different social environment, one with which the rector of St. Stephen Walbrook, the Reverend Chad Varah, was quite extensively engaged. Varah was, famously, the founder of Samaritans, the first suicide prevention helpline; he was an outspoken and unembarrassed advocate of sex education, and moonlighted as an author of science-fiction comics. (Figure 33)

Varah's efforts toward social engagement were not unrelated to the initiative he undertook at St. Stephen Walbrook, where, with a campaign already under way to repair structural damage, consideration was being given to new arrangements for the interior. In 1967, Varah and one of his churchwardens (a lay member responsible for church administration) approached Henry Moore with the commission for a new altar. The sculptor had been suggested by the churchwarden, Peter (now Lord) Palumbo, a property developer who was himself a patron of contemporary art and architecture. (He would purchase Mies van der Rohe's Farnsworth House in 1968, and later bought Frank Lloyd Wright's Kentuck Knob in Pennsylvania.) The rector provided the idea of the commission itself, for an altar to be placed at the center of the crossing, under

the dome; an altar "in the round, with the priest moving around the perimeter."[10]

Varah introduced the commission to Moore not by way of liturgical details, but rather, it seems, though evocations of its spiritual dimension: "I begged him [Moore] to forget any altars he had seen, if he had in fact seen any, and to think of something going back to the dawn of history, something primitive and inseparable for [*sic*] man's search for a meeting place with his God."[11] The altar could, he said, be the "quintessential, arche-typal, rough hewn altar of the Old Testament."[12] For his part, Moore had

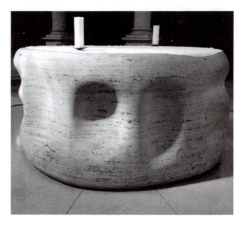

Figure 34. Henry Moore sculpted the altar into a cylindrical form, with its top surface a flat tabular plane but its sides irregularly contoured by hollows and ridges of different shapes and depths.

of course seen altars, but this was only his second commission for a religious work. (He had sculpted a Madonna and Child for a parish church in a provincial town during the war, but none since; his Mother and Child for St. Paul's Cathedral would follow in 1983.) Moore approached the Walbrook commission by visiting the church to sit contemplatively in its interior, sometimes for hours, to study the procession of light across Wren's space. Apparently given leave to determine the dimensions, Moore decided that the round altar should not overlap the fifteen-foot spacing of the transept columns, but also that an initially proposed five-foot diameter was insufficient; something bigger was needed "to produce a massive effect."[13] The height of the altar serves its purpose, allowing the priest to use the top for communion, but it also draws the surface up toward the plane implied by the column bases. These bases themselves seem oddly tall to a visitor now, but their height was originally set to align with the top of the box pews. Drawings of the new altar were finished and a full-scale model placed in the crossing early in 1972, and the final piece arrived at Moore's studio from the stoneworks early in 1973. (Figure 34) The completed altar was a cylinder of travertine, eight feet in diameter, three-and-a-half feet high, ten tons of weight to rest upon a broad footpace; smooth in its surfaces, level on its top but with subtle undulations carved into its sides that create a constantly changing articulation of depth within the circumference of the drum.

It was not until the early 1980s that the restoration work on the foundations and floor progressed to a point where the altar could be installed

in the church. But this installation still required what is called a faculty, a permission granted by diocesan authorities for any significant alteration to the fabric or furnishings of an Anglican church, and with this requirement, Moore's altar and Wren's church, with their respective aesthetic predispositions, were drawn into a social institution of law. A faculty consists of a judicial process in which the advocates of the alteration—typically the incumbent priest and the churchwardens—petition the Consistory Court, an ecclesiastical court that supervises church administration for the bishop of that diocese. A single judge, called a chancellor, presides over the Consistory Court and hears the case in the familiar forms of common law jurisprudence: one brief in support of the faculty presented to the court by a barrister and a countering brief in opposition.[14] The chancellor hears testimony from witnesses who may be examined and cross-examined, and detailed evidence may be submitted. The chancellor considers the arguments in light of other cases that may have established relevant legal precedents, and then either grants or refuses the faculty.

The Consistory Court of the Diocese of London heard the case of St. Stephen Walbrook beginning in January 1986. The case was an important one. The church had been closed for years by the reconstruction and the altar would be key to resuming its pastoral role. Yet because the building had been listed Grade I for preservation in 1950, such a significant change compelled careful deliberation. In the Consistory Court hearing, the chancellor pursued two distinct lines of interrogation, one aesthetic and the other theological. The first, the aesthetic, questioned the manner in which Moore's altar would affect Wren's architecture. Would the massive stone altar enhance or degrade the perceived perfection of the architecture? Were the two works of "totally different idiom" compatible, or were they insuperably at odds?[15] Certainly the testimony was at odds, as the chancellor noted and as exemplified in a comparison of two statements, one for the petition and one against. Mr. Peter Palumbo, the churchwarden: "As a general proposition, any two works of art, each of the highest excellence, can live together and each will set off and advantage the other." Mr. Ashley Barker, surveyor of historic buildings: "To take a work of great geometrical precision and introduce into it something large in comparison with the original building and of a different artistic nature is venturing on the impossible."[16]

Possibility and impossibility here mark out the boundaries of a judgment, potentially a judgment of ugliness, arising from the contrast of two objects that are to be placed in juxtaposition. The difficulty is clear enough: in Moore's sculpture one encounters a tactility, an emphatic materiality, a density of mass, but an indeterminacy of form and a "subtlety of line."[17] Wren's architecture by contrast proffers an elision of mass, and

a precision of line and form; the historian Kerry Downes saw in Wren's drawings of the church in sectional view: "Wren at the most severely geometrical, even theoretical, stage of his thought in which no more is committed to paper than the plane projection of the edges between surfaces and spaces."[18] Moore's sculpture also is severe, but not as abstraction, rather as what the Reverend Varah called "something primitive." This is not to say that either is simple. (Figure 35) The conjunction of dome and crossing comprises the ring and the twelve columns, and between them the eight equal arches that cleverly mask the differentiated barrel and groin vaults of transept and chancel, and the varied windows eroding the solidity of the exterior wall. And per-

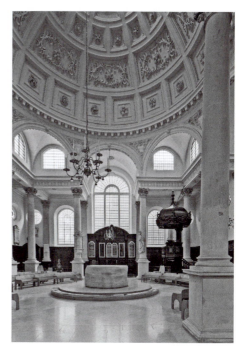

Figure 35. The volumetric complexity of Wren's arrangement of the structural transition at the base of the dome seen in relation to the sculptural volume of Moore's altar below.

haps the volumetric complexities of this transitional space are echoed by the concavities and convexities of the altar, as its circular mass certainly echoes the circular void of the dome.

In the setting of the Consistory Court, through the testimonies of witnesses, a viewing of the altar, a study of the church, substantive disciplinary conventions and concepts such as style and intention could be introduced into the space of law, but once there they did not simplify the task of judgment. The chancellor and the barrister in opposition agreed that an altar could be neither a convenient boulder nor a recumbent nude with settings upon it, but this did not resolve the nature of the object in question, which was not a boulder and not a statue. Endeavoring to understand the significance of the massive stone, the chancellor asked Varah how an altar of this shape might differ from one found at Stonehenge, to which the reverend replied that Stonehenge pointed toward a gruesome past and the new altar toward a redemptive future.[19] As the chancellor noted, "A great deal of evidence was given by distinguished experts as to the beauties of the church and as to the beauty of the piece of sculpture.

I accept without reservation that both are beautiful and I need not further discuss that part of the evidence. But are the two things congruent?"[20] The chancellor's question was nowhere near as simple as it might have sounded, for congruity is the aesthetic horizon of several different manifestations. Congruity appears as *concordance*, the stylistic concordance of forms; but also as *consistency*, the perceived consistency within subjective experience; and it is recognized also as *integrity*, the perpetuated integrity of an artistic intention.

To ask if these two things were congruent, or if their adjacency would render their respective beauty as a condition of ugliness, was to pose a question of aesthetic judgment, but a complex one that could not be indifferent to corollary social implications. Wren's design contrived a conflation of longitudinal and centralized arrangements: the longitudinal emphasis produced by the line of columns flanking the nave and framing the chancel; the centralized effect produced by the frame of columns surrounding the crossing. The columns are at once axial and a quartet of corners. (Figure 36) Witnesses opposed to the faculty argued that introducing the massive Moore altar directly under the dome would unacceptably change the church interior, doing "drastic violence" by disrupting or even destroying the architectural geometry.[21] It would, they insisted, enforce the centralized reading of the plan and repress its longitudinal expression. Ashley Barker, opposed to the faculty: "'The presence of the great solid form of the proposed altar under the domed centre would be to create an expectation of symmetry all about it by blocking the longitudinal and cross axes and establishing a false centre—reflecting each incident axis in turn—which, in my contention cannot have been the architect's intention.'"[22] Reverend Peter Delaney, in favor of the faculty: "'The placing of the circular altar directly under the dome will strengthen the feeling of space and engage those who visit and worship around it in Wren's original intention of a community under the dome.'"[23]

These confident yet contradictory assertions about the architect's intention reveal a conflation of planes of judgment presented to the court, with architectural arrangement joined to theological consequence. The aesthetic consequence of the new altar could not be contained within aesthetic judgment. In 1971, Palumbo, as churchwarden, had written to Moore to ask whether, "since the Church and its new altar will be complementary ... you have any preferences for the colour scheme inside the church, i.e. stone colour, white, off-white, etc."[24] Even if (as Ashley Barker reminded the court) "for Wren, the natural beauty of architecture was from geometry," the perception of this natural cause of beauty brought the workings of aesthetic judgment into relation with judgments of purpose, the wholeness of the church as architecture in relation to

the wholeness of the church as congregation.[25] The chancellor certainly was not convinced that Henry Moore's sculpture would complement Wren's church, and he was prepared to refuse the petition for the faculty for the stone altar on that grounds. As the barrister in opposition reminded the court, it was within his discretion to do so if the proposed altar were offensive or unsuitable. The testimony and the cross-examinations had made clear that the chancellor agreed with opponents that the juxtaposition of altar and church was incongruous,

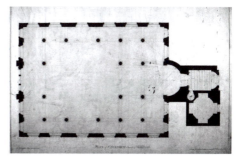

Figure 36. The overlapping configurations of the centralized and longitudinal arrangements can be discerned in this 1793 plan. The entrance to the church is at the right in the drawing. The shallow nave is defined by just two pairs of columns, and the space under the dome is framed by twelve columns arranged in a square. To the left is the shallow chancel where the original altar was located. Alexander Poole Moore, *Plan of St Stephen Walbrook* (1793).

indeed that it was, even if decorum prevented the use of the word, a condition of ugliness. But the chancellor concluded that the decision of the case could not be settled upon the discriminations of aesthetic judgment only, explaining that a crucial doctrinal question preceded the aesthetic concern and that it was a judgment on doctrine that prompted him to refuse the faculty. What was this decisive doctrinal consideration? It was that Moore's sculpture was indeed an altar, and was therefore certainly not a table.

This claim transfers the architectural assessment into an interpretation about theological significance. In the Anglican church, the Eucharist, the rite of communion during Mass in which wine and the wafer of bread are consumed as an enactment of a congregant's communion with Christ, is celebrated in front of an object that is understood as a table and not an altar. Church doctrine may now use the two words interchangeably, but theological understanding distinguishes between them. The chancellor explained it this way:

> The distinction between "altar" and "table," when the words are correctly used, is in itself essential and deeply founded, since "altar" signifies a place where a sacrifice is to be made, a repetition at every Mass of the sacrifice of our Lord at Calvary. This was the view of the Mass as held in the unreformed Church in England immediately before the Reformation, whatever may have been the case in the earliest ages of the Church. The reformers took the other view, viz that the Holy Communion was not a renewed sacrifice of our Lord,

but a feast to be celebrated at the Lord's table. The latter view prevailed, at least from the Prayer Book of 1552, with the result that "altars" were removed from churches and "tables" substituted.[26]

The chancellor ruled that "the marble sculpture [is] not, within any ordinary definition, a table" and that the petition must therefore be refused on the point of canon law.[27] For this ruling, he depended upon a prior sequence of cases heard within the ecclesiastical courts extending back into the early nineteenth century, transferring what had been an aesthetic incongruity, and a judgment about ugliness, into a matter of legal classification and definition.

Temporality and Materiality

The debate over the altar in St. Stephen Walbrook was a debate over aesthetic propriety in the context of perceptions of historical continuities and change expressed through style. Was it proper to introduce this massive stone, primitive, emotionally resonant, into the precise, rational articulations of columns, dome, and surfaces? Would the sum be an increased perfection or a despoiled one? Would the result be a condition of beauty or ugliness? These questions were being posed in London in 1986, at that moment when the kindling of postmodern architecture, political conservatism, patronage, and economic neoliberalism had ignited into front-page controversies. Not far from St. Stephen Walbrook, the new Lloyd's of London building, designed by the Richard Rogers Partnership, had just opened. East of the City, construction was about to begin on the massive Canary Wharf development, while elsewhere in London the Tate's Clore Gallery, designed by James Stirling, and the TV-am building by Terry Farrell and Partners, testified to the unsettled, uncertain state of architectural style. In this context, the debate over the stone altar at St. Stephen Walbrook was a proxy for a larger debate over the confrontation of high modernism and a rising historicism, and the terms of that larger debate had their cognate terms in the ecclesiastical proceedings. For one, the fundamental consideration of whether newness or change represented advance or degradation paralleled the theological question, so crucial in nineteenth-century Britain, of development and perfection, with the former the possibility of mankind's progress toward better states of existence and the latter the conviction that the better state of mankind was prior rather than future.[28] In addition, in a parallel of ecclesiastical adoption of aesthetic concerns, the role of language, the legibility of symbolic form, and the political function of architecture were each among postmodernism's critical points of inflection.[29]

By examining not only their conventional manifestations, but also their appearance in the longer duration and different conjunction of post-modernity that was the case of St. Stephen Walbrook, it may be possible to shift focus from the overt characteristic of style to a question underlying postmodernism: how are appearances of architectural congruity to be understood in the contexts of postmodernity, in which the aesthetic register has been loosened and detached from the supports of its former social and political structures? This circumstance prompts the assessment of not only the congruity within or between architectural objects, but the congruity between historical periods of differentiated stylistic appearance; crucially, it prompts also the assessment of congruity—and incongruity—between separate registers or spheres of judgment, for it is in this distance that ugliness assumes its possible instrumentality, not within the aesthetic but outside of it.

The dispute over the altar in St. Stephen Walbrook proceeded not forward but backward, to the early nineteenth century and another ecclesiastical court case that the chancellor's judgment used as a binding precedent. In 1839, an energetic group of Cambridge University undergraduates founded the Cambridge Camden Society, later known as the Ecclesiological Society, an organization dedicated to what might be colloquially described as the study of churches and liturgical arrangements.[30] (William Butterfield would become one of the group's most accomplished and determined architects.)[31] They were deeply influenced by the Oxford Movement, a group of Anglican leaders who were pressing for the return to what were called "high church" practices, or ritualism. Ritualism carried fraught political connotations because it was understood to veer closely toward the beliefs and liturgical principles maintained by the Roman Catholic Church. For centuries after Henry VIII split from the Roman Catholic Church in the sixteenth century, adopting the tenets of protestant reform to establish the Anglican church, Roman Catholicism met with suspicion and hostility in Britain. Only in 1829 did legislation provide for the "emancipation" of Roman Catholic practice, and even then much antipathy persisted to what was freely denigrated as "Popery." So those who endorsed seemingly Catholic tendencies, such as the return of medieval liturgical practices or the restoration of an atmosphere of mysterious ritual and rich architectural decoration, could encounter vehement denunciations.

For the Cambridge Camden Society such concerns came to a crisis in 1845, with the society's involvement in the restoration of the Round Church (St. Sepulchre) in Cambridge. In only a few years since its founding, the society had established itself as the leading authority on church buildings and so offered its expertise (and financial support) for the restoration of this dilapidated twelfth-century church. Members of

the society served as the committee to oversee all aspects of the restoration, an arrangement that proceeded happily until the incumbent of the parish, Reverend Faulkner, discovered that the existing wooden communion table had been replaced with a new stone table that could too readily be described as an altar. Accompanied by fierce polemics—for example a sermon titled "The Restoration of Churches Is the Restoration of Popery"—the issue of the stone altar quickly entered the ecclesiastical courts.[32] After the Consistory Court granted a faculty for the altar to remain, Reverend Faulkner appealed that decision to the Arches Court, the next higher ecclesiastical court, which represents the archbishop and is presided over by a judge called the Dean of Arches. The dean elaborated three points of inquiry: whether the object in question was to be considered a table or an altar; whether the use of stone for this object was permissible; and whether this object was moveable or set permanently in place. In other words, three registers of analysis, the symbolic, the material, and the functional, with the latter two categories—the materiality and the mobility of the table—inseparably linked to the first, its symbolic form.

To arrive at his decision, the dean proceeded through a comprehensive historical accounting of Church of England canon law regarding communion tables. Before the sixteenth-century Reformation, he reported, Roman Catholic liturgical practice employed an altar, fixed in place on the eastern chancel wall and carved in stone in resemblance of a tomb. During the ritual of communion, the priest would stand facing the altar with his back to the pews. According to reformers, this position could only reinforce a superstitious veneration of the Eucharist as a sacrificial rite in which the bread and wine of communion are transformed in substance into the blood and body of Christ. The reformed Church of England repudiated the doctrine of transubstantiation and its sacrificial emphasis, regarding communion instead as a congregational feast, a celebratory rite in the image of the Last Supper. In order to forestall a congregation's adherence to superstitious belief the reformers called for the altar to be replaced with a table, a table moreover that could be moved out from the chancel into the body of the church, so that the laity would be able to see and understand all the actions of the priest. (Figure 37) Within the mysteries of communion, the aestheticizations of style were to be superseded by a realism of facticity. The change, the dean reasoned, revealed that "something more than the mere alteration of name was intended. It would not have satisfied the purpose for which the alteration was made merely to change the name of altar into table. The old superstitions would have adhered to the minds of the simple people, and would have continued so long as they saw the altar, on which they had been used to consider a real

sacrifice was offered. For these reasons I consider a substantial alteration of the structure was made."[33]

Continuing through his scrupulous historical analysis, the dean determined that the holy table might be either wood or stone (though wood being more common and more suitable), but that irrespective of material the table must not be fixed in place. One of the "superstitious notions that belonged to the Popish mass ... was that it was essential that the altar be immoveable."[34] And so the holy table, in necessary contrast, must be moveable.[35] Its materiality and mobility settled, the symbolic dimension remained: if the change from altar to table held more significance than mere change of nomenclature, then the essential nature of the "table" should be defined in some manner, such that its symbolic resonance might be correctly construed (just as an "altar" correctly construed held the symbolic charge of sacrifice). To resolve this point, the dean reasoned from symbolism

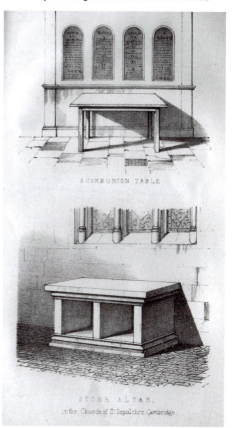

Figure 37. Comparison of a holy table made of wood, above, with the stone altar installed in the Round Church, below. In the words of Archdeacon Thomas Thorp, the chairman of the Restoration Committee, "a specimen of the kind of Altar commonly found in new churches" compared to "the unpretending Altar, now ejected from the Round Church by the Judgment of the Court of Arches."

A COMMUNION TABLE

STONE ALTAR.
in the Church of S! Sepulchre Cambridge

to form, from the symbolism intended to the form capable of fulfilling it. Noting that early canon laws on the sacrament of communion had instructed that "'the bread be such as is usual to be eaten at the table with other meats,'" he asked, "Can the word 'table' mean anything but that table at which meals are usually eaten?" The holy table, therefore, should be "nothing more than an ordinary and decent table."[36] The legible correspondence of language and form completed the framework for his judgment upon the stone altar proposed for the Round Church: "What is the notion that would present itself to any one's mind of the word

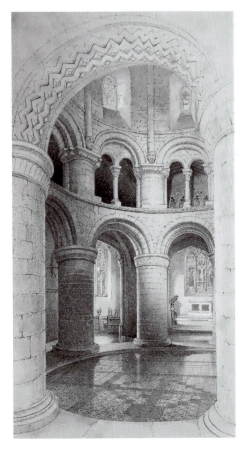

Figure 38. Drawing of the interior of the Round Church immediately after its restoration by the Cambridge Camden Society, with the stone altar visible through the arch at right.

'table,' taken abstractedly. Surely it would not be that of the object now under consideration—a stone structure of amazing weight and dimensions immovably fixed. It is undoubtedly possible, by an ingenious argument, to contend that the present erection is a 'table'; it may be so according to one definition given by Dr. Johnson—'a flat surface raised above the ground'; but that notion would not readily present itself to the mind; such is not the ordinary meaning of this word."[37]

The dean's ruling could not have been in doubt at this point, but one final contention remained to be addressed. The petitioners argued that they had undertaken the renovation with the aim of restoring the "original architectural character" of the Round Church, that is, restoring its Romanesque interior, physically and atmospherically. (Figure 38) With this goal, the petitioners testified, "it became essential, in accordance with such restoration and to preserve the uniformity of the internal arrangements of the said church, that a new communion table, corresponding with such arrangement, should be provided."[38] Reverend Faulkner submitted his rebuttal to this claim: "if the said stone altar ... [is] intended to be in accordance with the ancient design of the fabric of the said church and in uniformity with the original internal arrangements thereof, ... they are of necessity ... such as were and are erected and used in Popish churches, inasmuch as the said church was originally designed and built in Popish times and used for Popish purposes."[39] The dean concurred with the objection (though he was careful to indicate that he did not attribute heretical motives to the petitioners). He stated unequivocally that the

restoration of the physical church to a uniform state could not be taken as a compelling justification for the unorthodox altar: "The Court can never hold that the uniformity of a building, the architectural style of a building, is to be consulted and to be preferred to that which it is the intention of the Act of Parliament to preserve—uniformity in divine service. It cannot sacrifice that great principle to the minor one of the uniformity of the architecture of the church."[40]

Here then was a crucial claim to be carried forward from the nine-teenth-century legal arguments into the twentieth-century debate on St. Stephen Walbrook. The uniformity—that is to say, the consistency or the unity—of a church's architectural style could not be given preference over the uniformity of liturgical practice—the consistency of rituals performed within different Anglican churches. Liturgical consistency had been de-fined by the parliamentary Acts of Uniformity, legal measures designed to constrain interpretation, idiosyncrasy, and, above all, unorthodoxy. Of course, no similarly binding legal measure pertained to architec-tural form and decoration, but in returning to the case of St. Stephen Walbrook, the phrase if not the instrument—acts of uniformity—might be appropriated in order to propose the idea that congruity should be understood not as an inherent quality, but as a condition that is produced, that is forged by the encompassing framework of an act of uniformity. In other words, the incongruity perceived by opponents to be the cer-tain result of the introduction of the Moore altar into Wren's architecture arose from the framework of judgment within which these objects were set, and this framework of judgment might set the terms of uniformity to be applied to both aesthetic and theological objects. The judgment of ugliness in this case would not be a judgment of appearances—incongru-ity as a discomfort, an unsuitedness, a contradiction—but a judgment of consequences—incongruity as impropriety or ineffectiveness.

Language, Ambiguity, and Ugliness

In early 1986, the chancellor of the Consistory Court had refused to grant a faculty to admit the altar designed by Henry Moore into the church designed by Christopher Wren, having judged that the incongruence be-tween the two was so certain that the installation of the altar would spoil the spatial perfection of the church, and that the altar could not in any event be permitted because it did not meet the canonical requirements for a holy table. The rector Chad Varah and his churchwarden chose to appeal this decision. Normally the appeal would be heard by the next higher ecclesiastical court, the Arches Court, but in this instance, because the chancellor determined that the case turned on a point of doctrinal interpretation, the appeal was heard directly at the highest juridical level,

in the Court of Ecclesiastical Causes Reserved (CECR). Created in 1963, the CECR assumed what was the former prerogative of the Privy Council to settle doctrinal disputes.[41] Though in existence for nearly twenty-five years, the court had convened only once before, so rare were the issues it addressed.

In reviewing the St. Stephen Walbrook appeal, the five judges of the CECR made clear the unencumbered juridical position of their court. According to its founding legislation—which might itself be understood as a marker of postmodernity—the CECR was not bound by the precedent of any prior decisions of the Privy Council: "This court is therefore free to consider the issues afresh, taking account of more recent legislation and historical and theoretical knowledge which was not available to the courts in the mid-nineteenth century."[42] Nor was the court bound by declarations of the Arches Court, an important distinction because that lower court had set a number of judgments regarding alterations to listed churches, protected, like St. Stephen Walbrook, by civil preservation statutes. The Anglican church had long held statutory exemptions that recognized the priority of theological function over preservation, but over time the Arches Court had built a standard of judgment that emphasized the proof of theological necessity to justify changes to listed churches.[43] Not bound by precedents in the Arches Court, the CECR did not adopt its standard.

Reviewing the chancellor's decision, the judges concluded that because the expert witnesses for both sides had presented judgments of an aesthetic rather than technical nature, the "opinion of either [side] on the issue of congruity could [not] be shown to be right or wrong in any relevant sense."[44] Nevertheless, they were surprised the Chancellor had given such slight regard to some testimony, that of Kerry Downes in particular, given his scholarly authority on Wren. They themselves highlighted and quoted Downes's careful definition of "ambiguity" as an aspect of architectural experience: "By 'ambiguity' [the witness] meant—'the possibility or even the inevitability of a particular group of components being readable in more than one way with differing sense.'"[45] Though this appreciation of ambiguity is unremarkable as a point of architectural historical emphasis—especially in 1986—an ecclesiastical court might be expected to have found ambiguity to be less than desirable, at least to the extent that it muddled an underlying theological uniformity. What this moment of judicial elucidation then reveals, perhaps, is that to recognize the appearance of ambiguity was also to discern the tenuousness of architectural or theological congruity, and that the court's inquiry into ambiguity signals its effort to formulate an understanding of congruity adequate to and effective within the dislocations, the ungroundedness, of postmodernism. To wrestle with the possible judgments of ugliness

was precisely to occupy this uncertainty in the effort to discern what purchase an aesthetic quality or an aesthetic judgment might have upon the social dimensions of theological thought and practice in the late twentieth century.

The crucial question remained, whether or not the stone altar could be accepted as a holy table within the canons of the Church of England. The chancellor had decided that it could not, using the case of the Round Church as a forceful precedent. He acknowledged that twentieth-century canon law revisions had clarified that a holy table could be made of stone, and could also be immoveable, but he still regarded the "reasoning" of the 1845 ruling to be "binding," and therefore that the essential factor was the "table-ness" of the object: "the holy table in the church must still be a table."[46] "What is the connotation of the word 'table'?" the chancellor had asked, answering that "it must be construed in its ordinary sense," endorsing the definition provided by the *Shorter Oxford English Dictionary* and setting as his test the likelihood that any observer would look at the altar and recognize it as a table. Regarding Moore's sculpture, he found that "it seems difficult to suppose that an ordinary educated speaker of the English language would say, 'That is a fine table' or even 'That is a table.' On this ground I am of the opinion that this petition must fail, not as a matter of discretion, but of law."[47]

The CECR judges had little patience for his seeming certainty. As one judge put it, "I did not find it easy to follow the philosophical argument concerning the concept of 'tableness.' I find myself in sympathy with Dr Johnson's definition of a table as 'A horizontal surface raised above the ground, used for meals and other purposes,' and I prefer this to the definition in the *Shorter Oxford English Dictionary* on which the chancellor relied.... I have no doubt that the Henry Moore altar falls within the wide bounds of what can be reasonably called a holy table."[48] Apparently suspicious of the claim of the transparency of language, this judge was endorsing instead a compensatory breadth of definition. On these grounds, the Court of Ecclesiastical Causes Reserved reversed the chancellor's decision and granted the faculty for the stone table to be installed in St. Stephen Walbrook.

A visitor to Wren's church today will climb the stairs, pass through the vestibule, and find Moore's altar standing immovably below the dome. (Figure 39) With its strongly contoured sides a semblance of erosion, and with the surrounding architectural elements forming a rigid geometric frame, the altar conveys an echo of Wood's measured drawings of the standing stones at Stonehenge. (see Figures 3–5) It is easy to imagine a drawing for St. Stephen Walbrook similar to those from Wood's survey, with an irregular form set within the precise lines of a ruled boundary. Neither drawing represents an ugly object, not in any absolute sense, but

Figure 39. The stone altar installed at St. Stephen Walbrook at the center of the circular arrangement of pews. The artist Patrick Heron designed the kneeling cushion for the footpace in 1993, after the faculty for the altar had been granted.

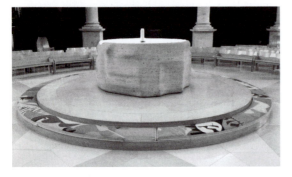

each captures a possibility for a judgment of ugliness. The participants in the altar debate at St. Stephen Walbrook did not make explicit reference to ugliness, nor did their ecclesiastical predecessors, but as Summerson's interpretation of Butterfield suggested (in agreement with the propositions David Hume put forward two centuries before) ugliness may be the situation that encompasses an object more than a quality of the object itself.[49] Occurring when it did, in 1986, the debate over St. Stephen Walbrook participated, unobtrusively perhaps, but participated nevertheless, in discursive challenges being staked in the confrontation of late modernism and a newly championed historicist postmodernism. To argue about ambiguity, to argue about symbolic form and legibility of meaning, to argue about precedents and about language and its transparency—surely this was to argue in the very terms being deployed in surrounding debates about postmodernist architecture in London and elsewhere in Britain.

Yet in the case of St. Stephen Walbrook, these arguments took place not on the pages of architectural journalism but in the space of the law, a distinctive space of judgment in which the terms of architectural thought assumed different valences, different associations, different temporalities. The space of law, and in this instance the more particular space of ecclesiastical law, stands aside (though not in isolation) from the currents of adjacent social or political endeavors. The fact of jurisdiction marks this apartness and affirms the application of privileged frameworks of interpretation and procedure; the adversarial process emphasizes conflicting evaluations of meaning and consequence, while the delegated sovereignty of the judge locates and constructs the authority of decision; and the requisite regard for precedents, as in common law generally, persistently collapses prior and present historical moments. Rather than isolating

the independently motivated development of architectural practices and theological practices, ecclesiastical law sets the interactions, the frictions, between architecture and theology as the actual object of inquiry.

In the case of St. Stephen Walbrook, this friction appeared as the concern for ambiguity, a concern that did not suggest a blurring of boundaries so much as the coexistence of multiple well-delineated boundaries of congruity. If Wren's architecture is the object circumscribed by a boundary, then ambiguity manifests in the congruities within his complex design; if Moore's sculpture is the bounded object, ambiguity manifests in the congruence of the stone and sacramental ritual. But when Wren's architecture and Moore's sculpture are considered together within a boundary of judgment, then ambiguity has a different significance, and congruity also, because not only their present appearance but their past and future significance must be accounted for within the boundary. The case of St. Stephen Walbrook evidences that the production of such a boundary, or horizon of congruity, is the essential task undertaken by acts of uniformity, whether they are institutional and legislative, or contingent and aesthetic, or as we have seen here some amalgam of the two. It is such acts of uniformity and their attempted juridical reconciliations that give deeper substance to the visible incongruities of postmodernism, and it was a judgment of ugliness that prompted the need for such reconciliations to be attempted.

At what point does the huge stone at the center of the church become ugly, or become a prompt for a judgment of ugliness? In its raw state, when it has not yet been presented as an object of aesthetic regard; or when sculpted into cylindrical shape with irregular hollows along its sides, when it may be judged for form, color, effect, and presence; or when it is given the designation of altar and placed into an architectural setting? The question can be addressed to the previous examples as well, to the stone cut from the quarry and set into the fabric of a building to be decayed by the atmosphere that encompasses it, and to the concrete given coarse textures and board markings, arranged into irregular forms and left in its unadulterated grayness. In none of these is ugliness an inherent quality, essential to the object. In each, ugliness is a category of assessment, manifest in different terms such as nuisance, irritation, or incongruity, for which stone is the prompt rather than the conclusion. The judgments arise initially as aesthetic judgments, but are in each case also social, collective rather than individual, and catalyze the constitution of some aspect of communal civic life. From the controversies precipitated by architecture—and therefore from aesthetic beginnings, or with aesthetic influence—and from the judgments that follow emerge social instruments that participate in the maintenance of the city, the definition and redefinition of norms, and the regulation of change over time.

Persons

The Architect

On September 30, 1812, the *Morning Post* published a letter from a reader identified as "Ambulator," who wrote to complain of a "nuisance" he had encountered: "I presume you have not lately passed through Lincoln's-inn-fields, otherwise I think you would have animadverted on a new-fangled projection now erecting on the Holborn side of that fine square. This ridiculous piece of architecture destroys the uniformity of the row, and is a *palpable eye-sore*."[1] The ridiculous eyesore was the facade of 13 Lincoln's Inn Fields, the home of the architect Sir John Soane. Soane, who was in the midst of transforming the interiors of his adjacent townhouses, had begun to construct a projecting stone structure—portico, loggia, and balcony—that covered the three bays of the facade and rose to a height of three stories, creating a startling contrast with the flat and unadorned brick facades of the flanking terrace. The idiosyncratic gesture was noticed in the press, and by local authorities; a second letter to the *Morning Post* published a few days after Ambulator's advised the editor that "a *multitude* of other persons" had complained of the extraordinary ornamented facade that disrupted the uniformity of house fronts, and that the district surveyor, judging it to contravene the Building Act, had "lodged an information against the unsightly projection" with the local magistrates.[2] (Figure 40)

The district surveyor, William Kinnard, had indeed advised Soane that the projection violated Statute 14 George III, cap. 78, commonly known as the Building Act, which prohibited enclosed projections to extend beyond "the general line of the fronts of the houses" on a street.[3] In their accounts of the case, heard before the magistrates at the Public Office in Bow Street, the *Morning Post* and the *Sun* reported that Kinnard

prised that those possessing requisite powers have suffered such a nuisance to be built.

"I am, sir,
"Yours, &c.
30th Sept. 1812. "Ambulator."

If we might advise, and we believe every *oculist* in the kingdom will agree with us, this *palpable eye-sore*" should not, as we say in our motto, *be touched.* However, so it is, that to *inflame*, rather than to *cure*, this said *eye-sore*, the ghost of a *modern Grecian* is *raised*, by which we mean to indicate that the fiery spirit of Inigo, the first architect who planned and ornamented *Lincoln's-inn-fields*, and who saw every object through *Grecian spectacles*, is doomed again

"to walk by day"

in the place adverted to, where, instead of admiring, as we have done, the classical interior of the attic mansion of Mr. *Soane*, he, forgetting that he once joined in matrimony in the chapel at *Somerset-house*, a lovely *Corinthian virgin* with a *Goth*, thus expresses his indignation against its elegant exterior :

To the Editor of the Morning Post.

"sir,

"Your correspondent Ambulator will, I dare say, be gratified to learn that one of the district surveyors has lodged an information against the unsightly projection in *Lincoln's-inn-fields*, of which he, in common with a *multitude* of other persons, complains. The case is to be argued by counsel on both sides at Bow-street on Tuesday next.

Oct. 2, 1812. "Inigo's Ghost."

The exhibition of the information against the builder of the projection mentioned in the last epistle, produced in a few days the following article :

Morning Chronicle, Oct. 13, 1812.

"Yesterday a case of considerable importance to the inhabitants of *public squares*, and who occupy areas enclosed by iron railing before their houses, occurred at the Public Office in Bow-street.

"An information was laid by Mr. Kinnaird, in his official character of district surveyor, against a projecting

on any person annoying the said field, or houses therein ; 50l. penalty on encroachments ; and 40s. on unlawful assemblies, &c.

Europ. Mag. Vol. LXII. Nov. 1812.

building in Lincoln's-inn-square, extending beyond the general line of the fronts of the houses, now constructing by Mr. Soane, the architect.

"The case was well argued by Mr. Wetherall and Mr. Const, in support of Mr. Soane's structure. The magistrates, Mr. Read and Mr. Nares, gave it as their opinion and judgment, that the proprietors of houses may lawfully build as far as the iron railings in the front of their respective areas.

October 13, 1812.

To the Editor of the Morning Post.

building projections.

"sir,

"As the magistrates of Bow-street have decided that Mr. Soane has a right to run out a projection beyond the line of the houses in Lincoln's-inn-fields, adjoining his own, his neighbours on the same principle may do the like ; I would, therefore, advise them to run out a partition on the side next Mr. Soane's new erection, and to the same height, or even to carry it out beyond that annoyance, so as to enclose the new front on each side, and give it the appearance of a large centry-box.

"Yours, &c.
Oct. 14, 1812. "Inigo's Ghost."
P.S. It is to be regretted that no counsel attended on the part of the prosecutor.*

The Sun, October 15, 1812.

"Bow-street. — An information having been laid at this office by Mr. Kinnaird, against a building erected by Mr. Soane, in Lincoln's-inn-fields, in consequence of a projection in the front of the said building, extending three feet six inches beyond the fronts of the adjoining houses ; the cause was tried before Mr. Read and Mr. Nares.

"Mr. Kinnaird produced one witness (from a number whom he had summoned, but did not attend) to prove that the projection was contrary to the Act, not coming within the exceptions of shop-fronts, &c. which was admitted by Mr. Const, on the part of Mr. Soane. He contended, that if this had been actually a common nuisance, it would not be under the jurisdiction of the magistrates to order it to be pulled down, as they had no power to enter on the freehold property of Mr.

* The preceding letters were all written by the same person, although palmed on the public as the production of different writers.
3 D

represented the facade as a public nuisance, to which Soane's counsel replied that the work could in no way be considered a public nuisance, as it did not extend past the line of Soane's freehold, the line of his property, which lay several feet beyond the projection. "A common nuisance must be that which deprives the public of some advantage, or puts them to some inconvenience," he argued, but this could not be the case at 13 Lincoln's Inn Fields, where the public was not permitted to enter Soane's freehold and thus was never in proximity to the facade.[4] (Figure 41) To further his defense, Soane's counsel introduced models of other buildings

Figure 41. The controversial facade of 13 Lincoln's Inn Fields, with its projecting portico and loggia. The railing in the foreground shows the boundary of Soane's freehold, which he had purchased in 1807.

on Lincoln's Inn Fields that had included similar projections without legal censure. Kinnard's attempt to distinguish the permissibility of these examples failed, and the magistrates ruled in Soane's favor. Kinnard appealed the magistrates' decision to the King's Bench, where the presiding judge Lord Ellenborough refused to grant an appeal because the district surveyor was not himself "aggrieved" by the magistrate's decision—that is, he did not suffer any private harm from it—and was therefore not entitled to be heard.[5]

This case was evidently of considerable interest, probably as much for its relevance to property owners throughout London as for Soane's celebrity; the *Sun* noted that the "cause excited great anxiety and curiosity in the minds of many professional men of eminence who attended, and who seemed unanimously to applaud the decision."[6] Even though it received legal approbation from the court, and perhaps the endorsement of spectators at the trial, the facade of 13 Lincoln's Inn Fields could still be, and was, regarded by the public that passed by or that read descriptions of it in newspapers as a curiosity of private taste. The attention now drawn by this seeming transgression solicited a justification independent from that required by law, but one that maintained a comparable emphasis on the distinction of public and private realms. The public aspect of Soane's house, its conspicuously assertive facade, could be sanctioned by law only because of its status as private property; it was not public, did not physically intrude upon the public, and could not therefore be a public

nuisance. It did, however, intrude upon the aesthetic attention of the public by its visibility and its idiosyncrasy. The justification of this intrusion lay in the singular imagination of the architect, whose private precinct of artistic creation was, like the physical building, removed from yet fully present within the public sphere. The publicness of Soane's house and the public notice it engendered projected this embodiment of architectural thought into the public sphere while simultaneously withholding it as a private entity.

The irrevocable projection of the architect's palpable eyesore into the public realm would occur two decades later when the House of Commons approved the private act of Parliament bequeathing Sir John Soane's house to the public as a museum. It was Joseph Hume, MP (a few years prior to his crucial intervention in the rebuilding of the Houses of Parliament) who presented the case for accepting this "noble and disinterested" gift to the nation.[7] Prior to the final reading and vote, the members of the House of Commons debated for the better part of an hour the legality and morality of Soane's donation, raising implicit and explicit questions about Soane's private character and his public reputation. Despite Hume's endorsement, some members of Parliament found fault with the donation, questioning the propriety of alienating his descendants from the property they might have inherited; other members then stood to rebut various aspersions upon Soane's motives. The house and its idiosyncratic architecture, the debate suggested, were a proxy for Soane's private character. Ultimately, with Soane's reputation successfully defended, the Soane's Museum Bill entered into law as private Act, 3 William IV, cap. iv. With the strict stipulation that the house and its contents be preserved in their arrangement and condition upon Soane's death, the palpable eyesore of Lincoln's Inn Fields became the real property of the public.

Libel

The London in which Soane resided offered countless venues for production and exchange of opinions; there were streams of correspondence to circulate news and gossip, which then made their way into personal diaries, pamphlets, or journals; there were debates and lectures, staged in drawing rooms and coffee houses, academies and Parliament. During the years of Soane's architectural career, talk in all these forms was the medium of "publicity," a word coined at the end of the eighteenth century to describe the condition of entering into the public sphere and being rendered an object of public attention.[8] At that time, dozens of different daily, weekly, and monthly newspapers and journals constituted the London press, the most popular of which had circulations in the thousands. Although limited to an educated and reasonably affluent readership,

they wielded a powerful influence with an amalgam of political commentary, literary reviews, artistic criticism, legal reports, financial data, and society affairs that, taken together, produced a constantly changing rendering of publicity and reputation. Soane himself not only read these publications—he subscribed to the *Examiner, Gentleman's Magazine,* and *European Magazine,* among others—but appeared in them as well. His name can be found in the pages of the *Morning Post, Morning Chronicle, Examiner, Literary Gazette, Times, Sun, True Briton, Champion, Guardian,* and *Observer.* His attentive and persistent interest in these media is apparent in twenty-one scrapbooks in which he compiled newspaper clippings about himself and other favored topics.[9]

Not all of the attention offered by these publications was favorable. On October 16, 1796, the *Observer* published a short poem with a comment that its anonymous verses delivered a satire "so just as to obtain for them a place in the *Observer.*"[10] Titled "The Modern Goth," this poem had circulated as a printed pamphlet several months earlier after first being read aloud at a meeting of the Architects' Club, a sociable professional club of which Soane was a founding member and in which frequent and vociferous disputes had perhaps set a precedent for what amounted to a quite public derision. The poem's rhyming couplets sarcastically praised Soane and his new designs for the Bank of England. Belittling comments on his diverse architectural practice—"Glory to thee Great Artist Soul of Taste / For mending pigsties when a plank's misplaced"—were set alongside hyperbolic epithets deriding the peculiarities of his architectural style and its interpretive development of classical precedent by noting its "pilasters scor'd like loins of pork" and seeing its "order in confusion move / scrolls fixed below and pedestals above." The poem ended with the succinct advice: "In silence build from models of Your own / And never imitate the Works of Sxxne."[11] The poem, once published and circulated in this manner, presented a public criticism, quite scathing in its tone, of the outward appearance and aesthetic consequence of Soane's architecture, and sneering at what it regarded as his pretensions to taste. (Figure 42) Satirical poems aimed at prominent figures were common currency in political and literary exchanges, and "The Modern Goth" employed their typical devices: ironic classical allusion, mocking praise, and the judicious use of innuendo by the elision of letters from Soane's name in the final line of the poem. These elements were of crucial importance, for satire often met with the equally common response of a suit for libel, and the strategy of innuendo could allow an author to evade the charge.[12]

During the course of the eighteenth century, instances of libel had been given greater prominence by the increase in published materials and by the intensity of partisan debate, and legal standards for libel soon accommodated the entire range of public discourse from political

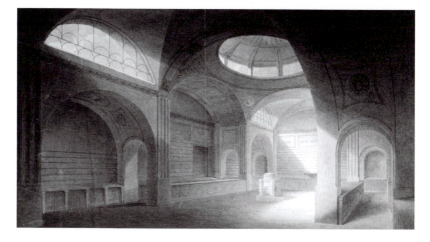

Figure 42. Soane's design for the Bank Stock Office in the Bank of England, with its incised ornamentation, profusion of vaults of several different types, and original interpretation of classical models, was one example of the architectural novelty derided by the author of "The Modern Goth." Joseph Michael Gandy, presentation drawing of the Bank Stock Office (June 7, 1798).

dissent to critical reviews. Libel could be charged as a crime or as a tort, and while criminal prosecutions drew much attention, the law courts heard civil suits with considerable and increasing frequency. Common law permitted an evolving conception of libel, without fixed or statutory definition, based upon two constituent criteria: defamation and publicity. Defamation was an injury to an individual's reputation, which was considered a legal right: "The common law [protects] the good fame, as well as the life, liberty, and property of every man—It considers reputation, not only as one of our pure and absolute rights, but as an outwork which defends, and renders them all valuable."[13] Because only a defamation conveyed to a third party could provide cause for libel, a claim also required evidence that the injurious statement had been published, that it had, even in the most circumscribed sense, been made public. Even with these criteria, though, the changing circumstances of media and the mutable nature of common law would have meant that a critical statement such as that directed at Soane could not definitely be known as libel prior to the presentation of legal arguments.

Soane's designs for the Bank of England, an institution of enormous civic and political importance, could hardly have avoided exciting public comment, particularly in light of their disregard for prevailing architectural conventions. Though a private institution, the bank, due to its

issuance of the national debt, occupied a central role in the governance and political economy of Great Britain. Soane's design for its enormous building in the City of London bore the responsibility of national representation, a responsibility that likely accentuated the severity of the poetical critique.[14] Soane chose not to ignore the satirical attack. Nor did he rebut it with a satirical response of his own, a common enough strategy but difficult in this instance because the actual author remained anonymous. Nearly three years passed before he could act, but in 1799 Soane began legal proceedings against surveyor Philip Norris, whom he named as the "Publisher" of "The Modern Goth" and a second, equally disparaging poem. (Figure 43) With the encouragement of his legal counsel, Soane submitted to the Court of the King's Bench a brief that, emphasizing the "scandalous, malicious, inflammatory" nature of the works, asserted that the defendant intended "to prejudice, vilify and disgrace the said J.S. in his profession and to injure his fame, credit and reputation."[15]

Under prevailing law, civil prosecution for libel could proceed against published statements about an individual that either impaired his position in society by holding him up to public "scorn and ridicule" or that had "a tendency to injure him in his office, profession, calling, or trade."[16] Soane's brief aimed precisely at these two standards, claiming that the satirical poems were deliberately intended to embarrass Soane publicly and to damage his professional reputation, as the nature of their publication demonstratively proved:

> We may fairly assume that [Soane's designs] could have been attacked in a more serious way than by an anonymous publication of an abusive poem. All public disquisitions on the subject ought to be fair manly candid criticism, and not be holding a man up as an object of scorn and ridicule, to hunt down in his profession and degrade him in Society. In the first stated libel the language is ransacked for terms of scorn and derision, and Mr. Soane is held out to the Public as a man who has disgraced his Country.... As the censure is general the reader is left to presume that the work is execrable in toto.[17]

During the trial, Edmund Law, the counsel for the defense (who would later, ennobled as Lord Ellenborough, hear the case of 13 Lincoln's Inn Fields), argued that although Soane was indeed an "Architect of great merit," the bank failed to exemplify his talents. Law proceeded to recite the poem line by line, substantiating each of its stinging slights with a comment on Soane's design. He aimed to demonstrate that the satirical lines criticized specifically the architecture of the building, concluding that "as a public work, in which the national taste was to some degree involved, criticism ought to be entirely free upon it"; the bank was a "public

performance" that, given its flaws, was a reasonable "subject of criticism, and even ridicule, provided that it was done in a fair, and manly, way."[18] Both parties emphasized the nature of the criticism—whether it was fair, manly, or candid—rather than its content, because the motivation of the defamatory statement would be evidence of libel, especially in a case where the truth or falsity of the libel could not be definitively asserted. In the case of "The Modern Goth," whose very title was an accusation of barbarism, the distinction was measured upon an aesthetic plane, with verses that constructed parallels of architecture and personality: "Come, let me place thee in the foremost rank, / By Dulness, fated to deface the Bank; / By him, whose dulness darken'd every plan, / Thy style shall finish what his style began." Was the intention of such lines to dismiss the architecture or to denigrate Soane? The judge admitted in his instructions to the jury "that architecture and all the other arts … were the subjects of fair criticism," but he advised that the jury consider "whether that might be done … in a Poem, that was to hold up a man to ridicule all his life long."[19] Viewed in a broader perspective, it was up to the jury to consider the liabilities of two accusations of ugliness, one being the claim made by the verses that the architecture of the Bank of England was ugly, the other being the claim of Soane's brief that the public scorn and ridicule was itself ugly. The jury's subsequent half hour of deliberation and verdict of not guilty dismissed Soane's libel suit and settled the proceeding in favor of the permissibility of the aesthetic critique of his architecture.

But "The Modern Goth" episode would prove to be only the first of Soane's encounters with defamatory publications. Critical letters, pamphlets, and reviews were attendants to his celebrity, and recourse to law became his instinctive response. During May and June 1821, three essays appeared in the *Guardian*, then a new weekly journal in which a correspondent referred to Soane and other architects by name in a

promised indictment: "We have arraigned the state of contemporaneous Architecture, and unfortunately we have ample evidence to make out our case."[20] He attacked Soane directly, deploring the "vapid" and "uninteresting" designs submitted by the architect to the annual exhibition at the Royal Academy. Since Soane's exhibits were "the Atlas of the Architectural fame of the Academy," the author insisted, "No exertions should be spared to check the adoption of his manner. It is the most pernicious and vitiated. Nature, common sense, propriety, simplicity, are all immolated to his idol, Novelty."[21] Soane responded at once, attempting to discover the identity of the author and consulting acquaintances on the advisability of bringing suit against the *Guardian*. Two of Soane's close friends recommended that he ignore these scurrilous attacks in order to avoid drawing further attention to the articles. One advised that he was "only paying the penalty, which all Public men are liable to, and which eminent, and successful men in particular, have always paid," while the other, John Taylor, the editor of the *Morning Post* and the *Sun*, worried that the uncertainties of libel law would require Soane to prove the injury to his reputation by demonstrating that actual commissions had been lost, a burden of proof he could not meet. Obviously familiar with the legal criteria of libel, Taylor advised Soane "to treat it with contempt," for if Soane were to lose, as in his first suit for libel, the publicity would compound the original insult.[22]

Very likely, the courts would have considered the *Guardian* commentary to fall under the category of criticism—critical commentary upon artistic works. Aesthetic criticism had long accompanied architecture and the arts, of course, but the dramatic increase in daily or weekly mass circulation newspapers and journals had fostered an equally dramatic increase in the quantity and timeliness of aesthetic criticism, which was eagerly consumed even or especially by readers who would not themselves encounter the buildings, artworks, plays, or books under critique. By the time the *Guardian* essays appeared in 1821, these critical commentaries on artistic work could not be cause for a libel action, even if they did occasion some loss of reputation. This principle had been set forward as legal precedent only several years earlier, in 1808, by a prominent libel case, *Sir John Carr v. Hood and Sharpe*, which heard an author's claim against booksellers who had published a pamphlet satirizing his works. The judge for the case was none other than Lord Ellenborough, serving as chief justice. In *Carr v. Hood*, he stated in his charge to the jury that all artistic works placed before the public were susceptible to "fair and candid criticism, which every person has a right to publish, although the author may suffer a loss from it. It is a loss, indeed, to the author; but is what we call in law *Damnum absque injuria*; a loss which the law does not consider as an injury, because it is a loss which he ought to sustain. It is,

in short, the loss of fame and profits, to which he was never entitled."[23] The only restraint against such criticism, albeit one that Lord Ellenborough firmly asserted, was that it not deride the personal character of the author, except insofar as he "embodied" himself in his work.[24] The law, in other words, distinguished between character and reputation, the former being the private moral composition of an individual and the latter his public representation, which was, at least in the case of an architect, artist, or writer, subject to public judgment. Lord Ellenborough went on to assert the positive value of such criticism in identifying and suppressing undeserving artistic productions: "It prevents the dissemination of bad taste, by the perusal of trash; and prevents people from wasting both time and money."[25] Here Lord Ellenborough was recapitulating a point he had formulated in 1799 as defense counsel in Soane's action against Norris, where he had argued that "ridicule, while it was applied to public works ill executed, was of admirable use to mankind; for it operated to keep in the shade unmeaning dulness, instead of her coming forward with her languid spirit and shapeless figure to obtrude herself among the Muses and the Graces."[26]

The *Guardian* correspondent endorsed this view of the role of criticism; in his third essay he acknowledged without regret that his comments had "given mortal offence" and inserted implicit references to Soane as he denounced the threats of prosecution for libel that had followed his first installments. "To those who, in the pride of their reputation, or in the confidence of their wealth, boldly and unceremoniously talk of *disarming Criticism by indictment*, we hold a very different language.... That anyone who has gone 'right onwards' to wealth and honor, doubtless with a large assistance from the panegyric of the press, should talk, not of argument, but of *prosecution* when criticism dares to be what it ought, to think for itself, and to speak boldly, whether its object be an R.A. or one unknown to Fame ... this, indeed, is monstrous."[27] No legal claim, he continued, may be made against honest criticism "which abstains from *personal* insults, and forgets the *man* while it condemns the *Artist*"—a careful distinction that revealed the author's awareness of the relevant legal standards.[28] The critic would not submit himself to a court of law, but only to the same tribunal of public opinion in which he had arraigned the architects: "If we are prejudiced, arrogant, unjust, and ignorant, the public will decide against us.... We laugh at the threats about prosecution; and the public shall laugh too, when we discover a serious attempt to set up attorneys and special juries into 'arbitri elegantiarum' in the last resort."[29] Soane apparently conceded this aspect of his critic's argument and turned to the medium of the press to submit his own case to the public. Two letters that, given John Taylor's proprietorship, must have been written with Soane's assistance or consent soon appeared in the *Sun*. The

first condemned the *Guardian* critic for his ignorance of architecture and the inconsistency of his arguments, which were inexplicable and unconvincing in light of Soane's "acknowledged eminence" and "most intimate and extended knowledge of his art."[30] The second reproached another journal, the *Magazine of Fine Arts*, for approving the "impudent and malevolent" *Guardian* essays as informed and impartial.[31] This epistolary defense placed less emphasis on the rebuttal of architectural discernment and more upon the unassailability of Soane's professional stature; it emphasized, in other words, the persona over the embodiment.

The publicity surrounding the *Guardian* essays subsided, but the episode was not Soane's last encounter with scurrilous publications or with the pursuit of libel claims. On June 12, 1827, the Court of the King's Bench heard the case of *Soane v. Knight*. Soane, apparently against the advice of counsel, had brought a charge against the publisher of *Knight's Quarterly Magazine* for printing three years earlier a lengthy satire of Soane titled "The Sixth, or Boetian Order of Architecture."[32] Like "The Modern Goth," this new satire mocked the novelties and idiosyncratic aspects of Soane's architectural work, sarcastically categorizing them as a Boetian Order (a reference to the classical characterization of the inhabitants of Boetia as a dull and foolish people inferior to their Athenian counterparts) on account of disproportion of columns and pilasters, discordance of parts and whole, and hanging arches "miraculously suspended by the back, like the stuffed crocodile on the ceiling of a museum."[33] Following arguments, the recitation of the offending essay, and the judge's instructions, the jury "immediately" found for the defendant. Given the legal standards outlined in the previous incidents, the verdict could not have come as a surprise. Soane's counsel attempted to portray the public ridicule of the satire as evidence of the critic's "private pique and malice," but the counsel representing the defendant responded by citing Lord Ellenborough on the permissibility and importance of aesthetic criticism and the idea that such criticism tended to the improvement of society by raising up works worthy of acclaim and exposing those deserving of ridicule.[34] "It was," argued the defense counsel, "the undoubted right of the press to endeavour to correct the public taste, and to explode by argument or ridicule all false notions and erroneous works," and this regulatory function was all the more vital in the case of an architect, "whose works, like his materials, are lasting, and who covers a metropolis with them."[35]

Adding to the obvious injuries inflicted on Soane by the trial—the evidentiary recitation of the libelous text and its reproduction in newspaper accounts, and of course the failure to win a legal defense of his reputation—was the fact that the proceedings were held in a building of his own design, the New Law Courts at Westminster Hall. (Figure 44) During the construction, Soane had already endured the examination

Figure 44. A plan drawing, partly by Soane himself, for the design of the new Law Courts at the Palace of Westminster. Soane Office, *Sketch of a Design for part of the New Law Courts at Westminster* (ca. 1822–30).

of his design by a parliamentary Select Committee convened to question his decision to append a neoclassical front to the existing gothic fabric. He was ordered to demolish part of the work already under way and provide a more congruous addition. Soane defended himself with a report submitted to the House of Commons that outlined the many checks upon his work, but this only furthered the extensive accounts that appeared in newspapers about the affair. During the 1827 libel trial, Soane had to hear the opposing counsel's superfluous addition of his own animadversions upon the design of the Law Courts: "With all respect to Mr. Soane, I confess that I do really think that he has made a mistake in these courts of justice ... I assure you I was nearly killed in the passage in getting into the court, so ill-contrived, as I think, are the passages."[36]

Through the decades-long course of Soane's several encounters with aesthetic commentary, the judgment of ugliness enacted a precipitating role rather than a concluding one. His career included successes and failures, and no one of the critical judgments had a fatal repercussion, but they precipitated a sequence of differentiations and identifications bringing the aesthetic register into new relations with circumstances outside of architecture. By prompting what was ultimately a detour through the institutions of the court and through the changing mechanisms of libel law, the judgment of ugliness led to the distinction or separation of aesthetic criticism, to its depersonalization, in a direct sense, and therefore allowed for its layering onto other planes of social transaction, such as the professional or the political. A judgment of beauty, of course,

Figure 45. Newspaper report of a case for the prosecution of a libel against the memory of the late Caroline Lady Wrottesley, one of many reports on libel cases preserved by Soane in his scrapbook of newspaper clippings.

COURT OF KING'S BENCH—SATURDAY.

LIBEL ON THE TANKERVILLE FAMILY.

THE KING v. WEAVER, ARROWSMITH, AND SHACKELL.
This was a criminal information filed against the defendants, the printer and the two proprietors of the *John Bull*, a weekly newspaper, for a libel on the memory of the late Caroline Lady Wrottesley. The cause came on to be tried before the Lord Chief Justice, at the Sittings after last Term, at Guildhall, when the Solicitor-General, on the part of the defendants, consented to a verdict of Guilty being recorded against them.
Mr. Dealtry, the Clerk in Court, was about to read the information setting forth the libel, when
Mr. SCARLETT interposed, and said this would not be necessary, as the libel was fully disclosed in the affidavits upon which the criminal information had been obtained, and which would be again submitted to their Lordships.
The affidavits in question were then put in and read. They were three in number. The first was from Sir John Wrottesley ; the second from the Countess of Tankerville ; and the third from Lord Ossulston and the Hon. Grey Bennet.—
The following are copies :—
" Sir John Wrottesley, of Wrottesley, in the county of

would not have prompted any such recourse to law or seeking of remedy; it was the serial assessments of dullness, distaste, disproportion that pressed the aesthetic toward the legal and thence toward the social. Soane's scrapbooks of newspaper clippings give palpable evidence of his concern for, and his attempt to bring to bear some personal control over, the public sphere made concrete in the ever-accumulating pages of newspapers and journals. The scrapbooks document his broad curiosity in diverse subjects and events, from the Napoleonic Wars to experiments in electricity, and throughout his attention to the cultivation of reputation is clearly evident. Among the clippings can be found dozens of reports of sundry types of libel trials—from defenses of professional competence to defenses of women's honor—that clearly suggest a more than abiding interest. (Figure 45)

Criticism

Resolved:
That no comments or criticisms on the opinions or productions of living artists in this Country should be introduced into any lectures given at the Royal Academy.[37]

On February 11, 1810, a correspondent for the *Examiner* reported with indignation upon a "preposterous assumption of privilege from critical animadversion."[38] The privilege to which he objected was a resolution forbidding criticism within the Royal Academy of any living artist in Great Britain, a regulation pointedly directed at the academy's own professor of architecture, John Soane, who was obliged by his post to deliver six lectures each year to the students of the Royal Academy. The lectures were held less frequently in practice and were notable events, attended by academicians and invited members of the public as well as the students. The obligation of the professors to deliver lectures was stipulated in the Founding Instrument of the Royal Academy, signed by King

George III in 1768 to grant royal patronage and hence public sanction to the body of artists. It specified the structure of governance for the Royal Academy (consisting of a Council and a General Assembly) and also included strictures upon the demeanor of the academicians. The very first clause stated that the Royal Academy should be composed of artists "of fair moral character, of high reputation in their several professions."[39] Speaking on January 8, 1810, Soane quoted directly from the Founding Instrument to describe the purpose of his lectures: "And amongst the laws of this Institution it is declared that, 'There shall be a Professor of Architecture who shall annually read six lectures, to form the taste of the students, to interest them in the laws and principles of composition, to point out to them the beauties or faults of celebrated productions, to fit them for an unprejudiced study of books, and for a critical examination of structures.'" Required to develop the knowledge and discernment of the students by exposing them to the history and principles of architecture, Soane would necessarily have recourse to the detailed discussion of architectural examples in his lecture. He was therefore forced to caution his audience that "if in the endeavour to discharge the duties of my situation, as pointed out by the laws of the Institution, I shall be occasionally compelled to refer to the works of living artists, I beg to assure them that, whatever observations I may consider necessary to make, they will arise out of absolute necessity, and not from any disposition or intention on my part merely to point out what I may think defects in their compositions."[40] Soane, already keenly sensitive to the nature of criticism, was evidently alert to the need for propriety in the institutional context of the Royal Academy, whose members were, by the definition of its charter, to be considered accomplished artists who merited their high reputations.[41]

On the evening of January 29, 1810, Soane delivered his fourth lecture, on the topic of the relationship between parts and the whole, employing drawings to illustrate his points. Proceeding to a discussion of buildings that failed to resolve into unified form, and as an example of the undesirable practice seen "in many of the buildings of this metropolis" of embellishing one facade at the expense of the others, he placed before his audience two illustrations of the side and rear facades of the recently completed Covent Garden Theatre by the young architect Robert Smirke: "These two drawings of a more recent work point out the glaring impropriety of this defect in a manner if possible still more forcible and more subversive of true taste. The public attention, from the largeness of the building, being particularly called to the contemplation of this national edifice."[42] (Figures 46 and 47) Soane's derogation of the architecture of a fellow academician—Smirke, then thirty years old, had been elected to the Royal Academy two years earlier—startled his audience, many of whom hissed in protest. Soane had obviously anticipated the effect

Figures 46 and 47. Illustrations of Robert Smirke's design for the new Covent Garden Theatre, used by Soane in his Royal Academy lecture. Soane displayed the illustrations, showing the front, rear, and side elevations of the building, to exemplify how subordinate facades may appear diminished and utilitarian due to their lack of ornamentation, an undesirable outcome in civic architecture.

of his remarks, for he immediately added: "It is extremely painful to me to be obliged to refer to modern works, but if improper models, which become more dangerous from being constantly before us, are suffered, from false delicacy, or other motives, to pass unnoticed, they become familiar, and the task I have undertaken would be not only neglected but the duty of the Professor, as pointed out by the Laws of the Institution, becomes a dead letter."[43] Having thus echoed Lord Ellenborough's reasoning, he then proceeded to recite once again from the Founding Instrument the "laws of the Institution" that obliged him to offer such criticisms for the edification of the students. Soane intended his two illustrations to show the marked contrast between the front facade, already more simple or grave than many had expected the new theater to be, and the unadorned sides and rear, whose scale and plainness suggested a warehouse rather than a civic building. The omission of adjacent buildings exaggerated the effect of an overwhelming dullness. Motivated by spite toward Smirke as much as by pedagogical intention, Soane's criticism was by some judged to be the uglier aspect of the affair. The Royal Academy responded quickly to his provocation; within the week, the council met and drafted the resolution that prohibited any "comments or criticisms on the opinions or productions of living artists in this Country" to be introduced into lectures.[44] Soane answered that this unacceptable condition would force him to suspend his course of lectures, but the General Assembly ratified the council's resolution nevertheless, with only one member voting in dissent.

The broad resolution prohibited even "comments" upon any aspect of an artist's work, whether the actual productions of an artist or his "opinions" expressed in another medium. Obviously intended to maintain a

presumed propriety in the affairs of the academy, it resulted in part from some members' personal antipathy toward Soane. But the resolution was undoubtedly also a reaction against the severe partisan criticism that circulated in newspapers and reviews outside the academy; each year, the annual exhibition exposed individual academicians and the Royal Academy itself to the juridical determinations of the press. In a period before illustrated newspapers and journals, criticism often circulated more widely than the paintings or sculptures it addressed; even architecture, more visible to the course of daily life in London, was depicted textually to a large audience who remained unacquainted with the actual works.[45] The members' experience of the exhibition reviews undoubtedly swayed many of them in favor of the ban, which promised to maintain the academy as a sanctuary in which one's "high reputation," the first of the criteria of membership, would never be impugned.

But while a large group of academicians had reacted adversely to Soane's comments, others agreed that the instruction of students required such criticisms and expressed their support privately, in correspondence and in social meetings. Soane solicited further sympathy by privately circulating a lengthy pamphlet titled "An Appeal to the Public: Occasioned by the Suspension of the Architectural Lectures in the Royal Academy," which presented his defense in a didactic brief, with more comments on the Covent Garden Theatre and arguing that criticism was necessary to prevent the propagation of bad taste through poor examples. Public support for Soane's position appeared in the pages of the *Examiner*, whose correspondent strongly opposed any constraint upon fair criticism, seeing it as vital for the development of architecture. A reader concurred in a letter to the editor, objecting to the "disgraceful" law, and declaring "criticism upon the Arts as necessary to their preservation and improvement, as the liberty of the Press is to preserve the freedom and promote a moral state of society."[46] This rhetorical figure—criticism as the improvement of society through the disciplining of taste and the opprobrium on ugliness—had been the basis for the legal defenses against libel, including of course the episode of "The Modern Goth," in which Edmund Law had rebutted Soane's charges by contending that criticism "kept dullness in the back ground, instead of stalking forth in the glare of public light."[47] Later, as chief justice, he would rule that "liberty of criticism must be allowed, or we shall neither have purity of taste or morals. Fair discussion is necessary to the truth of history and the advancement of science."[48] Soane now drew upon the same argument and defended his own criticisms by reasserting the claim he made when commencing his lectures, that he was motivated only by a sincere desire to improve architecture especially in such "works where in a great degree the national taste is implicated."[49]

The conflict formally ended in 1813, seemingly through the mutual exhaustion of the antagonists; the Assembly passed a statement regretting that Soane had taken personal offense at a law that was intended to apply generally, and an appeased Soane recommenced his lectures. But the question of criticism, like the resolution itself, had not been withdrawn. In March 1815, Soane ended the final lecture of his series by quoting the closing lines of Alexander Pope's 1711 *Essay on Criticism*, thereby claiming for himself, rather implausibly, Pope's attitude of a selfless, disinterested critic pursuing only the truthful "knowledge and love of architecture."[50] But by Soane's time, criticism, invariably accompanied by some disapproval, had already passed through the pages of Richard Steele's *Tatler* and Joseph Addison's *Spectator* and through the voluminous work of Samuel Johnson, to become a staple of the public discourse transacted in the competitive press of London. Soane's invocation of Pope, however sincere, was well out of date. Yet Soane perceived the timely role for criticism to be prompted by the very fact of architecture's public role in civic life, and the special urgency of his criticism of the Covent Garden Theatre, which he endeavored to show in as unflattering light as possible within the format of a Royal Academy lecture, to be due to "public attention, from the largeness of the building, being particularly called to the contemplation of this national edifice."[51] This same point would of course be directed against Soane in the 1827 libel trial, when the counsel for the defense had argued that only a book or building "that can stand the but [*sic*] of ridicule becomes immortal, for that which ridicule can put down ought to be put down. If this remark applies to books, still more does it apply to the artists whose works, like his materials, are lasting, and who covers a metropolis with them."[52]

The visibility and presence of architectural ugliness—of the palpable eyesores of the metropolis—conflated and collapsed otherwise differentiated social trajectories, the lives of real persons, the changing standards and predilections of taste, and the evolving legal regulations of common law. In condensing these, architectural ugliness also participated in the novel reconstitution of architect and subjectivity, in effect depersonalizing the sentiments of taste and refashioning them as social instruments, calibrated by conventions of criticism and by mechanisms of libel law. While the most notable judgments may have predictably pertained to buildings of national significance such as Soane's Bank of England or Smirke's patent theater in Covent Garden, these were not exceptions, but rather part of a broader assessment of the physical monuments of civic life. When Soane, Smirke, and their contemporary John Nash were appointed architects to the Board of Works to advise on the building program of the Church Commissioners, they joined an effort to construct a multitude of churches for a minimum outlay of expense. With a budget

of no more than twenty thousand pounds per building, the architecture of each was inevitably impoverished to some degree, even as it would just as inevitably be the focus of public scrutiny. One of Nash's designs, All Souls, Langham Place, received perhaps the most scathing derision in the House of Commons, when Henry Gray Bennet rose to say that "it was deplorable, a horrible object, and never had he seen so shameful a disgrace to the metropolis. It was like a flat candlestick with an extinguisher on it. He saw a great number of churches building, of which it might be said, that one was worse than the other.... No man who knew what architecture was, would have put up the edifices he alluded to,

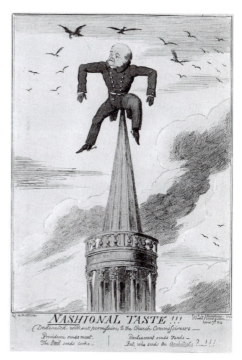

Figure 48. George Cruikshank, "Nashional Taste!!!" (1824).

and which disgusted every body, while it made every body wonder who could be the asses that had planned, and the fools that had built them."[53] Parliamentary privilege protected Bennet from any potential repercussion—statements made in the House of Commons were exempted from prosecution for slander—but in any case the notable aspect of his obloquy was the explicit absence of Nash's name, with Bennet wondering who could have been the person responsible for such architecture.

More curious, and perhaps more perceptive, was the caricature that the incident inspired George Cruikshank to draw. (Figure 48) His drawing shows Nash balanced uncomfortably upon the spire of All Souls, his posterior impaled upon its tip, carrion birds above and a vein of London smoke behind. The caption aligns Cruikshank's image with Bennet's disdain for the asses who had planned the new churches: "Providence sends meat / the Devil sends cooks—/ Parliament sends funds—/ But, who sends the architects?—!!!" Relevant too is the punning title of the drawing, "Nashional Taste," whose obviousness should not obscure the fact that it presumes, even fosters, the collapsing of the imagination of

an individual architect into a collective perception that in turn is equated with a civic standard of judgment and a civic aesthetics. It enacts the depersonalization of taste and the disembodying of the architect from his work (even as the image places his body in extremis). Cruikshank's drawing, in other words, seen in relation to the architectural object of All Souls on the one hand and the verbal or textual object of Bennet's obloquy on the other, is a succinct portrayal of the operation of criticism at this moment. It is a summative answer to the unasked question of how architectural ugliness might be discussed, instrumentally and consequentially, in the public sphere.

The novel constructions of aesthetic criticism formulated through these events and set forward in libel rulings at the beginning of the century gained substance as legal precedents over the decades. They did not, however, forestall further libel trials, including one of the most famous, *Whistler v. Ruskin*, held near the century's end. Incensed by John Ruskin's scathing critique of his *Nocturnes*, the artist James McNeill Whistler brought suit for libel. The trial in 1878 received extensive attention in the pages of journals and newspapers, enabling, just as in Soane's cases, the incessant repetition of the alleged libel, Ruskin's dismissive likening of Whistler's artworks to "flinging a pot of paint in the public's face."[54] Following by now well-established precedent, the judge instructed that fair criticism of Whistler's art was permitted by the law, but that insults to the artist as a person were libelous. After deliberations, the jury returned a verdict in Whistler's favor, deeming Ruskin's statements a libel, but awarded damages of only one farthing, a token amount whose insignificance indicated a sense that both critic and artist were wronged by the legal proceedings that followed from the initial publication. (Figure 49) But if such criticisms of the aesthetic value of architectural works had acquired a considerable degree of immunity from claims for libel, published statements that questioned professional competence did not. Harm to an architect's reputation might result from the disparagement of his completed works, but that reputation could suffer even more from insinuations that he was not good at his job. Daily newspapers did not give to the case of *Botterill and Another v. Whytehead* the attention they had given to *Whistler v. Ruskin* just a year before, but the case was reported in professional architectural journals. An architectural firm had lodged the claim against a vicar who had sent a communication to a neighboring parish urging them not to hire the firm for planned restorations of a church. The vicar had claimed the architects were not sufficiently knowledgeable in the work or in their religion, claims that the plaintiffs would argue insulted their professional character and damaged their business. The court finding "evidence of express malice" in the vicar's statements, the architects won their claim and were awarded

fifty pounds in damages by the jury.[55]

By the middle of the twentieth century, a moment when modernism was becoming widespread but had not secured the broad approbation of public taste, architecture remained susceptible to ridicule in terms not far removed from those familiar to Soane or Nash. The aesthetic and linguistic vocabulary was different, but the judged failing of an architect to recognize a manifest ugliness remained a distillation of critical comment. Architectural critics, by now a recognized profession of their own, diagnosed

Figure 49. "An Appeal to the Law." A cartoonist for *Punch* mocked both the "Naughty Critic" and the "Silly Painter" for their respective responsibility in bringing about the libel case.

the difficulty as a distance in understanding between architects and the lay public that corresponded to a distinction between the appearance of a building and the many contextual intricacies of its construction and use. Using the example of the lengthy official debates over the proposed plans for a large new building in Piccadilly Circus, Reyner Banham explained that the "general public was therefore baffled to find that what it thought was simply a straightforward argument about an ugly building seemed to be largely concerned with matters like illuminated advertising in Latin America, underground pedestrian circulation, shopping habits in Coventry … and other matters that seemed not to have even marginal bearing on the appearance of the building." The solution, he suggested, was to solicit more "responsible and informed criticism from the lay side," which had disappeared, Banham thought, in Ruskin's day.[56]

Along with Banham, a number of architectural journalists and editors in Great Britain expressed their concern that the criticism of architecture was insufficiently rigorous, that it was in fact rarely critical. Beginning in 1948, J. M. Richards, one of the editors of the *Architectural Review*, began to express the conviction that although an exacting criticism of architecture was an urgent necessity, it was constrained by fears of libel: "There is, however, one practical difficulty to be overcome: the law of libel, which applies more stringently to architecture than to the other arts because of the large amount of someone else's money involved.… In criticizing an architect's work it is often difficult to draw the line between what

is merely an opinion on his merits as a designer and what is an opinion on his competence to handle—or incompetence to mishandle—a client's or a company's funds."[57] The continuing confirmation of the standard of libel as requiring the distinction of architect from architecture had, according to Richards, come to forestall the possibility of matching the critical attention that prevailed in other arts. As a remedy, Richards speculated that more "frank architectural criticism" might arise "if there were some system of inviting criticism when a building was completed.... Following the precedent of the first night ticket sent to the dramatic critic and the book sent to the reviewer, which were an invitation to criticize."[58] Whether such a process could be installed, and whether it would lead to a new critical freedom, was a question he deferred to "the legal experts." But without such a process, he predicted a continuation of a harmful mediation of architectural discourse: "Any attempt at seriously criticizing buildings, since it takes on the character of an unwarranted attack, creates a resentful critical climate in which reasonable discussion is most difficult. As elsewhere, the law of libel chiefly operates not when it is really applicable but through the atmosphere of caution it engenders."[59]

Though less frequently pursued than in Soane's day, the threat of libel action has not disappeared from architectural discourse, even today. In late summer 2014, reports that the London-based architect Zaha Hadid was suing the critic Martin Filler for defamation were met with considerable surprise. In an essay titled "The Insolence of Architecture," ostensibly a book review and published in the *New York Review of Books*, Filler denigrated Hadid's work—"poorly conceived and questionably executed" is one illustrative phrase, "experimental showpiece" is another—and denounced also what he described as her "imperious" manner, accusing the architect of unconcern for the conditions of laborers who were to construct her architectural designs in places like Qatar.[60] News of the essay, and its most pointed passages, circulated through architectural media. But once Hadid herself responded to the essay with a lawsuit filed in a New York State court, Filler's essay, its assertions, and Hadid's reaction all became the subject of considerable interest for architectural and popular media.[61] The retaliatory lawsuit seemed to startle media audiences more than Filler's accusations. Why would an architect, secure in her international reputation, resort to a lawsuit to reply to the commentary of an architectural critic? Was not vituperative criticism simply the collateral cost of celebrity in the twenty-first century? Was not her architecture, especially in its most public manifestations, legitimately subject to the scrutiny of media? Such questions are evidence of a contemporary acclimation to the media environment of modern architecture, with the lawsuit received as a seemingly novel challenge to that structure.

The particular transgression in the recent case, according to the architect's brief, was Filler's assertion that Hadid had expressed unconcern over the deaths of workers in the construction of her work in Qatar and that she had disowned responsibility (which Filler implied she bore) for those deaths. In addition, the brief stated, Filler had presented an *ad hominem* attack, a defamatory criticism of Hadid herself rather than her work, or her embodiment within her work. Indeed, in this instance, it would be more properly characterized as an *ad feminam* attack, given the explicitly gendered nature of criticism to which Hadid was subjected. In addition to noting her "imperious manner," Filler also referred to her as "hard-hearted Hadid"; such phrases followed the example of any number of other critics who had derided Hadid's personality in similar manner and who all too frequently focused upon ridiculing her physical appearance as part of their critique. The result of the libelous article, the brief concluded, was that Hadid had been "impugned ... in her profession as an architect" and was "exposed ... to public ridicule, contempt, aversion, disgrace, and ... evil opinions of her in the minds of right-thinking persons."[62] The audience of architectural discourse gathered quickly into camps for each side: either Filler had been justified in denouncing the political ramifications of Hadid's work and her stated unwillingness to acknowledge them, or Filler had offered clearly misleading representations of Hadid's public statements in a deliberate effort to damage her reputation. While public opinion continued these rounds of debate, the protagonists settled out of court, with Filler offering an apology appended to the subsequently revised article and undisclosed damages that Hadid promised to donate to an unspecified charity in support of laborers' rights.

The surprise with which the case was met—surprise that Filler (or more, his publisher) would have presented such a scathing critique, and surprise that Hadid would respond with a suit for libel—should in fact have been no surprise at all, for both were predictable continuations of the trajectory along which public criticism and judgments of architectural ugliness were at first linked to and then separated from criticism of individual architects in the novel formulations of English libel law that emerged at the start of the nineteenth century. From those origins, moving along the course of professionalism in which an architect's reputation assumed the different and more concrete forms of artistic ability *and* technical competency, such critiques led to the loosening of the aesthetic register of architecture from its other dimensions, as well as to the sharper definition of the embodiment of the architect as a persona rather than a person. It was the pointed and personal nature of judgments of ugliness that prompted legal redress initially and gave particular purpose to the new instruments of libel law, and it is the nature of judgments of ugliness that remains the test of those instruments even now.

Chapter 6
The Profession

Writing in 1888 for Oscar Wilde's magazine *The Woman's World*, the novelist Ouida gave an unambiguous assessment of the streets of London: "To drive through London anywhere is to feel one's eyes literally ache with the cruel ugliness and dulness of all things around."[1] From the insufficiency of street lighting to the vulgarity of advertising hoardings, the meanness of the streets, and, above all, the awfulness of building exteriors, the city offered the resident or visitor navigating its streets only an unrelenting ugliness. "London," she wrote, "has been ill and unkindly served by the innumerable architects, engineers, and Boards of Works who have worked for it."[2] Responding to Ouida in the *Pall Mall Gazette*, the designer William Morris offered his agreement: "There is, indeed, as Ouida says, something soul-deadening and discouraging in the ugliness of London; other ugly cities may be rougher and more savage in their brutality, but none are so desperately shabby, so irredeemably vulgar as London."[3] Both wrote about the ugliness of the city not as occurring in a moment of emphasis, in a single building or monument, but as a generality, a quality diffused across the metropolis, much like an atmosphere. (Figure 50) The physical atmosphere was indeed one aspect of experience of the ugliness; Ouida listed atmosphere and climate as possible causes—"Is the cause atmosphere, architecture, national temperament, climatic influences, insular melancholy, or what is it?"—and Morris for his part made effective use of the analogy of smells to convey the sensation provoked by the ugliness of London: "There are certainly smells which are more depressing and deadly to pleasure than those which are frankly the nastiest: the refuse of gasworks, the brickfields in the calm summer evening, the faint, sweet smell of a suspicious drain, the London wood

Figure 50. Victoria Street, the first of several new streets opened through the city in the program of metropolitan improvement of the second half of the nineteenth century. Opened in 1851, it was fully built up by 1895 (when this photograph was taken) with frontages typically of considerable length, contributing to the scale and appearance of the buildings judged harshly by Ouida and Morris.

pavement at two o'clock on a hot, close summer morning—these kinds of smells are more lowering than the kind of stench that drives one to write furiously to the district surveyor. And the quality of London ugliness is just of this heart-sickening kind."[4] As with the difference between disgust and irritation, ugliness here was a smell that did not prompt one to action—with a letter to the district surveyor—but annoyed without surcease. Though many aspects of metropolitan life reinforced the ugliness, the monotonous effect of architecture was, for Ouida, centrally to blame for a city of "buildings constructed without an idea, without a meaning, without a single grace, without any charm of light and shade, of proportion or of form—repeating its own nullity, again and again and again, as an idiot repeats its mumbling nothings."[5] This monotony Morris was inclined to attribute not to insular melancholy but to a legislative cause: the Metropolitan Building Act of 1844.

Morris accused this legislative device, which imposed building standards upon the city to be enforced by newly appointed district surveyors, of having stifled the inventiveness of architects in favor of the repetitions of a degraded architectural consensus. The very success of the

Metropolitan Building Act in imposing a rule upon the city was in Morris's view its failure, with ugliness its consequence. He called, in remedy, for its repeal. While this action might have permitted a range of experimental freedoms for the builders and architects of the city, the law was not the only manifestation of the underlying metropolitan purpose that Morris diagnosed as the sickness of London. That purpose was commerce, and it too had an aesthetic consequence. "The monstrosity we call London … is at once the centre and the token of the slavery of commercialism which has taken the place of the slaveries of the past…. The sickening hideousness of London, the metropolis of the nation, which has worked out the sum of commercialism most completely seems to me a mark of disgrace."[6] If commercialism was, as Morris claimed, connected to the consequence of metropolitan ugliness, then the Metropolitan Building Act was only one of the mechanisms of architectural normalization that mediated economic practices and aesthetic performance.

An Average Profession

Other such mechanisms of architectural normalization proliferated during the decades that preceded and followed Morris's essay, from the beginning to the end of the Victorian period. Along with legislative devices such as the Metropolitan Building Act, the smoke abatement statutes, and laws mandating infrastructural improvements, new protocols emerged to regulate the practice of architecture. In January 1837, only a few months before Queen Victoria would ascend to the throne, the Privy Council granted a Royal Charter to the Institute of British Architects, founded three years earlier for the purpose of "the general advancement of Civil Architecture, and for promoting and facilitating the acquirement of the knowledge of the various arts and sciences connected therewith."[7] A Royal Charter enabled incorporation, or the conversion of a group of individuals into a single legal body with rights under law, and the significance of the Royal Institute of British Architects (RIBA) lay in its translation of the practice of architecture from the discrete activities of individuals into a professional body of architects.[8] The membership of the RIBA remained quite limited for much of the nineteenth century, with many architects practicing outside of and with no relation to the institutional body. But it nevertheless influenced directly the development of standards of practice, from fees to contracts to codes of conduct—in short, the elements of the profession. Controversies developed, first over the question of architectural education as earlier customs of apprenticeship gave way to formal academic training, and then over the question of examination and registration, with advocates in favor of regulating the practice of architects for the benefit of the public and

opponents defending the inscrutability of artistic skill. A Registration Bill presented in Parliament in 1891 brought these arguments onto the pages of the *Times* and other newspapers. By the end of the century (and of the Victorian period) the standing of architectural practice was largely established, the RIBA membership having grown to the extent that it could reasonably claim to represent the profession, and in 1931 the Architects Registration Act formally concluded the century-long establishment of the architectural profession.[9]

Architectural discourse during the Victorian period consisted of sustained polemics on style, including the debates between neoclassicists and gothic revivalists, the architectural evangelism of the Ecclesiologists, and arguments over the practical accommodation of the new building programs that emerged with industrialization. But alongside this overtly aesthetic discourse were equally contentious arguments about the nature of the architectural profession, and, as Ouida and Morris suggested, the state of the profession was not unrelated to the state of civic aesthetics. In a century consumed by business, matters of ethics, fairness, and propriety possessed an urgent relevance to economic life, and an ugliness in architectural appearance might be mirrored by an ugliness in professional behavior. A few years before Ouida and Morris lamented the ugliness of London, architects and men of business were expressing their concern over a case—undoubtedly one of many—of professional misconduct. A Mr. George Artingstall wished to enlarge his house, but having retained architect and builder and paid them to proceed with the work discovered the result to be shoddy and not in accordance with the agreed specifications. Artingstall's legal action against the builder and architect and their countersuits against him and each other were referred by the courts to legal arbitration and there settled in his favor.

This case led the *British Architect* to publish a lengthy reflection on the worrying indication of lacking professional propriety and a corresponding lack of public regard for the architectural profession. The journal presented its readers extracts from testimony, details of the specifications, an analysis of the bill of legal costs, and correspondence sympathetic to Mr. Artingstall. Among the latter, one correspondent regretted that the "profession of architecture unfortunately does not possess any fence through which admittance must be obtained by the prospective practitioner, or through which the unworthy can be expelled."[10] The journal agreed with the opinion that the profession required protocols and habits as well for elevating its standing as a body, and proclaimed itself dedicated to "the purpose of propagating and defending the interests of the architectural profession in Great Britain." To this end, it endeavored to "analyze and expose every discovered weakness, error, or wrong, whose existence endangers the reputation and progress of the Body;

either from without or from within."[11] Efforts to establish the norms of professionalism—education and training, examinations, codes of conduct, and the like—were efforts to guarantee an ethical probity and assume a moral standing during a period in which those qualities became valuable currency in the economic processes of the metropolis. Although these qualities could still be located in, or deemed absent from, an individual person, they were through the rise of professionalism increasingly attributed to a corporate body, to the profession of architecture.

The stylistic developments of Victorian architecture and the professional consolidation of Victorian architects are two strands of a historical narrative, both attended to by the accounts of architectural history, but the instrumental relationship that existed between these two strands has only been hinted at. The recognition of Victorian architecture by architectural history began almost bemusedly in the 1930s and then with a grudging seriousness in the two decades that followed.[12] Recognition, though, was tempered by a frank willingness to pronounce the architectural uncertainty and irresolution of a professional discourse that had been disoriented by its unremitting experiments with styles and the unmitigated pragmatism of some of its practitioners. The architect H. S. Goodhart-Rendel, who served as president of the RIBA and who spurred the historical interest in Victorian architecture, could nevertheless readily describe one of his Victorian predecessors as "not a man to get architecture right" and "incapable of producing a decent building of any kind."[13] Other nineteenth-century architects received complimentary assessment, but rarely without qualification. Delivering a lecture upon possible candidates for preservation in 1958, Goodhart-Rendel included the Liverpool Sailors' Home and the London Coal Exchange: "I do not rate highly the aesthetic value of either, but their historical and associational value is intense: After all, neither is as ugly as Stonehenge."[14]

This ambivalence was continued by John Summerson, who elevated it from connoisseurial opinion to historical analysis. Having proposed that there was in nineteenth-century Britain a "singular attraction on the part of some painters, architects, and writers towards ugliness," he went on to survey the work of the architectural class that produced Victorian London, taking recourse to a variety of colorful terms, including "mediocrity," "shoddy," "hasty and vulgar," "destructive and horrible."[15] Any period survey nominates highs and lows, but Summerson's accounts of Victorian architecture emphasized its typically middling achievement, which reflected architecture's participation in a prevailing social order to which "home life and making money were so very much the most important things."[16] Designed largely by "practitioners of a lower order of talent," the architecture of the civic realm of London was consequently "pretty crude," elevated by neither patrons' money nor designers' skill.[17]

The outward judgment cast by Morris and Ouida was from this perspective correct, but Summerson had his own interpretation of its significance, to add to Ouida's (emotional temperament) and Morris's (commercialism). Victorian architecture was, in a manner both simple and complex, "in its own time and in the eyes of its own best-informed critics, horribly unsuccessful."[18] "It was felt by many at the time to be a failure, declared by some to be a failure, and received by the next generation as a failure."[19] Summerson's historical judgment, in other words, was not a novelty, but a continuation of the self-perception of the Victorian period itself. And crucially, what is judged in this assessment is not, or not only, the individual works of individual architects, but the collective production of the profession. The author of ugliness is not the architect, as a person, but the architect as a corporate body.

The Death of the Architect

The life of the individual architect is of course made up of different consistencies and events than that of the corporate body. The life of the individual architect need not parallel exactly that of the corporate body, rather the two intersect in moments and routinely diverge. It is common, for example, for a corporate practice to dissolve while its individual members continue their careers, or conversely for it to continue in the absence of one or more of those individuals. Very likely, that absence is due to the death of the individual body, the individual person, the cessation of a trajectory of architectural production. The familiar conceit of the death of the author, only a half century old, has accustomed readers, or users, of cultural productions such as architecture to the possibility of a segregation of a biographical life from the cultural objects that it previously summoned.[20] This figural manifestation then opens into that concept of textuality in which intention, significance, and meaning are fully diffused among the biographical fragments of a life lived, disassembled and reassembled as interpretation, proposition, or possibility until the author as such has faded almost entirely from view. But the familiarity of this figurative death of the author (who may be writer, artist, architect) should not encourage one to overlook its accompanying literal manifestation, the actual death of an author, and to inquire into its consequences for, among other things, the determinations of aesthetic value.

One such death occurred on August 17, 1969; the person in question was architect Ludwig Mies van der Rohe. Mies—widely known even during his lifetime by his abbreviated surname—was eighty-three years old, forty years on from his radical design of the Barcelona Pavilion, thirty years on from his arrival in the United States, ten years on from the completion of the Seagram Building, that signal resolution of the modern

skyscraper. These architectural works, regarded as pivotal objects of the modern movement in architecture, were internationally known, as were his ascetic personality and aphoristic communications; together they amounted to a recognizable aesthetic. Before his death Mies, with a cohort of associates that included his grandson Dirk Lohan, was overseeing the work of his incorporated firm, the Office of Mies van der Rohe, work that included the final stages of construction for the Neue Nationalgalerie in Berlin and more preliminary stages of several other projects. It is one of these latter projects that competed with the authorial persona of its architect for the central role in architectural events in London, in the later twentieth century.

In 1958, the property developer Peter Palumbo (who would become churchwarden at St. Stephen Walbrook and who is now Baron Palumbo of Walbrook) set out to purchase plots of land in the City of London, at the heart of the financial center of the metropolis in the blocks near Mansion House and the Royal Exchange. Four years later, in 1962, he commissioned Mies to design for the prospective site an office tower facing onto an open plaza, set above an underground shopping arcade. Over the next several years, and with one visit to London to see the site in person, Mies and his Chicago office developed a scheme—known as the Mansion House Square scheme—for the tower and plaza that Palumbo presented to the City of London planning authorities in 1968. (Figures 51 and 52) This consultation with the authorities was required for several reasons, including the atypical height of the building—at two hundred eight feet, it would be one of a handful of towers in the City—as well as the significant alteration of existing street and traffic configurations by its footprint and by the large plaza. The required consultation was also due to the historical nature of the site itself; Mies's prospective tower was surrounded by the work of other well-known architectural authors—George Dance the Elder's Mansion House and Sir Edwin Lutyens's Midland Bank would form two sides of the proposed plaza—and a number of less-regarded though still-authored Victorian buildings would have to be demolished to clear space for the tower. The City of London, an entity coextensive with yet autonomous from the larger metropolis, and governed by the historic Corporation of the City, possessed wide discretion in the management and regulation of development within its boundaries and would need to be persuaded. City authorities did view the proposal favorably, but because Palumbo owned only some of the hundreds of leaseholds that made up the scope of the properties to be demolished, permission was withheld with an instruction that he first attain sufficient control over the relevant properties to ensure that the project was unlikely to be forestalled. Over the next fourteen years, Palumbo followed this instruction, buying a dozen freeholds and hundreds of separate leaseholds. Meanwhile, Mies's office refined the design, and a set of working

Figure 51. A photomontage of the Mansion House Square proposal shows the Mies van der Rohe tower flanked by George Dance the Elder's Mansion House (at center-left) and Sir Edwin Lutyens's Midland Bank (at center-right). Office of Mies van der Rohe (1981).

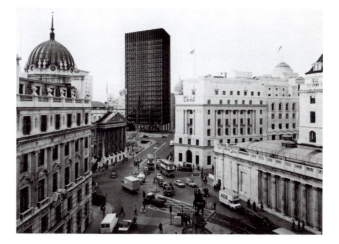

Figure 52. The proposed tower was first shown to the public in an exhibition held at the Royal Exchange in October 1968.

Figure 53. Photomontage of the Mansion House Square proposal in context, in a view along Queen Victoria Street, another of the streets opened by the metropolitan improvements of the nineteenth century. Office of Mies van der Rohe (1981).

drawings was prepared and ready for presentation in 1982, the year that Palumbo returned to the Common Council of the Corporation of the City of London with almost all of the required property under his control.

By this time, now more than twenty years after Palumbo had conceived the project, a number of relevant circumstances had changed. Throughout the 1950s, the blocks of the City were filled with new construction to replace buildings damaged or destroyed by aerial bombardment during the war. Though many notable historic buildings had been spared—most famously, St. Paul's Cathedral—vacant lots and half-fallen buildings were numerous. Damaged churches were most likely to be rebuilt, but the fabric of the City was replaced with newer and often speculative constructions. Through the 1970s, with the rapidity of postwar reconstruction evolving into the rapidity of the development of the finance economy, new towers appeared on the City skyline, and partially in consequence, a trend toward preservation had begun to emerge, so that the demolition of older buildings, even those of minor distinction, was now approached with greater hesitation. Conservation areas had been defined within the City, the first in 1971, several in the years that followed, and the year before Palumbo's renewed application for planning permission a full review of the conservation areas had resulted in the extension or designation of almost two dozen such areas across the City.[21] One of the conservation areas contained parts of the proposed Mansion House Square scheme, and a few of the affected existing buildings had been listed and therefore obtained various degrees of legal protection as either individual or grouped historic structures. (Figure 53)

These changes paralleled a more general revaluation of architectural style that had, over the preceding decades in Great Britain, catalyzed a concentrated hostility toward modernist architecture and fostered an increased veneration of English Victorian architecture (and historicist architecture more broadly). Summerson, among others, had contributed to this changed perspective, with his accounts of Victorian transformations of the metropolis. Although his was certainly an unsentimental view, it nevertheless offered an understanding of the seemingly

unexceptional fabric of the city that illuminated the relation of architecture and historical context. In the view of Ouida and Morris, of course, the same buildings that Summerson carefully distinguished were an undifferentiated landscape of dullness that heightened the overall ugliness of London, and the commercialism that was the basis of the City's existence was the commercialism that prevented the remedy of that ugliness. (see Figure 50) Ouida and Morris,

Figure 54. The 1984 Mansion House Square inquiry in session in the Livery Hall of Guildhall. The room is arranged as a court proceeding, with the inspector at the head of the room, and the advocates and opponents at tables on either side.

in other words, might have given a sympathetic hearing to the Mansion House Square scheme, but the circumstances of historical perception had changed. By 1982, in contrast to 1968, Mies's architecture was no longer presumptively contemporary, nor were the existing Victorian commercial buildings so readily designated as either insignificant or obsolescent.

Palumbo's renewed application faced strong criticism, and was summarily rejected by the Common Council. The autonomy of the City of London was not absolute. Its planning decisions could be subject to review by the government, and Palumbo therefore chose to appeal the decision, prompting a formal review of the case by an appointed inspector with authority to gather information and opinions and then to convey a recommendation to the secretary of state for the environment. To carry out the appeal process—and fully aware of the now considerable attention focused upon the Mansion House Square case by the media and professional groups—the inspector, Stephen Marks, convened a public inquiry held over ten weeks in 1984.[22] This inquiry, while not an actual judicial proceeding, was nevertheless organized as one, with evidence presented by barristers and witnesses speaking in favor of or in opposition to the appeal through direct testimony and cross-examination. (Figure 54) (It was similar in format to, though much more public in nature and in interest, the hearing that would shortly follow for the faculty at St. Stephen Walbrook, which overlooked the Mansion House Square site.) In this forum, the persona of the architect came prominently into view, for of all the changed circumstances since 1968, perhaps the most consequential was the fact that Mies had died in 1969. Despite his death, the design was still attached to his persona, and in 1984 this attachment assumed a considerable importance in light of the markedly diminished

appreciation for the proposed development on the part of planning authorities. (Figure 55)

In order to make their case, Palumbo and the project's supporters—John Summerson for one, along with the architects Richard Rogers, Colin St. John Wilson, and James Stirling—placed Mies's persona at the center of their argument, pointing to his stature as one of the most important architects of the twentieth century and to the widespread appreciation of his realized works as evidence of the value of this prospective tower. Summerson testified that the design was one of "irreproachable excellence," and Rogers stated confidently that "Mies was remarkably consistent in his high standard: he hadn't made a mistake yet and was unlikely to make a mistake here."[23] The advocates argued, in essence, that the City had an opportunity to construct a building by Mies, an architect of exceptional standing, and the price to be paid was a collection of Grade II listed buildings by "practitioners of a lower order of talent."[24] While proponents of the scheme affirmed its architectural value by reference to its architect, opponents—whose ranks, like those of the advocates, included architects and historians—sought to undermine precisely this argument, first by stating that the architect's reputation was less a historical determination than a "myth [that] had nothing to do with the actual quality of his buildings."[25] "Mies had become a symbol," they argued, which obscured the considerable inadequacies of his architecture. The theorist Geoffrey Broadbent asserted that "Mies really did not care at all about comfort, convenience, and the well-being of users ... buildings by Mies suffered from over-heating, problems of vertical circulation, wind vortex and other problems."[26] Architect Terry Farrell described the proposed tower with adjectives that echoed those Summerson had used to describe the mediocre buildings of Victorian London: "repetitious, boring, and joyless."[27]

Opponents sought to further undermine the attributed architectural value of the Mansion House Square scheme by suggesting that the design could not with certainty be attributed to Mies because the architect's death forestalled his first-person testimony and because of the absence of indisputable alternate evidence of his hand in authoring the design. Where were the sketches or original drawings, asked John Harris, historian and founder of SAVE Britain's Heritage, in a letter to the *Financial Times*: "Your correspondents make much of the tower having been designed and detailed both inside and out by the late master. To my simplistic mind this implies actual drawings by Mies, and not by assistants in his office. As not a single original drawing has ever been seen, neither at the Royal Exchange in 1968 nor at the RIBA this year, I am beginning to wonder if the claim is spurious."[28] Philip Johnson, critic and himself an architect, and Arthur Drexler, curator at

the Museum of Modern Art, neither of them an enemy of Mies, submitted in written testimony that the proposed building was yet another weak derivation of Mies's iconic Seagram Building, not an original contribution. The historian Henry-Russell Hitchcock, having been a leading authority in the rise of architectural modernism and therefore asked to give his opinion, also indicated that Mies's involvement could have been only at a preliminary stage.[29] In short, the opponents argued that the building was not definitively bound to

Figure 55. In Louis Hellman's cartoon, Mies van der Rohe occupies the coffin at center. On the plaintiff's side, Peter Palumbo is wearing the dark suit, and to his right is John Summerson. On the defense side, the man wearing pinstripes is Marcus Binney of SAVE Britain's Heritage. Louis Hellman, "Mansion House Square—Trial of the Century" (1984).

MANSION HOUSE SQUARE - TRIAL OF THE CENTURY

the person of Mies in biographical terms, and therefore did not possess in aesthetic terms the superior value claimed by its advocates. Forced to rebut this line of argument, Palumbo's barrister brought to the inquiry Peter Carter, who was the job architect on the Mansion House Square scheme, and who had continued the development of this and other projects in the firm after Mies's death. Carter assured the inquiry that the building had been designed with the full involvement of the famous architect, whose typical working method left little in the way of sketches or original drawings. He testified that "Mies personally had initiated and authorised virtually every feature of the proposals, and had been involved till 2 weeks before his death; this scheme had been particularly dear to him."[30] Any subsequent changes were minor, he said, and had no effect upon the appearance of the design.

Much of the contention of the Mansion House Square inquiry was pursued under categories, such as conservation or urban experience, that connected questions of aesthetics to various political or ethical stances toward cultural issues such as heritage or commercialism. Aesthetics alone would not be sufficient grounds for judgment. Style entered into the debate, in the form of a high modernism versus a high Victorianism or a rising historicism, but it pivoted upon the articulations of taste, for the various parties to the inquiry seemed to feel obligated to assign aesthetic evaluations accompanied by declared valuations. So, for example, the Mies tower might be beautiful in its form but also dull in its repetition. The Victorian streetscape might be vulgar in its appearance but

elegant in its endurance. There's no need for a suspenseful account of the outcome: following the inquiry and due consideration of the evidence, Inspector Marks recommended that Palumbo's appeal be dismissed. Patrick Jenkin, the secretary of state for the environment, agreed, and on May 22, 1985, the Mansion House Square scheme joined the catalogue of unbuilt work.[31] But what was curious in the inquiry's engagement with the aesthetic register, and with the articulations of taste, was the pertinence of nuanced designations of authorship, both in their positive and negative manifestations, so that aesthetic argument might be shaped by classifications of architects variously as significant, or influential, or mediocre, shaped by the distinction of the authorial architect and the anonymous architect.

In 1982, before the appeal process commenced, the cartoonist Louis Hellman cleverly satirized the City Corporation's refusal of the Mansion House Square scheme with a mocking account in which Christopher Wren and his 1666 plan for the rebuilding of London stood in for Mies and his Mansion House Square proposal. (Figure 56) In Hellman's cartoon, Secretary of State Michael Heseltine was made into King Charles II, and Peter Palumbo was the equally alliterative Christopher Columbo. By associating Wren and Mies in this way, Hellman drew attention to the stature of the latter architect, and also to the conservatism of his opponents, but also indirectly and suggestively linked such political dimensions to an aesthetic register. For the parody depended upon a simple, comic transposition of appearance—Mies's head (much photographed, with thinning hair combed flat) wearing Wren's luxuriant wig. Though not consciously speculating on Mies's authorship, Hellman's cartoon, with its suggestive interchangeability, certainly foreshadowed the evidentiary debates that would follow as to whether the design was or was not by Mies. An architectural drawing—the evidence of Mies's authorship demanded by John Harris and other opponents—has long been regarded as an extension of the architect's mind, functioning as an expressive object whose attribution enables the recognition of the architect to occur at a remove from a physical building or an actual body. Such distancing mechanisms within design, which might also include the separation of the process of design from the process of construction, or the typically collaborative structure of specialization and techniques within architecture firms, are, despite the broad understanding that architecture firms are corporate bodies, more often than not veiled by personality. In 1984, the drawing had seemingly lost none of its standing to evidence agency, even as Peter Carter's testimony brought to the inquiry an exacting description of the distancing figured not by the architectural drawing but by discussion, review, approval, and other habits and conventions of architectural practice.[32]

Sir Christopher Wren's wig signaled much the same interpretation, with the additional clarity of presenting an explicitly aesthetic object—the wig, which manifests the vanities of fashion by suggesting a beauty to substitute for, if not an ugliness, then at least a bare reality—as the summary of all of these contested claims. The conclusiveness of the aesthetic was presented in the trial in more technical terms, perhaps, but the claim was more

Figure 56. Mies van der Rohe wears the wig of Sir Christopher Wren. Louis Hellman, "Ye Building News" (1982).

or less the same. Extensive explications of design details were agreed by both proponents and detractors to be salient elements. The claim that Mies's buildings "spoke a single language" because they were unified by "7 shared characteristics" was submitted into argument, as was Ludwig Glaeser's exhaustingly detailed explication of the variance in module, bay size, and ceiling height in Mies's realized projects.[33] Consisting of both repetition and difference, the aesthetic was established here as a conscious deliberation within the design indicative of the author it embodied. Inspector Marks appears to have understood that the importance of this proposition lay not in whether Mies's authorship could be proven, but whether the case itself should rest upon authorial standing: "His authorship, whatever the degree of involvement, is a prima facie indication of the quality of the building, but it is ultimately not relevant to an estimate of the appropriateness of the building to the area; to give it great importance is to place undue emphasis on the building as a work of art."[34]

Against this emphasis was set another, the claim not for the aesthetic value of the individual existing buildings of the conservation area, though some were in fact listed, but for their aesthetic value as a group. The inspector concluded that "while it is obvious that considered individually they are not 'the best of our heritage,' I am satisfied that they possess special architectural interest and special historic interest."[35] This interest could not, though, be located in the function or historical use of the buildings. Nor could it be attested in terms of the professional accomplishment of their designers, only two of whom "could conceivably be considered principal architects of the period."[36] Instead, it was to be calculated in aesthetic quotients. But those were curious in themselves, with opponents of the demolition of the older buildings defending them with unconventional praise. The building at 23–38 Queen Victoria Street,

for example, was "noteworthy for its sheer verve and vulgarity which give considerable interest, even if not a high quality of architecture."[37] Collected together, the buildings exemplified the scale, configuration, and experiential sensibility of the Victorian city; most notably, however, they exemplified its mediocrity and unmitigated ugliness. (Figure 57) These latter qualities were not disqualifications; to the contrary, they were the aesthetic value derived from a professional authorship distinct from the personified authorship of the Mansion House Square scheme.

Aesthetic Judgment and the Summons of History

The Mansion House Square inquiry was a venue for judgment of several kinds—social and economic, legal and administrative—but each of these was entangled with aesthetic judgment, which ran through the inquiry as justification, analysis, defense, and evidence. But to be employed in any of these terms in the inquiry, aesthetic judgment—whether of beauty or of ugliness in cognate terms such as vulgar, boring, and mediocre—required a means of substantiation. Rather than the historical recovery of prior paradigms of taste—Summerson's "smiling surface of a lake whose depths are great, impenetrable and cold"—the process of the inquiry used the categories of professional authorship and personified authorship to attempt to ally the aesthetic and the historical. If the author was the initial category of personhood, then its counterpart was anonymity, both of them legible through a particular mode of aesthetic recognition: the signature. Though signature now inevitably invokes starchitects and their signature buildings, the architect as brand is only one narrow manifestation of signature, which is more usefully understood as the translation of personhood into a medium other than the actual person. In the case of Mansion House Square, one such translation would have been the legal attribution of liability, which, had the design been constructed, would be assigned not to Mies as an individual person, but to his incorporation as the Office of Mies van der Rohe or to the administrative licensure of the name stamped upon the working drawings; another, quite different, translation of signature that appeared during the inquiry was the assertion of the irreducible singularity of "genius," or what the inspector termed the "prima facie indication of quality," in which the designation Mies van der Rohe named a capacity beyond the grasp of biographical explanation. In such translations, the architectural person whose aesthetic production lay under scrutiny was not the living (or deceased) Mies van der Rohe, but another body acknowledged by the signature "Mies van der Rohe."

Though the Mansion House Square inquiry convened in order to resolve a present concern and to make a determination of a future outcome,

its debates and analyses were historical in nature; that is to say, the inquiry summoned the past to appear as witness and as evidence. The construction of signature played a crucial role in this summons. Understood as the translation of personhood into a medium other than the actual person, as a loosened attachment to personhood, signature can be seen to forge a contract with

Figure 57. F. J. Ward, Imperial Buildings, Queen Victoria Street.

history that acknowledges a relation between a work and its creator at a specific moment, but that also extends that acknowledgment indefinitely forward into the future, even in the absence of an accompanying body. The architect, when encountered and addressed as a person through the technique of biography, has always appeared with an emphatic presentness, reenacting in the present any and all prior decisive moments as being unqualified and unchanged. This presentness is the repetition of an already determined intention that, although it occurred originally in the past, is placed again before its audience, unchanged, as fact. In this sense, personhood forges an isolation from context, with the completed fact reasserted without reciprocation to its newer historical moment, and in such a case one might lucidly and legibly reference taste and its standards as the means of aesthetic judgment. But when encountered as signature, the architect is addressed differently through a technique of inquiry that acknowledges distance; a signature moves forward in time, always newly aware of its changing context and offering a coherent and knowable persona (rather than a person) to any future appropriations, including a future tribunal.[38]

The Mansion House Square inquiry was in quite literal terms just such a tribunal, resummoning the signature to a venue of unexpected inclination, and even though the form of the inquiry was unknown and unanticipated at the moment the signature was produced, the signature could nevertheless be incorporated into the tribunal's structure of thought.[39] In other words, where the inquiry was forestalled in making its biographical address—because Mies was dead, no conclusion could be reached as to his actual involvement—it was freed by the inquisitional address of signature, able to examine and resolve anew the relation of architect, building, and present context. The inquiry was not thereby arriving at a conclusion as to whether or not Mies designed the Mansion House Square scheme; rather, it was producing an embodiment that

enabled it to evaluate the scheme in both its prior and its present context. The testimony heard by the inquiry did not establish points of certainty; to the contrary, it produced an area of uncertainty, in which signature was an embodiment of a process of architectural practice; not a personification of Mies, that is, but an embodiment of the acts and operations of Mies's office and its client. Put another way, the signature stood not only for individuality, already recognized by history, but also for anonymity, fully within yet unrecognized by history.

Through its corporate body, anonymity rewrites the contract with history, further loosening—though not severing—the conjunction of work and persona so that any future tribunal can no longer resummon the author to the same standard of presence.[40] When the signature reads "Anonymous," no specific body can be entered under judgment, no determined past is announced, and therefore no lineage can be established from the persona and to the work. A past exists nevertheless, manifest in the existence of the work, in its embodiment of decisions made and situational potentials realized. But this past cannot be described by the tribunal; it must instead be posited, put forward as a claim that burdens more than satisfies judgment. Regarding the fabric of Victorian London, Summerson conceded that "not much is known, except their names, about the builders of these things or of their architects," and it for this reason that he endeavored to construct a broadly social motive, a collective orientation toward profit and domestic ease.[41] The evidentiary appropriation of signature in such instances would be unable to claim the usual signifying parameters of personhood, and the anonymous signature would then predicate a different shape and agenda of inquisition of an architectural practice by a future tribunal—whether of historians or lawyers—with the relation of signatory to what has been signed premised upon a void, a distance, or a displacement. In a literal sense a depersonalization, the anonymous signature consists of a transfer between attributes of personality and personhood and those of institution, system, or technique. The corporate body assumes or indeed refuses responsibility for an aesthetic judgment of ugliness in a different manner than the authorial body, such that the anonymous signature actually solicits the projection of the tribunal's own motives and the intentionality of its own aesthetic judgments.

In performing the actions of such of tribunal, using the instrument of signature to resummon the architect for the purposes of examination and inquisition, the Mansion House Square inquiry was the site of two significant consequences. First, by bridging the event of Mies van der Rohe's death and installing the signature of Mies van der Rohe as the object of scrutiny, the inquiry embedded that signature with the predispositions of the inquiry itself; the signature became less a representation of Mies than a representation of the terms of interrogation to which the aesthetic

was subject in the historical time and the legal space of the inquiry. The aesthetic register became a plane of deliberation for the adjudication of both property and propriety. Second, by bringing forward on equal terms the claims of the existing Victorian architecture on the site, the inquiry introduced a categorical opening for ugliness arising from the anonymous, mediocre, or professional objects of architecture, distinct from authored work. One of the curiosities of the inquiry testimony was the need for some of the witnesses who wished to protect the existing buildings and prevent the Mies tower to adopt an unfamiliar distribution of aesthetic judgment, valuing the ugliness of the former and devaluing the beauty of the latter. Not all witnesses did so—several emphasized the ugliness of the tower—but one outcome of the inquiry as a whole was to forge an identification between ugliness and the anonymous or the mediocre, and by so doing enabling ugliness to enter into debate as a diffuse or generalized condition, rather than only as a specific objective trait. The anonymous, professional fabric of Victorian London so disdained by Morris and Ouida was judged to have a signature of its own—and it is worth noting that a signature is, of course, the crucial instrument of that most basic of professional tools, the contract—that might be balanced against that of a better-known deceased architect.

The inspector's recommendation and the secretary's decision to deny the appeal brought an end to the Mansion House Square scheme, though not to the architectural event. Following the denial of his appeal, Palumbo conceded that "the Mies scheme is dead" yet did not abandon his plans to develop the Mansion House site.[42] He commissioned a new proposal from the architect Sir James Stirling (who had testified in favor of the Mies design) and steered it through heated debate, refusal of planning permission from the City Corporation, and yet another public inquiry held in 1988; this inquiry, which resulted in approval for the scheme granted by the secretary of state, was appealed first to the High Court, then the Court of Appeals, and finally to the House of Lords, where the final judgment was rendered in Palumbo's favor. This new building, to be known as No. 1 Poultry, was eventually completed in 1998. By then, Stirling had been dead for six years.[43] (Figure 58)

The entanglements of authorship—individual and corporate, as signature and as anonymity—only increased with this seeming resolution of the Mansion House episode. The footprint of the new building was much smaller (and no longer accompanied by an adjacent plaza) and the scope of demolitions therefore considerably smaller, but the proposal still required the removal of one building, the 1870 Mappin & Webb building, which became the central focus of preservation efforts. The legal inquiry convened to evaluate the No. 1 Poultry proposal subjected Stirling's design, like its predecessor, to detailed scrutiny and critique. The new design,

Figure 58. Photomontage showing the proposed building for No. 1 Poultry, viewed along Queen Victoria Street. James Stirling Michael Wilford & Associates (1986).

characterized by Stirling's highly articulated postmodern historicism, faced aesthetic disparagement that, if anything, exceeded that directed toward Mies's tower proposal. In this case, however, the architect was present to answer the summons of the tribunal—Stirling presented evidence to two public inquiries, answering questions about his design and its revisions. But the seemingly incontrovertible affirmation of the person of the architect—the affirmation of a living and present author—did not endure for long. Construction of No.1 Poultry did not begin until two years after Stirling's death in 1992, and the building's posthumous attachment to a persona rather than a person thus followed a course similar to that of its predecessor project.

The Architect's Two Bodies

The fact of the building's realization has led more recently to an additional exhumation of the question of authorship. In 2015, the submission to planning authorities of a proposal to modify certain aspects of No. 1 Poultry met with a strong reaction. The firm Buckley Gray Yeoman had prepared plans for interior and exterior alterations to the building in order to redevelop its commercial spaces, prompting a number of previous participants in the Mansion House process, as well as some new protagonists, to speak out in protest. One preservation advocacy group called for the building to be listed Grade II (an appeal whose ironic relation to earlier events could not be overlooked) in order to prevent or mitigate any future changes to Stirling's design. Palumbo and Rogers both endorsed this petition, with Rogers arguing that "James Stirling was the first British architect to develop a truly modern style" and that No. 1 Poultry, "one of his last buildings," was a "beautifully designed, post-modern masterpiece."[44] Stirling's widow, Mary Stirling, conceded the possible need for changes to the building to ensure its maintenance and viability, and what she called the building's "integrity," but opposed the specific proposals under consideration, which would, she argued, "emasculate the design concept."[45]

Contrasting aesthetic judgments were accompanied by the disputation over interpretations of authorial presence. Some nineteen former employees of the firm Stirling, Wilford, and Associates (which had been a limited company, in other words, a corporate body) joined the defense of No. 1 Poultry, adding their support to the petition to have the building listed. Other parties, however, entered into the public debate to suggest that there was in fact a measurable distance between Stirling's architectural ideas and the realized building. One of the titular partners of Buckley Gray Yeoman suggested that the new scheme intended only to rectify certain shortcomings that Stirling himself would have corrected had he been alive during the final stages of design and during the period of construction. The insinuation that the design was at some remove from Stirling's intentions was translated into explicit terms by Tom Muirhead (who had worked with Stirling on the Venice Biennale bookshop pavilion), who stated flatly that if Stirling had been alive, the building that emerged from the construction site "would be profoundly different" from the one recommended for listing: "When I look at No. 1 Poultry I see the well-meaning approximation or simulacrum of a James Stirling building completed by acolytes, who must admit that they could not possibly have known what he might have done."[46] This claim provoked in turn a rebuke from Michael Wilford:

> I worked alongside James Stirling for over 30 years (in partnership for 21 years) and participated in the meticulous design process which the office employed for each project. Ideas and decisions were sequentially layered over each other, obviating the need for subsequent changes and avoiding the occurrence of doubt and dissatisfaction with the design. Drawings and models were not released from the office unless James Stirling was satisfied with them. From a first-hand position I can confirm that the assertions are untrue, misrepresent the status of the project at the time and are self-serving.[47]

Echoing Peter Carter's inquiry testimony from three decades earlier, Wilford's argument returned to the difficult circumstances of architectural personhood and authorial presence, then as now balanced on a fragile calibration of persona, signature, and anonymity. The process employed by the office, and the sequential layering that Wilford claimed it produced, became embodiments for authorial presence, one subsequently verified by the support of anonymous (in terms of the process of design, though named at least as signatures on a petition) employees.

To affirm or refute the accuracy of either account of the design history of No. 1 Poultry, though, is not the point; rather it is to reveal the instrumentality of that uncertainty, which has origins in the aesthetic and in architectural ugliness. As with the usefulness of the pile at South

Figure 59. Memorial to Sir James Stirling, designed by Celia Scott and carved by Lois Anderson. Christ Church Spitalfields (2004).

Bank or the approbation of ambiguity and therefore ultimately incongruity in the case of St. Stephen Walbrook, instrumental terms were needed here to navigate that uncertainty, and the composite of corporate and individual personhood—the architect's two bodies—answered that need. The building was awarded Grade II listed status in late 2016, but the events that preceded the result were once again a resummoning, a summons issued to the persona of the architect on behalf of a historical present. In the endeavor to assign responsibility as a prerequisite of passing judgment, this summons would again participate in the invention of the persona being recalled, translating the qualities and intentions revealed in an aesthetic register into those of a professional or corporate or bureaucratic register of categories, licenses, nomenclature, and other instruments of administration.

Set against these impersonal and legalistic instruments is a small memorial plaque in the vestibule of Christ Church Spitalfields, in the east of London. Carved in slight relief, its details are spare, simply the form of an arch set above the outline of a pediment. (Figure 59) The plaque is dedicated to Sir James Stirling, whose ashes are interred behind the stone. Both the persona and the bodily remains are thus present here, in a building that is itself one of the masterful works of the architect Nicholas Hawksmoor, who designed the church at the beginning of the eighteenth century and to whose authorship is assigned the value of the architecture. Damaged in the nineteenth century and fallen into disrepair in the twentieth, the church was closed for a number of years before a program of restoration commenced. The fabric of the church was rebuilt and several hundred bodies exhumed from its vaults, with the object of bringing the building back to pastoral use while also preserving Hawksmoor's architectural conception into the future. This dual intention, of an active church and a passive historical object, was set into tension by the persona of the architect.

Like the stone altar in St. Stephen Walbrook, the Stirling memorial required a faculty, for it contravened standards for memorials placed within churches such as Christ Church Spitalfields. First, it was not intended

that the church become the repository of any more human remains; and second, a memorial, even without remains but certainly with them, was presumed to acknowledge a deep and specific connection to the church, both in terms of the practice of faith and also in terms of marked support for a particular parish. Stirling did not appear to have met these criteria, and thus more careful consideration by the Consistory Court was required. Opponents argued that the physical presence of human remains—the body of the architect, even as ashes—could pose a cultural boundary within the neighborhood of the church.[48] But an even greater issue to the opponents was that Stirling had not been a parishioner, nor had he been a faithful member of the Anglican congregation, and to grant him the privilege of a memorial would open a precedent for any number of future requests for similar honors. The diocesan advisory council, in considering and approving in principle the Stirling memorial, had qualified that "it would not be appropriate for this great building to become a 'pantheon' for deceased architects."[49] The response to the objection that Stirling could not be considered a member of the church was that he had been one of the most dedicated advocates of the restoration of Hawksmoor's building, and that upon his death donations to the church funds in lieu of flowers had provided enough money to restore the Georgian doors and entrance connecting the vestibule and church. As a benefactor in this sense and as a champion of Hawksmoor, he was seen as a legitimate candidate for the honor of a memorial.

The Consistory Court, although sympathetic to some of the opponents' concerns, agreed with the petitioners that the memorial should be allowed, though as a singular instance and not a precedent for further concessions, and therefore granted the faculty. The presence of Sir James Stirling in Christ Church Spitalfields is therefore also attributable to developing and mutable ideas of architectural persona. In this instance, and in the Mansion House Square inquiry that preceded it, aesthetic judgment gave substance to instrumental discriminations through the institutional constructions of personhood, rather than through the descriptive devices of taste and style. Quite simply, the architectural profession was not just a fact, but a mode and a framework for aesthetic judgment. The conjunction of Stirling and Hawksmoor in this presumably permanent, not to say eternal, fashion puts forward the figure of authorship and persona as an instrument of social consequence, but at the same time the accompanying legal provisos that aim to make this memorial a singular instance give presence to anonymous bodies as well—to the exhumed bodies of the Christ Church crypt, but also to the dead and living bodies that structure the practice of architecture as a profession.

Chapter 7
The Monarch

In what was perhaps the most widely quoted accusation of architectural ugliness in the latter decades of the twentieth century, the Prince of Wales offered a scathing assessment of a proposed extension to the National Gallery in London: "Instead of designing an extension to the elegant facade of the National Gallery which complements it and continues the concept of columns and domes, it looks as if we may be presented with a kind of vast municipal fire station ... what is proposed is like a monstrous carbuncle on the face of a much-loved and elegant friend."[1] The design of a long-anticipated addition to William Wilkins's 1838 building had proceeded through a somewhat convoluted competition process.[2] During the short list stage, in May 1982, the general public were invited to vote for their most and least favorite schemes among seven selected from the large pool of entries. Some eleven thousand out of nearly eighty thousand visitors did so, with the results defining a ranking of three proposals but also anomalous indicators of opinion, such as the fact that one design (by Richard Rogers Partnership) received enough most favorite votes to be in the top three while simultaneously getting the highest overall number of least favorite votes. The process proceeded clumsily, with Ahrends, Burton, and Koralek, the first choice in the public survey, selected as the winning firm but asked to propose a revised design, which was submitted for planning permission in December 1983.[3] (Figure 60) Because of the prominence of the new extension, and the prominence of the listed building to which it was juxtaposed, the secretary of state moved the application directly into a public inquiry.

This inquiry, held in April 1984 in the Council Chamber of Westminster Council House, was not in itself a dramatic affair—the planning inspector

Figure 60. Notice of application for planning permission for an extension to the National Gallery, filed in December 1983 under requirements of the Town and Country Planning Act.

noted that "a striking feature of the inquiry was the lack of involvement and attendance"—but it would be wrong to mistake this for unimportance or irrelevance.[4] Rather it should be considered in terms of its sequestration of aesthetic discourse within procedural terms and categories. These terms and categories did not place such an emphatic focus upon persona as those in the Mansion House inquiry (which was to begin the following month), but they nevertheless placed the aesthetic dimensions of architecture into a procedural framework. And through this framework it was possible to subordinate the characterizations of taste in favor of those of propriety. The first design entered by Ahrends, Burton, and Koralek in the initial stage of competition had, like many other entries, attempted a deferential relationship to the original National Gallery building. Offset

from the main building by an exterior rotunda, its primary facade of stone and glass conveyed the impression of four arched bays similar in scale to the neoclassical arrangement of the predecessor building, but more subdued in expression. In the firm's final proposal, under examination in the inquiry, the masonry and glass of the facade were arranged into a dense grid of square panels and a thirty-meter-high glazed tower occupied the space between old and new buildings, with a stepped form and a scaffold of masts at its top. (Figure 61) Strong criticisms of the design included satirical insults by members of the Westminster City Council that the "intrinsically dull" design was an example of "lavatorial architecture"; in its place, one councilor wanted "something more beautiful, more lovely."[5] A defense of the scheme from the president of the Royal Institute of British Architects (RIBA) was less an endorsement of its appearance than a rebuke of the elevation of subjective opinions to the standard of technical analysis. At the conclusion of the inquiry, the inspector explicitly stated that he would not vouch for the aesthetic excellence of the design, but he recommended that planning permission should be granted. However, after receiving the inspector's recommendation in June, the secretary of state (Patrick Jenkin, as in the Mansion House Square inquiry, responsible for the final decision) refused planning permission.

Between April and June, a pivotal and now infamous event occurred outside of the proceedings of the official inquiry. The Prince of Wales, addressing the RIBA—addressing directly therefore the architecture profession—delivered his scornful critique of the appearance of the proposed addition as "a monstrous carbuncle on the face of a much-loved and elegant friend."[6] The criteria for this judgment of ugliness were evident, consisting in the contrast of materials—although the proposed addition was masonry in part, glazing covered much of its facades as well as the tower—the contrast of ornamentation, and, most significantly, the contrast of a modernist building with the neoclassicism of the original. The prince's statement immediately sparked controversy, recorded not only in newspaper articles and letters to the editor but also in confidential memoranda circulated in the Department of Environment, led by the secretary of state who would be responsible for a final determination following the inspector's inquiry. The civil servants who wrote these notes expressed alarm at the "dangers of the Prince's expressing his views on schemes which were *sub judice*."[7] The prince's private secretary had contacted the department the day before the speech and explained that it would criticize the National Gallery proposal along with other projects (including No. 1 Poultry, also under inquiry). The reply from the department was that the proposal was under a planning inquiry and no official statement could be made, with the clear implication that the prince's remarks were likely to be seen as improper.

Figure 61. Revised proposal for the National Gallery Extension, seen at center of the drawing, to the left of the "face of a much-loved and elegant friend," Wilkins's 1838 facade. Ahrends Burton & Koralek (1983).

After the speech, with the secretary of state facing criticism himself for not preventing the remarks, John Delafons, a veteran civil servant and deputy secretary of the department, concluded, "I would agree that HRH [His Royal Highness] was very unwise to launch such an attack on two schemes that are currently the subject of planning inquires. Both schemes are financed by private developers and Parliament has provided the means, under the Planning Acts, for dealing with such proposals." Recommending an official course in response to the event, he advised, "As HRH did not put his point of view at the public inquiry on either scheme, neither the Inspectors nor the Secretary of State are obliged to take any account of it in reaching their conclusions.... We should, for the purposes of the formal procedures, treat it as we would had the remarks been made by any other person.... The fact that the remarks were made by HRH does not mean that they should be treated any differently as regards the inquiry procedures."[8] The prince's statement did not enter into the inquiry as testimony, or indeed in any formal way as evidence, but the exchange of worried memos and the public commentary in the press made perfectly clear that the statement was not treated as that of any other person. When the secretary of state decided, as he had full discretion to do, to reject the planning inspector's recommendation and to refuse planning permission it was immediately and not unreasonably supposed that the prince's speech had encouraged his decision. The influence of this particular statement was simply not comparable to that of

other published criticisms, such as those from the Westminster councilors, carrying as it did the authority of a future monarch and resembling therefore nothing so much as the wish of a patron. Yet the statement was treated not only as an assertion of royal prerogative, because it was also understood to be in alignment with a broadly popular feeling of disaffection for modern architecture and therefore to be, quite potently, an assertion of public preference as well.

A few years later, in 1987, at the annual dinner of the Planning Committee of the Corporation of the City of London, the Prince of Wales voiced his serious concern over Paternoster Square, a planned development adjacent to St. Paul's Cathedral: "Surely here, if anywhere, was the time and place to sacrifice some profit, if need be, for generosity of vision, for elegance, for dignity; for buildings which would raise our spirits and our faith in commercial enterprise, and prove that capitalism can have a human face."[9] But the designs that had been proposed seemed to him to be entirely given over to financial calculation, excessive in their square footage, deficient in the generosity of their public amenity, and in style and scale antagonistic to the historic monument that they would overshadow rather than complement. Such designs, he argued, could not plausibly be praised as good unless they were being assessed only according to some astringent quantitative measure or some impassive technocratic checklist. Referring to free-market economics, to the influential writings of Hayek and Mises, to the deregulatory Big Bang of London's financial markets, he made clear his understanding of the neoliberal frameworks that encompassed these schemes and deplored their reductiveness. He hoped that they would be reconsidered in favor of more contextually sensitive—and if necessary financially sacrificing—designs.

In making this argument, Prince Charles presented himself as a barometer of public opinion expressing feelings that were widespread and commonly held: "it is not just me who is complaining—countless people are appalled by what has happened to their capital city"; "if there is one message I would like to deliver this evening, in no uncertain terms, it is that large numbers of us in this country are fed up with being talked down to and dictated to by an existing planning, architectural, and development establishment"; "we, poor mortals, are forced to live in the shadows of their [the professionals'] achievements."[10] This "we" was not a royal "we." The pronoun nominated a collective of the British public whose sentiment and desires could be identified and conveyed. An eyebrow must be raised, of course, at any future monarch's claim to speak as a poor mortal, with, and therefore on behalf of, the common man. Yet the sentiment expressed could have had resonance at any moment from the middle of the nineteenth century onward. The anticipation of some more elevated social condition marked by the qualities of elegance

or generosity had a Ruskinian echo, while the optimism that commerce and capitalism might be aimed toward benevolence repeats the hopeful cadences of postwar economic booms. There was also the regretful conviction that economic logic and aesthetic consequence are at odds, and that the increase of the one requires the sacrifice of the other, a common enough refrain, as was, above all, the complaint about a professional class hostile to the desires of a general public.

Following his rhetorical inquiry as to whether profit might be sacrificed for elegance, Prince Charles posed the crucial question: "what place, if any, do the opinions of the general public have within the legal labyrinth of the planning system?"[11] The current system, he told his audience, had relegated public opinion secondary to professional opinion, such that a system of technocratic projection and assessment operated in largely self-reflexive terms, disengaged from pedestrian concerns, popular taste, and, at its most extreme, even from commonly held human values. This critique that "what architects think" must be utterly dissimilar from "what people think" is familiar enough, having proliferated throughout Europe and North America (and thence beyond) during the latter half of the twentieth century. Spoken in London in 1987, amid shifting perspectives on the social and cultural inheritances of the welfare state—with modern architecture very much one of these inheritances, as evidenced by the inventory of London County Council buildings constructed around midcentury—and amid the production of new configurations of aesthetic discourse, the sentiment expressed not a regretful retrospective view, but a call for architects and the developers who commissioned them to begin to take notice of the demands of popular opinion. More generally, though, it was a critique of the bureaucratic architecture of the postwar period, the managerial practices of the welfare state, and a critique of the relation between architecture and the welfare state. The presumption here was that a form of governance in which the articulation of decisions and procedures (such as what to build, or how, or what a building should look like) was the responsibility of bodies at a remove from representative government and at a remove from personal influence had resulted in an abstracted realm of technical vision.

Such critiques depended upon the idea of public opinion, a phrase and a conceptual term very much taken for granted as attention played, and continues to play, rapidly across architectural, economic, or political merits in an architectural debate. Taken for granted not in the sense that public opinion is ignored or falsely interpreted, but in the sense that public opinion has been presumed to exist, to be a concrete and measurable expression within the structures and protocols of cultural debates and civic proceedings. Put simply, public opinion is presumed to be a fact. From the 1930s through the 1950s, Mass Observation famously aimed

to produce comprehensive records of the thoughts, feelings, and habits of Britons that could be deployed first as a form of academic or cultural knowledge and later commercially as market research; the extensive archive of letters and diaries compiled by Mass Observation give credence to the perception that public opinion is a factual matter, but they also demonstrate that its factuality must depend upon the circumstance or the institutional setting in which it can be instrumentally deployed.[12] In other words, public opinion must have a medium; judgments of ugliness must have a medium. The means by which public opinion and professional opinion meet and contest one another do not remain stable, though curiously stable has been the agreed point of contention, or the pivot of difference, around which they orient themselves: the aesthetic.

Architecture and the Bodies of Public Opinion

In the succinct assessment of the architectural historian Peter Collins, "'Aesthetics' have long enjoyed undeserved prominence in definitions of architectural ideals."[13] Collins made this claim within an argument that identified the misaligned perceptions of public and profession as a specific and rather critical problem. What Collins described as the "credibility gap between professional comprehension and public comprehension" was increasing, he argued, because both sides mistakenly prioritized the aesthetic dimension of architecture. He did not wish to deny that aesthetics were a fundamental concern, but questioned their primacy in judgments of value. The aesthetic dimensions of architecture should instead be incorporated into a matrix of considerations embedded in the design process—structural efficiency, human safety, material longevity—fully known to professionals but invisible to the public. It becomes clear that Collins sought to achieve some stabilization of judgment, at a moment at the beginning of the senescence of the welfare state and with the first suggestions of a postmodern condition emerging, and that he sought this stabilization on terms favorable to the professional, arguing that the success or failure of an architectural design was "only determinable by those with the professional skill to understand [the full matrix of considerations]." An unhelpful conclusion if Collins had not taken one further step, which was to admit the fragility of this professional judgment: "I would contend that the real problem of professional ideals has nothing to do with rival aesthetic theories of the plastic arts, but is the result of a dilemma which confronts all those who practise [sic] a profession with full awareness of their human frailty. That dilemma is the extent to which any professional expert can really trust his own judgment."[14]

Recognizing this fragility of professional certainty as a dilemma led Collins to argue against both the certification of absolutist ideals *and* the

consensual diffusion of architectural ideals into a "climate of opinion," to argue against both technocratic dogmas and popular taste cultures. In their place Collins advocated an assertion of architectural principles based upon judgment that was continually tested and refashioned in a process similar to that of legal reasoning. The inspector who led the Mansion House inquiry expressed a similar view, noting at the very outset of his "Findings of Fact" that "it is always difficult to know what weight to attach to expressions of public opinion, especially where, as in relation to the present appeal applications, there has been no controlled testing."[15] More relevant here than the aesthetic or interpretive principles Collins himself might actually have endorsed is the mediating process of judgment enacted by the inspector, for it describes a process capable of containing professional *and* public opinion, a process of testing and revising judgment in light of conditioning facts on the model of legal procedure.[16] The incremental development of the administrative state that emerged in Great Britain in the mid-twentieth century included the 1947 Town and Country Planning Act, which established a comprehensive planning permissions process under which virtually all new development—all new architecture, in other words—was subject to review by local planning authorities. This same act also incorporated provisions regarding the treatment of listed historic buildings, provisions that came to operate quite directly with the planning permission process. Under the 1947 act, architecture became subject to formal public scrutiny. An application for planning permission would be reviewed by a planning board, whose members might be professional but who were delegates of the general public, according to a transparent protocol that also allowed for interested parties to submit their views or opinions. If permission was refused, the 1947 act provided the possibility of an appeal, and it is this particular contingency—the appeal—that evolved into a singularly instrumental space of architectural debates on civic aesthetics.[17]

The appeal is made by the party applying for permission to build who has been denied, and it is made to the secretary of state.[18] The secretary of state then designates a planning inspector to hear the appeal, and the inspector in turn convenes a public inquiry, a hearing of material arguments for and against the proposed development. It is also possible for the secretary of state to "call in" an application for an inquiry, even prior to the local planning review; this action is customarily taken in cases where the public interest regarding an application is manifestly a national concern or appears to turn upon a conflict in national policy. The inquiry adopts the model of a judicial proceeding, with the inspector in the role of judge (though he or she is not in actuality a judge in the legal system), and with advocates for and opponents against the application for planning permission. These advocates and opponents, very often represented

by lawyers, present evidence; expert witnesses are called and examined and cross-examined; interested institutional parties may weigh in with their positions on the case. Even the room in which an inquiry is held is modeled on a courtroom. (Figure 62)

The inquiry permits the expression of embodied points of view, though these expressions are mediated through the protocol of the inquiry itself and the institutions that stand in for individuals in this civil arena. To whom do the points of view belong, and by whom are they embodied? The property owner is one, and, as evidenced by the history of nuisance law, holds a preeminent standing derived from the ancient respect accorded to property in common law as a basic unit of social organization. The property owner (who may well be a corporate body) is embodied by a legal representative, a solicitor or not infrequently a barrister. Alongside the property owner, embodied by the same legal representative, is almost certainly a member of the architectural profession, the architect (again likely a corporate body) responsible for the proposed design under scrutiny. On the other side of the adversarial courtroom is the public. This public has many actors, and can include neighboring property owners or local government and local institutions or members of the local community. In planning inquiries related to prominent projects such as the National Gallery extension or the Mansion House Square proposal, the embodiment of the public will often include the presence of one or more national amenity societies.

The national amenity societies are voluntary groups whose efforts are directed toward the preservation of significant works of architecture, and that have been recognized by acts of parliament to have legal standing within planning inquiries. The oldest of the societies, the Society for the Protection of Ancient Buildings, was founded in 1877 by William Morris, and given legal standing in inquiries in 1968 under amendments to the Town and Country Planning Act. Three other societies represent specific historical periods: the Georgian Group, founded in 1937 to advocate the preservation of architecture from the eighteenth and early nineteenth centuries; the Victorian Society, founded in 1958 to pursue the protection of buildings built during the reign of Queen Victoria; and the Twentieth Century Society, founded in 1979 as the Thirties Society but since renamed to represent an expanded interest in British architecture from 1914 onward.[19] These four national amenity societies thus comprehensively cover the span of British architectural history, not as governmental agencies, but as voluntary embodiments of public interest. In the circumstances of a given inquiry, the national amenity societies will gather expert witnesses, provide documentation, and assemble briefs and petitions, all as elements to constitute a concrete expression of public opinion.

The monarch has no special legal standing or royal prerogative within the space of the planning inquiry. The planning inquiry as constituted in 1947 was intended precisely to diminish such forms of prerogative, and did so in formal terms. As a representative of public opinion, the monarch could appear in the space of the inquiry through one of the elements that possess legal standing, such as one of the national amenity societies. It is also possible that the Crown may be represented in the inquiry as property owner; the Duchy of Cornwall, for example, in the possession of the Prince of Wales, amounts to 130,000 acres of land. But there is no formal standing or privilege as an embodiment of state authority, and the planning inquiry is thus marked by

Figure 62. "Suggested Layout of an Inquiry Room," from *The Venue and Facilities for Public Inquiries and Hearings* (UK Planning Inspectorate, 2013).

ANNEX 1 – SUGGESTED LAYOUT OF AN INQUIRY ROOM

a particular absence, the absence of a prerogative capable of claiming a peculiar dual authority of singularity (a monarch) and multiplicity (a body politic).[20] If the inquiry is made resistant to the blandishments of that voice, it is also resistant to the endorsement of that voice, so that patronage would properly have no role in the legal procedure. The "fact" of aesthetic approbation can be entered into the deliberations of the planning inquiry in various ways—for example, through expert testimony by architects, or by architectural critics, or borough councilors, as they were in the case of the National Gallery inquiry. But the case of the National Gallery extension, with the result of the inquiry weighed equally, as it seemed, with the statements made by the Prince of Wales, exposed the possible translation of aesthetic judgment into the register of patronage, with the dual voice of the monarch and the people assuming a peculiar standing as being removed from the legal inquiry, yet still enforceable upon it.

For the architects who formulated the principles of civic architecture in Britain in the early modern period, the relationship between

Figure 63. Tapestry portraying Queen Elizabeth I received by Sir Thomas Gresham on the opening of the Royal Exchange, 1571. Richard Beavis, "Opening of the Royal Exchange" (1887).

the monarch, architecture, and public life was an explicit concern. (Figure 63) For Inigo Jones and his contemporaries, in the decades prior to the Civil War, and for Sir Christopher Wren and his contemporaries, in the decades following the Restoration, the distinction between the monarch and the people was politically fraught as diverse elements of civic life sought authority within the structures of common law, or the court, or political economy. But within this context, the role of architecture was one of representational clarity: to represent the monarch, and therefore the state, was to represent the people or the nation. Under the medieval conception of the king's two bodies, the monarch was understood to have a physical, mortal body but also a metaphysical, immortal body, the one installing a real presence, the other conveying a symbolic duration. For Inigo Jones, as surveyor of the king's works responsible for the design of royal buildings such as the Banqueting Hall, the two bodies of King James I had direct architectural corollary in the columns of his *all'antica* designs. These columns were present in the building as physical structure and as metaphysical appearance of idealized proportions.[21] The relationship between lived reality and legal authority was contained in singular form by the idea of the king's two bodies, and contained therefore, in the aesthetic register, in the architectural column as well.

For the architects who developed the civic landscape of Britain following the Second World War, the conceptual and political understanding of the relationship between the monarch, architecture, and public life was obviously very different. (Figures 64 and 65) For Sir Basil Spence or Sir Denys Lasdun or their contemporaries, the monarch who attended the

opening of a civic building or who presided at a ceremonial laying of a cornerstone stood at a distance from public life not because of a divine right to assert law but because of the deliberate separation of the monarch from governance instituted over the intervening centuries. When Queen Elizabeth II, in 1956, set the foundation stone of Spence's new Coventry Cathedral, its modern architecture was taken to be a symbol of a newly restored public life, but with no parallel restoration of the monarch to legal authority. Whether there will, retrospectively, be identified a Neo-Elizabethan period of architecture to reflect the long-reigned modern monarch in similar fashion to her predecessors remains a subject of speculation. But with or without a stylistic designation, what is perhaps distinct about the period is the measurable reflection in architectural terms of a peculiar relation between monarch and public that is

Figure 65. Queen Elizabeth II lays the foundation stone of Coventry Cathedral, March 23, 1956.

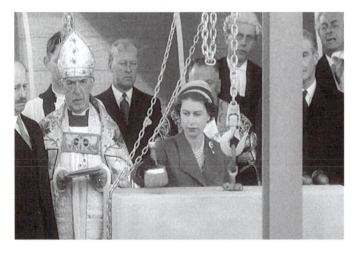

at once more distant and more intimate. It is not the designation of style that will reveal this, but the translations of taste into procedural forms through aesthetic debate over the matter of ugliness. Like the column for Jones or Wren, these procedural forms mediate the embodiment and disembodiments of the monarch; they mediate a corporeal presence and what was in the early modern period a legislative presence, but which is now an instrumental legislative absence, instrumental because by being absent from the legislative forum, it is able to lay claim to the form of public expression.

Of course, the royal figure who has with his public expressions entered strongly into architectural debates and who has repeatedly put forward the charge of ugliness is not the monarch but a monarch-in-waiting, the Prince of Wales, heir to the throne. Prince Charles's standing within these public debates, and specifically within the legal proceedings that accompany and shape them, is far less definite and therefore far more complex. The public has standing, through the mechanisms outlined above, but the monarch does not, as a result of the historical arc of representative democracy from the Restoration to the present day. Prince Charles, however, though he is neither public *nor* monarch, would suggest the representation of both public *and* monarch. And it is precisely this status that, through the aesthetic debate on ugliness, has been brought vividly into view as an aspect of the civil sphere, for following the refusal of planning permission for the first proposed extension to the National Gallery, and continuing as Prince Charles's critical pronouncements upon architectural projects accumulated, concern arose over the

propriety of his interventions into public debate. If the planning process had been established precisely in order to ensure representation in the matter of the development of the nation's built environment, did these interventions circumvent that process entirely, permitting the entrance of a royal fiat presumed extinct? Supporters of the prince and his architectural opinions argued that they did not, that they amounted to no more than expressions to which any private citizen was entitled. Critics of the prince and his architectural opinions argued that they usurped an extra-constitutional power to which the prince was not entitled, and amounted to a direct and unconstitutional intervention by the monarchy into the political life of the nation. While newspaper reports often characterized the events as squabbles over taste, fought between a professional class and a princely man of the people, the judgment of ugliness was here not solely a question of aesthetic preference, but an assertion of political authority between these rivals.

In the Shadow of Sir Christopher Wren

The postmodern historicism that in the 1980s and 1990s brought forward a neoclassical architectural movement (called the New Classicism by some of its protagonists) accompanied by broader antimodernist sensibilities centered architectural debate at the millennial turn around questions of style: traditional versus modern and therefore traditionalists versus modernists. But although style was undoubtedly a significant aspect of the conceptual transformations then taking place, it was in many ways more symptom than cause. From the 1980s onward, the architects, critics, politicians, and patrons pitted against one another in forum after forum established alignments between the overt characteristics of architectural appearance and the presumed social standing, economic standing, and even ethical standing of supporters and detractors of those appearances. And it was therefore often the case that existing motives—the political predispositions of individuals or their economic interest—were presumed to be the spur toward aesthetic preferences.[22] In a manner recalling eighteenth-century aesthetic philosophy, taste and morality were once again identified, though now with the complex layerings of modernity rendering them institutional characteristics as much as personal ones. The politics woven through architectural disputes such as the National Gallery extension, the Mansion House proposal, or the hearing on St. Stephen Walbrook, though evident in many of the personalities involved, could be equated with aesthetic judgments only in complicated ways. While the individual motives of Lord Peter Palumbo, or the Prince of Wales, or those of architects such as the modernist Lord Richard Rogers or the classicist Quinlan Terry are

obviously pertinent, to see them as conclusive is to remain constrained by an older paradigm of taste. In the present-day iterations of the long British debate on architectural ugliness, the alignment of political orientation and aesthetic preference in a simple accounting of political interests may distract from the critical perception of the instrumental structures and processes that have emerged to enable aesthetic judgment to participate in civic life.

In late spring 2005, the design for a new infirmary at the Royal Hospital at Chelsea was reviewed by the local authority, the borough of Kensington and Chelsea planning committee, and put forward for a vote. But just hours before the committee was give its approval, the deputy prime minister, John Prescott, invoked Article 14, a three-week holding delay to consider, as his office announced, whether possible objections to the scheme required the proposal to be called in for a planning inquiry. Two government bodies, English Heritage and the Council for Architecture and the Built Environment (CABE), had already given their clear approval to the scheme, which was to neighbor the original hospital buildings designed by Sir Christopher Wren. One local group, the Chelsea Society, founded in the early twentieth century in response to demolitions to protect the character and amenities of the neighborhood, had expressed opposition to the scale of the new building, but the architect of the scheme, Quinlan Terry, was well known for his contextualist approach to design and reverence for historical architecture such as the Wren buildings.[23] It quickly emerged that the government had taken the unusual and unexpected decision to impose the holding delay in response to concerns that Richard Rogers had privately conveyed to the government along with a request that the proposal be called in for an official planning inquiry. The dispute then unfolded in the pages of professional journals and the daily newspapers, with Rogers and other critics disparaging Terry's design as ill-conceived and inappropriate company for Wren, and Terry and his supporters protesting the unorthodox intervention into the planning process. To Rogers's scornful description of the proposed infirmary as a pastiche, an "architectural plagiarism" unsuited to the site, Terry responded angrily that the intervention was an abuse of unofficial access to the government.[24] At the end of the three-week period, the government chose not to convene a planning inquiry, allowing the scheme to proceed under the local permission. Terry's new infirmary opened a few years later. (Figure 66)

Significant as it was, in retrospect this episode was in some ways only a prelude to another dispute centered upon Wren's Royal Hospital at Chelsea. This subsequent dispute concerned the development of Chelsea Barracks, a parcel of land adjacent to the Royal Hospital Chelsea (and facing Terry's infirmary building across the street) sold off by the

Figure 66. Aerial view of Royal Hospital Chelsea, with the original Wren buildings at center and the new infirmary designed by Quinlan Terry at the top center of the photograph.

government to a private consortium. The joint developers—CPC Group of the London property magnates the Candy brothers, and Qatari Diar, a real estate investment company of the Qatar Investment Authority controlled by the emirate of Qatar—had proposed a large complex of residences, with a density calculated for financial return, and commissioned Rogers's firm, Rogers Stirk Harbour + Partners, for the architectural design. A first scheme, in a modernist idiom contrasting with Terry's adjacent classicism, with rectangular blocks set perpendicular to the streets and clad in glazing and panels set between clearly expressed structural frames, was modified in response to comments from CABE and from the local council. In 2009, the revised scheme, still with its idiom of structural frame and panels, still with separate blocks, and still with modernist conviction, had progressed to the point of submission for planning permission. But shortly before the case was to be formally reviewed, the developer withdrew the planning application entirely, with the intention to hire a new architect to pursue the development. In this instance of a sudden suspension of the planning proceedings, it emerged that the Prince of Wales had conveyed privately an opinion on the design, explaining directly to the emirate his feeling that the proposed scheme and its architect were unsuitable.

The antagonism between Prince Charles and Lord Rogers was by this point decades old and firmly entrenched, but the provocation in this

Figure 67. Proposal for Chelsea Barracks, drawn by Francis Terry. Quinlan & Francis Terry Architects (2009).

particular case, from Prince Charles's point of view, was not that the proposed design was by Rogers Stirk Harbour + Partners, but that Wren's hospital grounds should not have a context of modern architecture imposed upon them by this adjacent development; from Rogers's perspective, the provocation was not simply the criticism of the design, but more egregiously the manner in which that criticism had been conveyed outside of the protocols of the planning process. Rogers immediately accused the Prince of Wales of an unconstitutional intervention in the democratic process established more than a half century earlier by the 1947 Town and Country Planning Act. By conveying his opinion in private—effectively speaking as one royal to another—Prince Charles had conveyed the impression, according to Rogers, of an official disapproval that the emirate would necessarily take into account. The prince's disapprobation, however, had no official legal standing; it had not been entered into the by then well-advanced planning permission process, as had many statements of public support and opposition. The defense offered on behalf of the Prince of Wales was twofold: first, that his communication was that of a private citizen and was therefore not an intervention into the planning process, and additionally, his aesthetic judgment was correct and shared by others—Quinlan Terry, with a sketch drawn by Francis Terry (his son and partner), quickly published a substitute design for the development, giving an explicit model to accompany the prince's judgment. (Figure 67)

The aesthetic prompt for the ensuing controversy—the architecture of the proposed development, its suitability in relation to its famously authored architectural neighbor, and its public appreciation as a contemporary form and idiom—these elements that were claimed to have ignited the dispute were soon translated into a political register. The prince had, Rogers and his supported argued, circumvented the constitutional separation of the monarchy from political process, creating not only an unfair distortion of the evaluation of the Chelsea Barracks scheme and a consequent financial loss, but also a constitutional crisis about the

role of the monarchy itself. While representatives of the prince declined any comment as to whether he had issued private communications regarding Chelsea Barracks, the details of his actions were subsequently confirmed.[25] He first had written to the prime minister of Qatar, cousin to the emir, saying, "I can only urge you to reconsider the plans for the Chelsea site before it is too late. Many would be *eternally* grateful to Your Excellency if Qatari Diar Real Estate Investment could bequeath a unique and *enduring* legacy to London."[26] Two months later, he took the opportunity of a private meeting with the emir in London to repeat his disapproval of the proposed design. The application for planning permission was withdrawn soon thereafter.

A number of leading architects, an international group with Pritzker Prize winners and other honorees among them, joined Rogers in denouncing the political implications of the prince's actions and expressing alarm over the implied assumption of power:

> It is essential in a modern democracy that private comments and behind-the-scenes lobbying by the prince should not be used to skew the course of an open and democratic planning process.... If the prince wants to comment on the design of this, or any other project, we urge him to do so through the established planning consultation process. Rather than use his privileged position to intervene in one of the most significant residential projects likely to be built in London in the next five years, he should engage in an open and transparent debate.[27]

Other participants in the architecture and planning professions pointed out that the ideal of a transparent planning process accessible equally by all British citizens remained just that, an ideal, and that the prince's actions, while undesirable, were not unique. The president of the Royal Institute of British Architects offered the diplomatic explanation that "it's difficult for citizens, even the Prince of Wales, a prominent Westminster resident, to take part in the planning process. Most people feel disenfranchised, and believe that decisions about big developments such as Chelsea are 'done deals' taken behind closed doors," while the editor of *Building Design*, Amanda Baillieu, suggested, as the prince himself had previously done, that he was "speaking up because he feels local people, aside from anyone else, are not being listened to."[28] To Rogers and others, however, these actions amounted to nothing short of an "abuse of power" requiring an urgent response: "We should examine the ethics of this situation. Someone who is unelected, will not debate but will use the power bestowed by his birth-right must be questioned."[29]

The challenge issued by Rogers and those who agreed with his complaint took on a broader significance beginning the following year, when

a journalist for the *Guardian* newspaper filed an appeal to fulfill a freedom of information request to see copies of letters that Prince Charles had written to government ministers. These letters, which were known as black spider memos for their distinctive scrawl in black ink, raised the concern that the prince had communicated his opinion on a range of issues with political implications, and had therefore violated the constitutionally established political neutrality of the monarch. Though the *Guardian* request sought memoranda written a few years prior to 2009, the publicity around the Chelsea Barracks dispute only strengthened the demands that these communications should be made public; indeed, the dispute was specifically referenced by the applicants. A complicated legal process ensued, beginning first with the refusal by the information commissioner and government departments to fulfill the request, followed by a judicial hearing held in 2012 before the Upper Tribunal of the cases made by the two parties, the newspaper on one side and government departments and the Prince of Wales on the other. The argument hinged upon two concepts, the public interest and the constitutional status of the heir to the throne, that appeared to be set into conflict by the prince's communications, with the presumption of the public benefit of transparency set against the constraints imposed upon the relation between the monarchy and the government. It is an acknowledged constitutional premise, known as the tripartite convention, that the monarch has "the right to be consulted, the right to encourage, and the right to warn" and that these rights legitimate communications with ministers in government.[30] However, the Prince of Wales is not the monarch; he is the heir to the throne, and the heir to the throne does not have any constitutional role.

But another constitutional convention, known as the education convention or the apprenticeship convention, does pertain to his participation in political life, specifying the need for the heir to the throne to be educated over time in his future monarchical responsibilities by rehearsal of them.[31] Such preparation for kingship may include the performance of ceremonial tasks as well as discussions with members of government in order to become cognizant of relevant issues, debates, or policies. Barristers presenting the case against the release of the black spider memos put forward the education convention as a central point of their brief, arguing that such rehearsals are customarily and necessarily private and do not constitute an advocacy or persuasion toward specific political outcomes. In putting forward this claim, they depended upon an assertion that the education convention had become more expansive—or even that a new convention had been established—as a result of Prince Charles's long-standing efforts to engage in public discourse and his many contacts with public officials on his topics of concern.[32] Justifying

this "novel" and "innovative" privilege would require a difficult parsing of the public and private roles of the prince, because his established habit of speaking publicly, even, as in his remarks on Paternoster Square, as a poor mortal, as one of the public himself, could not be reconciled with the constitutional requirement that the monarch not offer public views on matters of public interest. It could not be argued that his communications fell under the convention of rehearsal for kingship if his actions were otherwise in stark contrast to the constitutional requirements of that future kingship. Additionally, if the claim were that his communications fell under the prerogative of the tripartite convention, an even more serious question arose as to his possible arrogation of a constitutional privilege that belonged to the monarch alone.

The Upper Tribunal was not persuaded by the novel constitutionalism suggested to protect the black spider memos. Although the tribunal did not find his petitions to government ministers to be unconstitutional (as the *Guardian* journalist asserted in the filing, and as Richard Rogers argued in the Chelsea Barracks dispute), they regarded them as being outside the boundaries of constitutional convention. On the additional point of monarchical privilege, the tribunal spoke unambiguously: "It is the constitutional role of the monarch, not the heir to the throne, to encourage or warn government. Accordingly it is fundamental that advocacy by Prince Charles cannot have constitutional status.... It would be inconsistent with the tripartite convention to afford constitutional status to the communication by Prince Charles, rather than the Queen."[33] Considering the appeal from the opposing side and the weight to be placed upon public interest, the tribunal found that the presumption by the Prince of Wales, and by government ministers, that the communications were private had no bearing—believing them to be confidential did not make them so. "Those who seek to influence government policy must understand that the public has a legitimate interest in knowing what they have been doing and what government has been doing in response, and thus being in a position to hold government to account. That public interest is, in our view, a very strong one."[34] Before the black spider memos could be released, however, the attorney general vetoed the tribunal's decision, arguing in part that the letters contained "most deeply held personal views and beliefs" of the Prince of Wales, and that these should be protected in order to preserve the perception of his political neutrality.[35] A sequence of challenges and appeals over the next two years to overturn the veto eventually culminated in a hearing at the Supreme Court, which ruled that the attorney general's veto had been improperly applied and authorized the release of the black spider memos.

Published in May 2015, the black spider memos did not in themselves satisfy the public curiosity that had been provoked by the strenuous

effort to keep them private.[36] Prince Charles had written to the prime minister and other government figures about subjects ranging from agricultural regulations to homeopathy to the conservation of explorers' huts in Antarctica, in each case with a quite specific point of attention, but collectively the memos contained no significant differences from his public stances. Yet as the drawn-out appeal demonstrated, the argument lay not in the topics but in the very fact of his advocacy and motivated communication to ministers, a process that muddled the formal as well as the informal categories of civic discourse. At the same time as he pursued his private conversations with members of the government, the Prince of Wales presented arguments to professional audiences in the voice of public opinion, suggesting a formulation that is not the familiar distinct segregation of public and private realms, nor a private sentiment expressed aloud in public, but rather the possible construction of a public opinion privately expressed. The Prince of Wales may or may not continue with this mode of communication—a 2010 amendment to the freedom of information laws has exempted the heir to the throne, and the second in succession to throne, along with the monarch—but the instances of architectural judgment of ugliness, in regard to the National Gallery and to Chelsea Barracks, revealed a newly provocative dimension of civic aesthetics: that rather than representing the king's two bodies in a direct, but archaic manner, architecture may serve to dissemble the body politic of the public.

Juridico-Aesthetic Transactions

The personal realm of taste, in order to enter into public discourse and to assume any instrumental effect over civic aesthetics, requires a sequence of translations or structures of mediation—but even then it may not be correct to imagine that taste is the origin or source of judgment. The formulation and development of discursive instruments such as the legal perspective on libel and criticism or the organization of professions has led to the possibility that those instruments too have a role in the production of judgment, which may then be directed back into the standards of taste. The inquiry, as a central forum (and again, instrument) in the processes of planning, should thus be understood not as a neutral space, nor as a space co-opted in advance by protocols of power, but as an apparatus that sustains a field of transactions of judgment. The legal inquiry is a modern apparatus, installed as one of the constitutive elements of postwar planning and more generally of the welfare state structure itself, but could reasonably now be regarded not as a legacy of modernity—an artifact of the welfare state—but as a constitutive space of postmodernity, having evolved over time not only in itself, in its capacities, but also

and perhaps more eventfully in its relations to the other dimensions and structures of the state and civil society. The ecclesiastical inquiry, the venue of the debate over the altar at St. Stephen Walbrook, having eluded the consolidations of postwar modernity, also possesses a constitutive function in postmodernity, only in a different form than its civil parallel. With legitimacy not externally guaranteed by the state, the postmodernity of the apparatus of legal inquiry now manifests in its heightened susceptibility to contingency, a susceptibility apparent most dramatically in its contrast to the presumptive stability of a legal structure. The law should be resistant to change—and so it is in its outward forms—but it is how those forms now produce translations among the contingencies surrounding them that reveals the manner of architecture's participation in judgment and in civic aesthetics.

Through his involvement in the episode of the National Gallery extension, the proposal for No. 1 Poultry, the planning of Paternoster Square, and the abandoned version of the Chelsea Barracks, the Prince of Wales, as person and as legal entity, vividly exposed the contingency of what is designated as public opinion. Theorist Jean-François Lyotard coined the term *différend* to designate a dispute that cannot be resolved determinately and equitably because the means of judgment is itself under dispute.[37] When the parties in the dispute do not share the same rule of judgment, then resolution is necessarily forestalled. This is not the same as saying nothing will happen—a decision *will* be issued, in the planning inquiry by the planning inspector—but this decision will emerge after the performance of incompatible rules of judgment. The différend is not extinguished; it continues to exist, but embodied as a set of provisional translations between aesthetic and other registers. In telling instances in London in the 1980s and 1990s, in disputes over ugliness, such translations accompanied the appearance of architecture in the legal space of postmodernity. As a generality, Lyotard's différend is a space of the postmodern condition, of "incredulity toward metanarratives," a space of fragments and ungrounded authority.[38] But more specifically it is a space inhabited by what Lyotard called phrases and genres, with phrases being the multiple and incommensurable depictions in language of events, experiences, motives, or perceptions, and genres being the protocols through which those phrases are assembled and oriented toward a particular end. No stability or determinacy is guaranteed by this orientation, for genres also are multiple and coexistent within the différend.

Although the planning inquiry was conceived in the rationalist administrative framework of the 1947 Town and Country Planning Act as a space of clarity and the resolution of judgment, the inquiry cannot fulfill that task with consistency. And in the events recounted above, it

Figure 68. Cracked windows and weathered facade of the abandoned Broome and Butler Houses, two towers that stood at the Chelsea Barracks site. The buildings, designed by Tripe & Wakeham, opened in 1962 and were demolished in 2014 for the redevelopment of the site.

has come to perform instead the function of the différend. The différend, though, is not a failure in the conventional sense, rather it performs a function of deferral, of decision without resolution, that enables the emergence and propagation of the aesthetic—or the juridico-aesthetic, or civic aesthetics—as a register of postmodernity. In the legal inquiries recounted in the episodes of this book, such inquiries now appear to be inducing the modulation of phrases and genres in debates about the built environment of postmodernity. As public opinion circulates through these venues, it is not merely validated or refuted; it is material in the assembly of legal aesthetics. Genres such as "public opinion"—for public opinion is indeed a genre—have to be contrived, fashioned to permit the transmission of certain phrases, phrases that have to be modified in their turn in anticipation of the genres they will encounter. To claim to speak in the voice of the public, to announce public opinion, is not enough to enter into the juridico-aesthetic transaction of the inquiry in a defined role and with recognized standing. As Inspector Marks made clear, public opinion must be subject to further tests to achieve its recognition in the space of inquiry and to be deemed evidentiary proof of aesthetic judgment. The assumed prerogative of the Prince of Wales was one such

test, in which an older conception of the monarch's two bodies found its echo in a constitutional chimera.

As for Chelsea Barracks, the development is proceeding ahead, with different architects and a different architecture, committed to neither a modernist nor a classicist dogma. In the shadow of a building John Wood must have visited, and in a prosaic repetition of Wood's transformative program of civic improvements, the cracked windows and weathered facades of existing buildings on the site will be replaced by new materials and new architectural arrangements. (Figure 68) Aesthetic judgment will be cast, certainly, but with the instruments foreshadowed by Wood's experiments toward a civic aesthetics—the social instruments of assessment and their means of expression in the legal and social embodiments of architect, profession, and monarch. As the architectural affairs at Chelsea Barracks have been set in order, the legal repercussions of the dispute have subsided also. The CPC Group filed suit against their partners, Qatari Diar, arguing that they had an obligation to make reasonable efforts to obtain planning permission for the proposed development, and by withdrawing before the hearing they had breached their contract.[39] Mr. Justice Vos ruled in favor of CPC Group, freeing them to seek damages, but also sympathized that Qatari Diar had been put in a difficult political position by the prince's comments. This suit was ultimately settled between the two parties, and CPC and their preferred architect Lord Rogers would soon have their attention consumed with another speculative project, the luxury residences of One Hyde Park, on the former site of Bowater House (the same building Ian Nairn had nominated as an aspirational average for contemporary architecture). In this project, too, difficulties of public opinion would arise, with aesthetic criticism of the design accompanied by moral disapprobation, but none that rose to legal challenges. Legal concerns played out at a further distance from public view, as advisors grew concerned over the need for CPC Group to maintain its legal standing as an offshore company. The details lead into the abstract territories and arcana of globalized finance, sovereign funds, and the vast circulations of capital characteristic of contemporary London. But the precipitating judgment of ugliness still resonates, as it did in the London of two centuries earlier when John Soane projected his precinct of private taste into the public realm, and was met with the denunciation of his palpable eyesore and the inconvenience of a legal inquiry.

Conclusion

Ugliness and Its Consequences

The history of aesthetic judgment and its social valuation, spanning three centuries as it is reconstructed through the particulars of the historical episodes in the preceding chapters, can help establish a different perspective on the architectural events of the contemporary moment, even as the significance of those events will change and refract as their consequences unfold over time. Consider, for example, two events that shared a week in June 2017, both of which seemed to underscore the distance between the aesthetic dimension of architecture and the urgencies of social existence, and both of which have their connections to the fitful debate on ugliness reconstructed in this book. The first event was the listing of the Isle of Dogs Water Pumping Station designed by John Outram Associates. (Figure 69) Built in the late 1980s, this building was one of three pumping stations installed to manage rainwater runoff in the Isle of Dogs, a regeneration project covering some five thousand acres of former docklands in east London. While the development project was, at the insistence of the Thatcher government, privately financed and built, below-ground infrastructure was the responsibility of the public sector. The pumping stations, though above ground, could be fit reasonably enough into the category of infrastructure that the chief architect of the Docklands Development Corporation (DCC) was able not only to build them with public financing, but commissioned leading architects for the designs.[1]

A simple shed in essence, the small structure contains nothing more glamorous than pumping equipment, intended to operate unmanned, and yet it is a decisively dramatic building, a shed willfully transformed into a temple. Two oversize columns with exaggerated and colorful capitals

flank a small industrial door; above the door a large, and functioning, exhaust fan hangs below a shallow pediment faced with corrugated metal; deep eaves with projecting and again colorfully painted rafter tails supported by pilasters and brick buttresses complete the arrangement. This playful classicism, familiar within the broader movement of historicist postmodernism, was typical of Outram's work. The Temple of Storms, as the architect called it, was brought forward for consideration for listing because it exemplified this aesthetic tendency, the refashioning of classical referents in modern materials and for modern purposes with a sense of experimentation curtailed by a desire to remain within what was often capriciously defined as an architectural tradition. That the building was utilitarian, and public, certainly added to its retrospective attraction, for it was not to be associated with the personal whimsy that often exposed private commissions in this stylistic vein to strong criticism; it could be placed within the lineage of Victorian metropolitan infrastructures rather than in the lineage of bank buildings and corporate headquarters. The listing happened at a moment of favorable distance, when sufficient disciplinary curiosity existed toward a postmodernism retrospectively viewed as an important theoretical turn to temper rehearsals of the vitriolic arguments of the 1980s in which a polychromatic and allusionistic design such as the pumping station would have been deemed ugly by at least one side of critics. Instead, the building could be regarded as an important example of its historical moment and an important surviving work by Outram, sufficient grounds for listing in the absence of debate over aesthetic value, or more precisely, in the absence of debate over how aesthetic value connects to social value.

The Isle of Dogs Water Pumping Station received its Grade II* listing on June 19, five days after another architectural event of a very different nature, the Grenfell Tower fire of June 14. A high-rise council housing block in northwest London, the Grenfell Tower caught fire at its lower floors and was rapidly consumed by a blaze that spread up the exterior cladding of the building, causing the deaths of approximately eighty residents. The charred hulk with blackened scars that traced the rise of the fire could be seen the next day and in the days that followed, not only from the neighboring streets but in pictures distributed across Britain and around the world; it was the image of architectural ugliness. (Figure 70) The ugliness of the ruin, the ugliness of the stain of combustion and soot, but much more than that, here was ugliness of the most visceral sort, the ugly consequence of inequity, of rapacity, and, above all, of institutional indifference. Because following the fire, once the accidental cause was known but before official inquests and inquiries had been initiated, a constellation of contributing factors came into view, bearing upon governmental housing policies, the financing and oversight of

maintenance in the public sector, the existence and nonexistence of certain construction and safety regulations, and the unquiet coexistence of highly differentiated housing markets in London.

Grenfell Tower was built in 1974 for the Kensington and Chelsea Council (the same council that had hosted the architectural confrontations at Chelsea Hospital and Chelsea Barracks). Designed by Clifford Wearden and Associates, a private firm commissioned by the council, the tower was constructed in concrete, for columns and slabs as well as for its exterior panels. Gray and spare in its outward appearance, with the vertical line of external columns used to compensate for the squatness of proportion, the tower fit the tendencies of late modern housing blocks in Britain of the early 1970s and certainly also fit within the conceptions of ugliness brandished by the aesthetic criticism directed at late modernism at that time. In 2012, the council announced a regeneration plan to upgrade the mechanical services in the tower, replace the existing windows with double glazing, and install an insulated aluminum cladding on the exterior surfaces. This cladding, attached to the concrete structure of the building, was intended to improve thermal performance, but it was also suggested that it would "improve the external appearance of the building."[2] It consisted of aluminum panels sandwiched on a polyethylene core, set in place over a thermal insulation bonded to the concrete; elements of this cladding system were combustible, and caused

Figure 70. Grenfell Tower immediately after the fire of June 14, 2017.

the rapid spread of fire up the exterior of the tower. The new aluminum cladding was thus a central cause of the disaster, responsible certainly for the magnitude and speed of the fire. The scale of the tragedy was exacerbated by deficiencies such as the lack of a second stair for egress and the lack of sprinkler systems—the latter could have been retrofitted in the renovation—and these causes were in turn attached to other failings, systemic and institutional, in the inadequacies of building codes and fire safety requirements, the parsimoniousness of the council and its privately contracted management firms, and the fecklessness of national oversight and foresight in regard to public housing.[3]

This then is now the ugliness of the Grenfell Tower, an ugliness of the most grotesque degree. And it is this ugliness of social failure and the preventable deaths resulting from it that begs the question as to whether the aesthetic register of architecture is something that ought to be given much attention at all. Taken together as coincidental companions in time, the Isle of Dogs Pumping Station and Grenfell Tower seem to underscore the distance between the aesthetic and the social dimensions of architecture, seem to suggest that if a civic aesthetics exists, it exists at a remove sufficient enough that it can be listed for preservation as a historical relic. Ought the aesthetic capacity of architecture—and discussion of that aesthetic capacity—be understood now as an irrelevance or a luxury, and architectural ugliness as the capricious squandering even of that luxury?

I hope that the historical episodes in this book, and my accounting of them, have suggested the possibility of a different perspective. After all, both of these architectural events of June 2017 bear the legacy of John Wood's initiation of speculations upon a civic aesthetics in the early eighteenth century. Both would be legible under the conceptual framework of improvement that he and his contemporaries employed, with the "regeneration" of Grenfell Tower intended to repair the perceived disorder of the existing building with a new, precisely machined facade, successor to Wood's precisely cut stones; and the ornate temple of the pumping station a clear echo of Wood's imagining of a noble temple to stand above the ordinary coal pit beside the Bristol road. These are resonances only, with different outcomes in the tangency of architecture and social circumstance; but such resonances suggest the possible recognition of ugliness as a malleable conjunction of the aesthetic and the social, with the former contributing to the instruments of the latter.

The argument of this book, in distilled form, is that the judgment of ugliness signals the participation of architecture in a social circumstance in which resolution is not achieved by aesthetic means; instead, the aesthetic dimension of architecture, precisely because of its insufficiency, is transferred into other instruments of social consequence. Ugliness, therefore, is the judgment of an irresolution and an insufficiency, but additionally is the instantiation of that insufficiency into social technologies, into concrete processes, customs, and institutions. Such instruments of social consequence include, in the historical episodes explored here, legal mechanisms like the formulation of laws of libel to shape the cultural role of criticism, and the development of statutory regimes and new interpretations of nuisance law to manage the economic and physical effects of industrialization; they also include institutional concepts such as the reasonable man or the profession, and the recalibration of those concepts to answer unresolved social transformations in the modern city. The settings in which such instruments gained efficacy ranged across distinct realms of the social production of knowledge, from the laboratory to the club, from committee rooms to courtrooms, and to the social institutions that these entities embody such as the public, the state, or the law; they also include settings that seek to exist slightly apart from the more consolidated, interwoven elements of the social sphere, settings such as the ecclesiastical court or the monarchy, in which new, perhaps anachronistic formulations are either echoes of a past possibility or premonitions of a future one.[4]

Assembled together, these elements do not trace a history of ugliness as such, nor do they render a systematic philosophical account of the aesthetics of ugliness. By gathering up the myriad synonyms, symptoms, and cognates of ugliness into an inquiry into episodes of aesthetic judgment,

the history presented here offers a view of the instrumentality of those judgments in the emergence or development of social technologies in Great Britain. This inquiry into the judgment of ugliness attempts to modify the relevance of two primary categories, style and taste, that often signal the relegation or detachment of aesthetic judgment rather than its instrumental participation in social debates; and to see these entrenched categories not as conclusive in themselves but as only the most rudimentary of lenses through which to gain a perspective on judgments of ugliness. Style and taste appear throughout both parts of this book, with style more present in the first part, focused on the materiality of architecture, and taste more present in the second, focused on the personae of architecture. In the chapters of Part I, the recurring theme of stone, with concrete as a modern corollary in the case of brutalism, draws a relation between broad currencies of style and the empirical reality of materials. In the chapters of Part II, the recurring theme of taste draws a relation between the designations of individual or collective opinion and the structures and processes that impersonally define personhood. Both of these displacements, of style into empiricism and taste into impersonality, should suggest the way in which judgments about ugliness in particular are seen to be movements or transactions between an aesthetic register and other social dimensions. In each chapter of the book, architecture—as objects and as discourse—plays a role as a site and as a catalyst for debate on a broader social circumstance of change or conflict: pollution and co-existence in London, for example, or the delineation of English norms of privacy and publicity, or the constitutional standing of the British monarchy. These contested circumstances are negotiated through instruments such as nuisance law, libel law, or constitutional convention, which are modified into novel forms, taking on new capacities as social technologies of diagnosis, regulation, or anticipation. But within these capacities remains the influence of aesthetic judgment, which, though more often assumed to exist at a remove from such social realities, cannot readily be separated from other modes of judgment employed in each episode. Specifically, it is the judgment of ugliness that precipitates this process of architecture's participation, because the judgment of ugliness (in the various implicit and explicit forms encountered through these episodes) signals friction, incompatibility, excess, or insufficiency as well as the immediate proximity of aesthetic concern to social materials.

The consequences in these cases, distributed across centuries, are cumulative evidence of the influence of aesthetic judgment rather than its detachment, and of the participation of architecture in the civic realm, though not in the conventional manner. Throughout the book, the deliberate use of history (rather than philosophy, or connoisseurial opinion, or other approaches to aesthetic matters) is an attempt to show the

judgment of ugliness to be proximate to the constellation of social realities of processes, customs, and institutions; to demonstrate the ways in which debates about architectural ugliness do not conclude in buildings themselves, nor in judgments about buildings as such, but move laterally, migrating into the sponsorship of other social techniques in other spheres of civil society. By recognizing that ugliness has a determinate proximity to various manifestations of social reality—materiality, legality, cost, liability, and so on—it becomes possible to see that though the effect of ugliness may be aesthetic, its consequences can occur in the multiple registers of this social reality. But, crucially, ugliness is not, in the episodes explored in this book, a resolution of the circumstances in which it emerges; it is, rather, an accommodation of those circumstances, a persistence within them that is transferred to and prompts consequences in adjacent registers of social debate. Architectural ugliness can thus be understood not just as an aesthetic quality but as a manifestation of uncertainty, or better, as an event that brings into view, momentarily at least, the horizon that distinguishes the possibilities and impossibilities of a given historical moment.

Acknowledgments

One of the great rewards of writing a book is the multitude of intriguing conversations one enters into along the way. A book like this one, ranging across different fields of inquiry through different periods and written over a number of years, affords many chances to meet, talk to, argue with, and listen to perceptive and intellectually generous people whose cumulative contribution to the final book has been very great indeed. In a variety of convivial settings—a unique farmhouse and archive in Somerset, classrooms in Toronto, restaurants in Manhattan and London, and even a cemetery in Stockholm—I have benefitted enormously from the insights of scholars and students at the Courtauld Institute of Art, the KTH Royal Institute of Technology, Oxford University, Columbia GSAAP, Princeton University, the University of Michigan, and the University of Toronto. Colleagues and audiences at meetings of the Society of Architectural Historians, the European Architectural History Network, Nordik, and the Architectural Humanities Research Association also provided helpful responses and criticism that guided me as I refined my arguments. I am indebted to all the people who invited me to speak about this research and all those who were willing to listen.

The materials for this book could not have been accessed, let alone assembled and interpreted, without the assistance of a number of archivists and librarians whose professionalism and enthusiasm, in equal measure, must be recognized and lauded. My sincere gratitude, therefore, to the staff at the London Metropolitan Archives, the National Archives in Kew, the Soane Museum, the RIBA Drawings and Archives Collection at the V&A Museum, and the Huntington Library. Additional thanks to the Diocese of London for permission to consult restricted materials in the London Metropolitan Archives. My work in these various settings, along with that most valuable commodity—time for writing—were made possible by funding generously provided by the Paul Mellon Centre for Studies in British Art, the Huntington Library, the MacDowell Colony, and the Clarence H. Blackall Career Development Associate Professorship at MIT.

I have been very lucky to have been surrounded by inspiring colleagues in several different settings within which I work. The faculty and students in the Department of Architecture at MIT, and especially my colleagues in the History Theory Criticism group, should take credit for challenging me with the example of their own work, erudition, and curiosity. My colleagues in the Aggregate Architectural History Collaborative have also put forward a challenge, with their willingness to present their scholarship and to review my own, and to ask questions and offer critiques and advice

on matters small and large. Students have been absolutely indispensable aides as well, in seminar discussions and in providing uncomplaining help with research tasks, some of them (I hope) rewarding but some of them (I admit) mundane. A wonderful editor, Michelle Komie, and her colleagues at Princeton University Press, Pamela Weidman, Karen Carter, and Steven Sears, have provided expertise, wisdom, and energy for the latter stages of the book's realization. The efforts and contributions of all of these people and institutions are present throughout the book, though only its author is to be blamed for any of its shortcomings.

These professional settings are, of course, accompanied by a personal setting without which this book never could have been written, friends and family who have given me boosts of morale, cautions against tunnel vision, and gifts of patience. Thank you most of all to Sarah, Elias, and India, and to my late aunt and uncle, Patricia Squires and Jack Squires, who helped me see London in endlessly novel ways.

Notes

Introduction

1. John Crowley, "'Vile' Buildings That Should Be Demolished," *Telegraph*, August 16, 2004, http://www.telegraph. co.uk/news/uknews/1469502/Vile-buildings-that-should-be-demolished. html; Jim Pickard, "Vision That Will Send Eyesores Tumbling," *Financial Times*, August 7, 2004, http://www. ft.com/cms/s/0/7a456f18-e80f-11d8-bae0-00000e2511c8.html?ft_site =falcon&desktop=true#axzz4hFlivP9g.

2. Zoë Blackler, "Scars, Blots and Eyesores," *BDOnline*, October 5, 2007, http://www.bdonline.co.uk/ readers-free-classifieds/scars-blots-and-eyesores/3096795.article. For the Carbuncle Cup, see http:// www.bdonline.co.uk/buildings/ carbuncle-cup.

3. Nathaniel Lloyd, *Building Craftmanship in Brick and Tile and in Stone Slates* (Cambridge: Cambridge University Press, 1929), 1; Nicholas Salmon and Derek Baker, eds., *The William Morris Chronology* (Bristol: Thoemmes Press, 1996), 6; Philological Society of London, *The European Magazine, and London Review*, vol. 23 (London: J Sewell, 1793), 183.

4. Karl Rosenkranz, *Aesthetics of Ugliness*, trans. Andrei Pop and Mechtild Widrich (London: Bloomsbury, 2015), 25. This first English translation and critical edition includes a very useful introduction that situates Rosenkranz in a philosophical context. Though he was not widely influential, his surpassing contribution was to have articulated a systematic theory of ugliness accessible to various aesthetic fields. In many ways, *Aesthetics of Ugliness* serves as a prologue and preface to subsequent explorations of concepts of ugliness, even if they do not engage with Rosenkranz directly.

5. Ibid., 258.

6. Definitional or book-length studies of concepts of ugliness include Andrei Pop and Mechtild Widrich, eds., *Ugliness: The Non-beautiful in Art and Theory* (London: I.B. Tauris, 2014); Nina Athanassoglou-Kallmyer, "Ugliness," in *Critical Terms for Art History* (Chicago: University of Chicago Press, 2003), 281–95; Sianne Ngai, *Ugly Feelings* (Cambridge, MA: Harvard University Press, 2005); and Lesley Higgins, *The Modernist Cult of Ugliness* (New York: Palgrave, 2002). More focused in concern or more limited in scope, but also of interest, are Vernon Lee and Clementina Anstruther-Thomson, "Beauty and Ugliness," *Contemporary Review* 72 (1897): 544–69, 669–88; Robert Martin Adams, "Ideas of Ugly," *Hudson Review* 27, no. 1 (1974): 55–68; Theodor Adorno, "The Ugly, the Beautiful, and Technology," in *Aesthetic Theory* (London: Routledge, 1984); and Mark Dorrian, "On the Monstrous and the Grotesque," *Word & Image* 16, no. 3 (2000): 310–17. This list is neither extensive nor comprehensive, but suggests texts that illuminate disciplinary perspectives on ugliness and that served as key points of theorization in the development of ideas about ugliness in the modern period. The argument that follows in this book draws upon these sources, as well as others cited below, though the focus will remain on a historical elucidation of ugliness and its consequences rather than an abstracted philosophy of ugliness.

7. Gretchen E. Henderson, *Ugliness: A Cultural History* (London: Reaktion Books, 2015).

8. Mark Cousins, "The Ugly (Part One)," *AA Files*, no. 28 (1994): 61–64; "The Ugly (Part Two)," *AA Files*, no. 29 (1995): 3–6.

9. Cousins, "The Ugly (Part One)," 62.

10. Ibid., 63.

11. John Macarthur, *The Picturesque: Architecture, Disgust, and Other Irregularities* (London: Routledge, 2007), 91.

12. Rosenkranz, *Aesthetics of Ugliness*, 49.

13. The term "civic aesthetics" will be clarified through its use in the chapters that follow, but I mean by this cognate an aesthetic whose intent or consequence is the articulation of a collective recognition of a civil sphere substantiated by behaviors and institutions. "Aesthetic" and

"aesthetics" will be used throughout as general terms, not as technical terms or with narrow reference to a particular philosophical stance. They are to invoke the perception and evaluation of the appearance and sensory effects of objects, and also to encompass the concept of experience that precedes or is not immediately translated into causal origins, such that it has some independence from these objects as well as from modes of rationalization. I aim to take advantage of what Terry Eagleton describes as the "indeterminacy of definition which allows [the aesthetic] to figure in a varied span of preoccupations." For useful views on the central problems of modern aesthetics in particular relation to politics, see Eagleton, *The Ideology of the Aesthetic* (Oxford: Blackwell, 1990). (The preceding quotation is from page 3.) For a survey of the development of modern aesthetics, see Jerrold Levinson, ed., *The Oxford Handbook of Aesthetics* (Oxford: Oxford University Press, 2003), esp. chaps. 1 and 2.

14. Debates on architectural ugliness can be found in other settings, of course, in Europe or North America across the same historical span as that covered here. But the contours of these debates, while they may have discursive similarities, arise from the very different circumstances of the public sphere in which they occur. Contrast the secular republicanism of France, for example, with the constitutional monarchy of Great Britain, with the additional distinction between Napoleonic Code and common law, and their incommensurability becomes clear. In comparison with the United States, the distribution of political and cultural influence across several cities in that nation obviously differs sharply from the consolidated metropolitan influence of London in the English context. Another important and defining dimension that would separate a study of civic aesthetics in England from any inquiry into civic aesthetics in other settings is the continuity in Great Britain of a philosophical and critical debate on aesthetics emphatically oriented by an empiricism that would more or less presume the social instrumentality

of cultural artifacts and social technologies.

Chapter 1: Improvement

1. William Stukeley, *Itinerarium Curiosum; or, An Account of the Antiquities and Remarkable Curiosities in Nature or Art Observed in Travels through Great Britain*, Itinerary VI (London: Baker and Leigh, 1776), 146. Because my argument presents the textual evidence of different disciplinary perspectives, in different historical periods, the original punctuation, spelling, grammar, and emphasis are maintained in all quotations throughout the book.

2. For the urban history of Bath, see Sylvia McIntyre, "Bath: The Rise of a Resort Town, 1660–1800," in *Country Towns in Pre-industrial England*, ed. Peter Clark (New York: St. Martin's, 1981), 198–249, and Peter Borsay, *The Image of Georgian Bath, 1700–2000* (Oxford: Oxford University Press, 2000).

3. See John Eglin, *The Imaginary Autocrat: Beau Nash and the Invention of Georgian Bath* (London: Profile Books, 2005) and Borsay, *Image of Georgian Bath.*

4. Quoted in McIntyre, "Bath," 240.

5. John Wood the Elder was born in Bath in 1704, was working as a joiner in London by 1721, and returned to Bath permanently in 1727. He realized buildings in Bristol and in Liverpool, but the great majority of his work was in and around Bath. His own accounts of the city and of his career are unreliable, though quite detailed. A volume of his drawings is held by the Bath Reference Library, and the most comprehensive accounts of his career are Tim Mowl and Brian Earnshaw, *John Wood: Architect of Obsession* (Bath: Millstream Books, 1988) and Charles Edward Brownell, "John Wood the Elder and John Wood the Younger: Architects of Bath" (PhD diss., Columbia University, 1976).

6. John Wood, *Essay towards a Description of Bath* (London: W. Bathoe and T. Lownds, 1765), 232.

7. Ibid., 264.

8. Ibid., 264.

9. Ibid., 265.

10. Letter from the Duke of Chandos to John Wood, September 24, 1728, Duke of Chandos copy-books, Brydges Family Papers, Stowe Collection, Huntington

Library, San Marino, CA. The letters from the Duke of Chandos to John Wood in these years show frequent strain in the relationship of architect and client. Also see Mowl and Earnshaw, *John Wood*, chap. 2.

11. The first edition of Wood's *Essay* was published in 1742, in two parts. A revised edition in four parts was published in 1749 and, in a sign of its relative success, reprinted by a London bookseller in 1765. Quotations here are from the 1765 edition. Although the frontispiece of the late edition used a shortened title, *Description of Bath*, it is variously catalogued with the shorter or the original edition title. For clarity and consistency, the title *Essay towards a Description of Bath* (or simply *Essay*) is used here in reference to all editions of the book.

12. Wood, *Essay towards a Description of Bath*, 225.

13. Ibid., preface.

14. Ibid., 216, 224.

15. Although Alexander Baumgarten's *Aesthetica* was not published until 1750, the concepts that the term "aesthetics" would come to encompass were very much under discussion in Wood's time. The Earl of Shaftsbury had written on sensation, experience, and moral sense in his *Characteristicks of Men, Manners, Opinions, Times* at the beginning of the century, and William Hogarth was undertaking his *Analysis of Beauty* (published in 1753) and Edmund Burke his *Philosophical Enquiry into the Origin of Our Ideas of the Sublime and Beautiful* (published in 1756), both of them seeking to examine the properties of objects and images in relation to human emotion and judgment. The contributions of Hogarth and Burke were responses rather than sources for the inquiry into aesthetic matters. Wood was familiar with scientific knowledge that circulated from London to the provinces and would have been generally aware of contemporary arguments such as Shaftsbury's. However, the extent of Wood's personal knowledge is less important than the fact of a general formulation of ideas of aesthetics and society at this time in Great Britain.

16. David Hume, *A Treatise of Human Nature* (Oxford: Clarendon, 1896), 586–87. See also Hume, "Of the Standard of Taste," in *Selected Essays*, ed. Stephen Copley and Andrew Edgar (Oxford: Oxford University Press, 1993), 133–54.

17. John Wood, *The Origin of Building; or, The Plagiarism of the Heathens Detected* (Bath: J. Leake, 1741), 11. *The Origin of Building* is both fascinating and frustrating, combining as it does "Learning ... Enthusiasm ... and nonsense," in the words of Sir William Chambers. Chambers's note can be found in one of the copies owned by Sir John Soane. The Soane Museum also holds Wood's first manuscript of the book; the second manuscript can be found in the Bath Reference Library. For interpretations of Wood's notorious text, see Edward Eigen, "The Plagiarism of the Heathens Detected: John Wood, the Elder (1704–1754) on the Translation of Architecture and Empire," *Journal of the History of Ideas* 70, no. 3 (2009): 375–97; Eileen Harris, "John Wood's System of Architecture," *Burlington Magazine* 131, no. 1031 (1989): 101–7; and Christine Stevenson, "John Wood the Elder and *The Origin of Building*" (London: Courtauld Institute, 1981).

18. Wood, *Origin of Building*, 219.

19. Ibid., 219.

20. Wood, *Essay towards a Description of Bath*, 30, 36. See also Harris, "John Wood's System of Architecture," 106–7.

21. Wood, *Essay towards a Description of Bath*, 136, 158.

22. Ibid., 157.

23. Inigo Jones, *The Most Notable Antiquity of Great Britain, Vulgarly Called Stone-Heng, on Salisbury Plain, Restored* (London: James Flesher for Daniel Pakeman, 1655); William Stukeley, *Stonehenge a Temple Restor'd to the British Druids* (London: W. Innys and R. Manby, 1740).

24. John Wood, *Choir Gaure, Vulgarly Called Stonehenge, on Salisbury Plain, Described, Restored, and Explained* (Oxford: J. Leake, 1747), 30.

25. Ibid., 49.

26. Ibid., 56–57.

27. Ibid., 67.

28. Ibid., 60.

29. Ibid., 60, 62.

30. Wood reasoned that given the immense difficulty of moving the stones, they would not have been removed intentionally. If they were not on the site

as fallen, then they must never have been brought to the site at all. The monument was therefore incomplete in its original construction. Based on comparison of stones found on hills not far distant, Wood believed the source of the stones to be Marlborough Downs. Ibid., 77–83.

31. Wood, *Essay towards a Description of Bath*, 57–58. Wood referred to the theories presented to the Royal Society by John Strachey and published in *Philosophical Transactions*: Strachey, "A Curious Description of the Strata Observ'd in the Coal-Mines of Mendip in Somersetshire," *Philosophical Transactions* 30 (1717): 968–73 and "An Account of the Strata in Coal-Mines," *Philosophical Transactions* 33 (1724): 395–98.

32. See letters from the Duke of Chandos to John Wood in July 1728. Duke of Chandos copy-books.

33. Wood, *Essay towards a Description of Bath*, 426–27.

34. On Ralph Allen, see R.E.M. Peach, *The Life and Times of Ralph Allen* (London: D. Nutt, 1895) and Borsay, *Image of Georgian Bath*. On the architecture of Prior Park and the relationship of Wood and Allen, see chap. 7 of Mowl and Earnshaw, *John Wood*. On Pope's contribution to the garden of Prior Park, see Marion Harney, "Pope and Prior Park: A Study in Landscape and Literature," *Studies in the History of Gardens & Designed Landscapes* 27, no. 3 (2007): 183–96. The English picturesque movement would become a crucial setting for the theoretical and formal elaboration of the aesthetic of ugliness. While beauty and sublimity were the aesthetic goals, the practitioners of the picturesque pursued explorations of qualities such as surprise, irregularity, changeability, and roughness, opening novel understandings of the subjective encounter with attributes more readily associated with ugliness than beauty. For the summary principles of the picturesque, see Sir Uvedale Price, *An Essay on the Picturesque, as Compared with the Sublime and the Beautiful* (London: J. Robson, 1794). The standard account of the English picturesque is Christopher Hussey, *The Picturesque: Studies in a Point of View* (London: G.P. Putnam, 1927), while the authoritative theoretical account is Macarthur, *Picturesque*, in which see especially chaps. 3 and 4.

35. Wood, *Essay towards a Description of Bath*, 339. Also see Mowl and Earnshaw, *John Wood*, 42–43. Wood can be seen grappling with the logistics of valuing and transporting building materials in letters he wrote to William Brydges, who commissioned Wood to design a new sanctuary and altar for the rural Tyberton church. See letters from John Wood to William Brydges in box 1, William Brydges Papers, Huntington Library, San Marino, CA.

36. Wood, *Essay towards a Description of Bath*, 242.

37. Ibid., 58–59.

38. John Wood, *A Description of the Exchange of Bristol* (Bath: J. Leake, 1745).

39. Edward Howell, ed., *Ye Ugly Face Clubb, Leverpoole, 1743–1753* (Liverpool: Edward Howell, 1912), 26. This volume is a verbatim reprint of a manuscript containing the club's bylaws and minutes and its record of membership. Also see Gretchen E. Henderson, "The Ugly Face Club: A Case Study in the Tangled Politics of Deformity," in Pop and Widrich, *Ugliness*, 17–33.

40. Howell, *Ye Ugly Face Clubb*, 26.

41. *Spectator*, March 20, 1711.

42. *Spectator*, May 30, 1711.

43. The Civil Club was founded in 1669. On the history of such associations and their effects, see Peter Clark, *British Clubs and Societies 1580–1800: The Origins of an Associational World* (Oxford: Oxford University Press, 2000).

44. Howell, *Ye Ugly Face Clubb*, 42. John Wood the Younger, born in 1728, lived for a period of time in Liverpool to supervise the building of the Liverpool Exchange, which commenced in 1748. Since he would have been permitted to be a member of the club only while a bachelor, he must have resigned his membership by 1753.

Chapter 2: Nuisance

1. The Assize of Buildings (or the Assisa de Edificiis in the Latin used for legal proceedings) was responsible for hearing complaints of nuisance, a legal charge or writ formulated in the medieval period. The institution, the writ, and the records of the proceedings were all referred to as the Assize of Nuisance.

See *London Assize of Nuisance, 1301–1431: A Calendar*, ed. Helena M. Chew and William Kellaway (London: London Record Society, 1973), British History Online, http://www.british-history. ac.uk/london-record-soc/vol10.

2. "Misc. Roll DD: 19 Aug 1328–15 Oct 1339 (nos 299–348)," in Chew and Kellaway, *London Assize of Nuisance*, 69–85, http://www.british-history.ac.uk/ london-record-soc/vol10/pp69-85.

3. Ibid.

4. Such codifications did not have a systematic order and were most likely compilations of rules and strictures from other sources. See "Introduction," in *London Assize of Nuisance*, http:// www.british-history.ac.uk/london-record-soc/vol10/ix-xxxiv. For a detailed study of the party wall and the legal constructions of public and private space in medieval London, see Vanessa Harding, "Space, Property, and Propriety in Urban England," *Journal of Interdisciplinary History* 32, no. 4 (Spring 2002): 549–69.

5. Article V in "Charles II, 1666: An Act for Rebuilding the Citty of London," in *Statutes of the Realm: Volume 5, 1628–80*, ed. John Raithby (Great Britain Record Commission, 1819), 603–12, British History Online, http://www.british-history.ac.uk/statutes-realm/vol5/ pp603-612.

6. John Wood described the rating of residences in Bath according to their number and type of stories, suggesting his aim for regularity not only in the form but in the classifications of buildings in the city. See Wood, *Essay towards a Description of Bath*, 241–43.

7. John Gwynn, *London and Westminster Improved, Illustrated by Plans. To Which Is Prefixed a Discourse on Publick Magnificence* (London: Dalton, 1766), 3.

8. Ibid., 3, 5.

9. The events and debates that accompanied the process of rebuilding the Houses of Parliament are described in detail in M. H. Port, ed., *The Houses of Parliament* (London: Yale University Press, 1976). Also see Caroline Shenton, *The Day Parliament Burned Down* (Oxford: Oxford University Press, 2012) and *Mr. Barry's War: Rebuilding the Houses of Parliament after the Great Fire of 1834* (Oxford: Oxford University Press, 2016).

The story of the rebuilding of the Houses of Parliament has served architectural history by consolidating two strong narratives of the nineteenth century: the rise of historicism, read through debates on style, and the rise of functionalism, read through technological innovation. The design and realization of the building strengthened advocacies of the gothic revival, centering architectural discourse upon questions of style and civic representation, and of structure and ornamentation that persisted through the nineteenth century and formed a foundational undercurrent of subsequent modernisms. Its design and realization also solicited an attention to the building's programmatic requirements that produced an explicit concern for organizational and technical function that was similarly drawn forward into the technological premises of later architectural modernism. Though the recognition of these dimensions as pivotal factors in the later unfolding of modernism may be retrospective, they were certainly acknowledged at the time as having great significance and were central to the public and professional discussions that surrounded the project.

10. "Report from Select Committee on Houses of Parliament" (1836), 4. Joseph Hume was a Radical MP, with associations to the Utilitarians, who had been involved in the planning of new accommodations for Parliament even prior to the 1834 fire that destroyed the existing buildings and made rebuilding imperative. See George H. Weitzman, "The Utilitarians and the Houses of Parliament," *Journal of the Society of Architectural Historians* 20, no. 3 (1961): 99–107.

11. "Report from Select Committee on Houses of Parliament," 4.

12. Ibid., 4.

13. "Report of Commissioners Appointed to Consider the Plans for Building the New Houses of Parliament" (1836), 2.

14. "Report from Select Committee on Houses of Parliament," 5.

15. Ibid., 13.

16. Ibid., 21. The commissioners gave evidence on March 10, and Charles Barry gave evidence on April 29.

17. Ibid., 21.

18. See Christine L. Corton, *London Fog: The Biography* (Cambridge, MA: Belknap, 2015).

19. John Evelyn, *Fumifugium; or, The Inconveniencie of the Aer and Smoak of London Dissapated* (London: W. Godbid, 1661), np. New editions of *Fumifugium* were printed in 1776 and in 1825, with the relevance of Evelyn's criticisms still very much apparent in London.

20. Ibid., 5, np.

21. In an 1819 pamphlet addressing the problem of London's air pollution, the actuary William Frend noted that though visitors were astonished by the "dirt and nastiness" of the city's blackened air, many Londoners were resigned to this industrial atmosphere, convinced that this particular "evil" was an "incurable" symptom of the city. William Frend, "Is It Impossible to Free the Atmosphere of London, in a Very Considerable Degree, from the Smoke and Deleterious Vapours with Which It Is Hourly Impregnated?" (London: Charles Wood, 1819), 2.

22. For a survey of the history of air pollution in Great Britain, see Peter Brimblecombe, *The Big Smoke: A History of Air Pollution in London since Medieval Times* (London: Methuen, 1987); Peter Thorsheim, *Inventing Pollution: Coal, Smoke, and Culture in Britain since 1800* (Athens: Ohio University Press, 2006); and William M. Cavert, *The Smoke of London: Energy and Environment in the Early Modern City* (Cambridge: Cambridge University Press, 2016). A growing literature on air and architecture now includes studies of episodes from early modernity to the contemporary period. See, for example, the contributions to the special issue on City Air: *Journal of Architecture* 19, no. 2 (2014) and Jorge Otero-Pailos, "The Ambivalence of Smoke: Pollution and Modern Architectural Historiography," *Grey Room*, no. 44 (2011): 90–113.

23. Letter from Christopher Wren to Bishop Atterbury, 1713 in Christopher Wren, *Parentalia; or, The Memoirs of the Family of the Wrens* (1750; Farnsborough: Gregg Press, 1965), 299.

24. The scientific and aesthetic attention paid to clouds—from Luke Howard and John Constable to John Ruskin—during the nineteenth century is another index of the developing perceptions of atmosphere.

25. Alfred Bartholomew, *Hints Relative to the Construction of Fire-Proof Buildings* (London: Library of Fine Arts, 1839), 17. Bartholomew's impressive array of adjectives parallels the extensive taxonomy offered by Karl Rosenkranz as a catalog of symptoms of ugliness.

26. "Report from Select Committee on Houses of Parliament," 13.

27. Ibid., 13.

28. Henry de la Beche was the first director of the Geological Survey of Great Britain, and William Smith was the creator of the revolutionary 1815 *Geological Map of England and Wales*. On William Smith and his map, see Simon Winchester, *The Map That Changed the World: William Smith and the Birth of Modern Geology* (New York: HarperCollins, 2001). On Charles Harriott Smith and his role in architectural discourse, see Edward John Gillen, "Stones of Science: Charles Harriot Smith and the Importance of Geology in Architecture, 1834–64," *Architectural History* 59 (2016): 281–310.

29. See David G. Bate, "Sir Henry Thomas De La Beche and the Founding of the British Geological Survey," *Mercian Geologist* 17, no. 3 (2010): 149–65.

30. "Stone for the New Houses of Parliament," *Civil Engineer and Architect's Journal* (1839): 331.

31. Ibid., 332.

32. Ibid., 331.

33. Ibid., 332.

34. Ibid., 331.

35. Ibid., 333.

36. Robert Angus Smith, "On the Air and Rain of Manchester," *Memoirs of the Literary and Philosophical Society of Manchester* 10 (1852): 207.

37. Ibid., 207.

38. Robert Angus Smith, "On the Air of Towns," *Quarterly Journal of the Chemical Society of London* 11, no. 3 (1859): 196–235. Smith published an even more comprehensive body of research in 1872. See *Air and Rain: The Beginnings of a Chemical Climatology* (London: Longmans, Green, and Co., 1872).

39. Smith, "On the Air of Towns," 232.

40. "Report of the Committee on the Decay of Stone at the New Palace of

Westminster" (1861), v.

41. For example, Smith was able to explain that when the stone beds in the initially selected Bolsover quarry turned out to be insufficient in dimension, further inspection identified a neighboring quarry at Anston that became the source for most of the stone used in the construction.

42. See appendix 1 in "Report of the Committee on the Decay of Stone."

43. Ibid., 98. Harriot Smith apparently did not agree with the chemists' conclusion that atmospheric harm was the significant cause, emphasizing instead the use of deficient stone.

44. Ibid., 95.

45. Ibid., 96.

46. Ibid., ix.

47. Ibid., 17.

48. The Houses of Parliament were the setting for new techniques of interior ventilation, designed by the engineer David Boswell Reid. See Robert Bruegmann, "Central Heating and Forced Ventilation: Origins and Effects on Architectural Design," *Journal of the Society of Architectural Historians* 37, no. 3 (1978): 143–60.

49. Alfred Waterhouse, "Mr. Waterhouse on Architecture," *Building News* 44 (1883): 246.

50. Ibid., 246.

51. On the evolution of nuisance law and its relation to the progression of smoke abatement, see Rebecca Jemima Adell, "Creating Parliamentary Smoke: The Quest for a National Smoke Pollution Law in Nineteenth-Century England" (PhD diss., University of Alberta, 2005); Joel Franklin Brenner, "Nuisance Law and the Industrial Revolution," *Journal of Legal Studies* 3, no. 2 (1974): 403–33; and John P. S. McLaren, "Nuisance Law and the Industrial Revolution—Some Lessons from Social History," *Oxford Journal of Legal Studies* 3, no. 2 (1983): 155–221.

52. See Brimblecombe, *Big Smoke*, and Thorsheim, *Inventing Pollution*.

53. *An Act for giving greater Facility in the Prosecution and Abatement of Nuisances arising from Furnaces used and in the working of Steam Engines (Smoke Prohibition Act)*, 1 & 2 Geo. IV, c. 41 (1821).

54. Adell argues that the 1821 law was motivated by the belief that existing common law would be capable of regulating the problem of industrial smoke, and that subsequent efforts turned toward the instruments of statutory law.

55. *Report, Addressed to Viscount Canning, &c. By Sir Henry Thomas de la Beche and Dr. Lyon Playfair, upon the Means of Obviating the Evils Arising from the Smoke Occasioned by Factories and Other Works Situated in Large Towns*, April 6, 1846. See *British Sessional Papers* 43 (1846): 331–44.

56. The 1853 Smoke Abatement Act was followed in 1863 by the Alkali Act, prompted by the inquiries of the parliamentary Committee on Injury from Noxious Vapours. In that committee, Playfair had described emissions from alkali manufacture as the "monster nuisance." These statutory developments were accompanied consistently by an awareness that urban smoke was also a symptom of industrial and economic advancement, and the problem of smoke was therefore understood to be as ambiguous as the substance itself. See, for example, "The Blessings of Coal," *Illustrated London News*, November 3, 1849; and Peter Reed, *Acid Rain and the Rise of the Environmental Chemist in Nineteenth-Century Britain* (London: Routledge, 2014).

57. Smith, "On the Air and Rain of Manchester," 196.

58. London Metropolitan Archives, folder LCC/PC/GEN/01/033.

59. "The Decay of London's Public Buildings," *British Architect*, August 30, 1901.

60. On the broad relationship of processes of governance and visuality in the Victorian period, see Chris Otter, "Making Liberalism Durable: Vision and Civility in the Late Victorian City," *Social History* 27, no. 1 (2002): 1–15.

61. See Waterhouse, "Mr. Waterhouse on Architecture," and Halsey Ricardo, "Of Colour in the Architecture of Cities," in *Art and Life in the Building and Decoration of Cities* (London: Rivington, Percival, 1897), 211–60. Also see Michael Stratton, "Shining through the Smog: Terracotta and Faience," in *Good and Proper Materials: The Fabric of London since the Great Fire*, ed. Hermione Hobhouse and Ann Saunders (London: Royal Commission on the Historical

Monuments of England, 1989), 25–37. The architectural strategy employed by Waterhouse in the London context is exemplified in his design for the Natural History Museum in South Kensington and would have been evident as well in his design for the Royal Courts of Justice had he won the competition for that notable public building.

62. Lyon Playfair, in "Report on the State of Large Towns in Lancashire," pointed out that this regime of painting and whitewash necessitated by industrial smoke had a significant financial cost. See Catherine Bowler and Peter Brimblecombe, "Environmental Pressures on Building Design and Manchester's John Rylands Library," *Journal of Design History* 13, no. 3 (2000): 175–91, n. 74.

Chapter 3: Irritation

1. Gavin Stamp, "Anti-Ugly Action: An Episode in the History of British Modernism," *AA Files* 70 (2015): 80.
2. For details of Anti-Ugly Action, including its founding and members, see ibid.
3. Quoted in ibid., 80.
4. Ian Nairn, *Modern Buildings in London* (London: London Transport, 1964): 46. Rob Baker draws the association between Anti-Ugly Action and Nairn's remark on Bowater House in Baker, *Beautiful Idiots and Brilliant Lunatics: A Sideways Look at Twentieth-Century London* (Stroud: Amberley, 2015).
5. See Audrey Jaffe, *The Affective Life of the Average Man: The Victorian Novel and the Stock-Market Graph* (Columbus: Ohio State University Press, 2010) and Mary Poovey, *Making a Social Body: British Cultural Formation 1830–1864* (Chicago: University of Chicago Press, 1995).
6. Jaffe, *Affective Life of the Average Man*, 9.
7. Also phrased as the man on the street. The *Oxford English Dictionary* dates the first published usage to 1770, and by the end of the nineteenth century the man in the street, or, with less frequency, the woman in the street, was a common designation of the ordinary person.
8. This in contrast to the simple farmer or the "salt of the earth," the collective rural subject whose normality is legitimated by a very different set of concerns.
9. See Jaffe, *Affective Life of the Average*

Man, for the significance of oscillation.
10. See Cullen's illustrations in "Bankside Regained," *Architectural Review* (January 1949): 15–24.
11. On the development of the South Bank Arts Centre, see "Proposed Scheme for South Bank Development," *Architects' Journal* (1953): 501–6; "South Bank Development," *Builder* (1961): 601–5; "South Bank Development—the Next Stage," *Architects' Journal* (1961): 469–78; "South Bank Arts Centre," *Arup Journal* 1, no. 5 (1967): 20–31; and "South Bank Arts Centre," *Architectural Review* 144, no. 857 (1968): 15–26. Together with the Royal Festival Hall, the complex is now officially called Southbank Centre. The original name will be retained here to clarify that references are to the newer buildings only, with the Festival Hall named separately.
12. Charles Jencks, "Adhocism on the South Bank," *Architectural Review* (July 1968): 27–30. This survey solicited the opinions of engineers.
13. Peter Moro on "Concert Halls," *Architects' Journal* 145 (April 26, 1967): 1003
14. Jencks, "Adhocism on the South Bank," 27.
15. Nicholas Grimshaw and Terry Farrell were also members of the design team, and the engineer for the project was Ove Arup & Partners. Archigram included models and drawings of the South Bank Arts Centre project in a 1965 survey of their work: "Archigram Group, London: A Chronological Survey," *Architectural Design*, November 1965, 559–74. Documentation of the project can be found in the Archigram Archive Project: http://archigram.westminster.ac.uk/project.php?id=17.
16. Variants of brutalist architecture are now found across the globe, with each example belonging more to local (in spatial and temporal terms) circumstances than to any global aesthetic movement. The literature on brutalism, critical and complimentary, is equally expansive. In regard to the case outlined here, the important texts are two central statements—Reyner Banham, "The New Brutalism," *Architectural Review* (December 1955): 355–61 and *The New Brutalism: Ethic or Aesthetic* (London: Architectural Press, 1966). Brutalism is placed in

the English historical context by Elain Harwood, *Space, Hope, and Brutalism: English Architecture 1945–1975* (London: Paul Mellon Centre for Studies in British Art, 2015) and a critical appreciation of the aims and consequences of British brutalist architecture can be found in Barnabas Calder, *Raw Concrete: The Beauty of Brutalism* (London: William Heinemann, 2016).

17. Quoted by Warren Chalk in the project description for the "South Bank Development, London" in the Archigram Archive Project, http://archigram. westminster.ac.uk/project.php?id=17.
18. Jencks, "Adhocism on the South Bank," 27.
19. Warren Chalk, "Architecture as a Consumer Product," *Perspecta* 11 (1967): 135.
20. Alexi Ferster Marmot, Julian Wells, and Kenneth Browne, "Proposals for Bringing Life to the South Bank," *Architectural Review*, July 1979, 23–34.
21. Patty Hopkins, one of the founders of the firm now known as Hopkins Architects, had been active in Anti-Ugly Action, as had Sir Michael Hopkins, the other founding partner of the firm.
22. On the proposed redevelopment in its initial form, see Mark Brown, "Southbank Centre Unveils Ambitious £100m Redevelopment," *Guardian*, March 6, 2013, https://www.theguardian. com/uk/2013/mar/06/southbank-centre-redevelopment. One proposed alteration, the enclosure of the undercroft, has been withdrawn in response to a vigorous campaign by the Long Live Southbank group to preserve the skateboard park that has been the customary use of the space since the late 1970s. On the cultural history of the use of the undercroft, see *Long Live Southbank: The Book* (London: Long Live Southbank, 2015). For the official conservation statement published in 2015, see "Looking after Our Heritage: A Conservation Plan for Southbank Centre" (London: Southbank Centre Heritage Lottery Fund, 2015).
23. Peter Moro in "Concert Halls," 1002.
24. Cousins, "The Ugly (Part One)," 63.
25. Banham, "New Brutalism," 358.
26. Though the Townscape movement attempted with some rigor to translate principles formed within eighteenth-century painting and landscape design into principles applicable to the city, less attention was paid to the social, economic, and environmental determinants that had motivated and given pertinence to the eighteenth-century picturesque. Consequently, the neo-picturesque, though attuned to consumerism, was less explicitly engaged with the social or political circumstances of the postwar city than the New Brutalism. New Brutalism, with its appreciation of irregularity and indeterminacy, as discussed above, also possessed a debt of its own to the eighteenth-century picturesque. On the neo-picturesque in England at this time, see Nikolaus Pevsner, *Visual Planning and the Picturesque*, ed. Mathew Aitchison (Los Angeles: Getty Research Institute, 2010); Reyner Banham, "Revenge of the Picturesque: English Architectural Polemics, 1945–65," in *Concerning Architecture: Essays on Architectural Writers and Writing Presented to Nikolaus Pevsner*, ed. John Summerson (London: Allen Lane, 1968), 265–73; and Macarthur, *Picturesque*, 197–215.
27. Nikolaus Pevsner, "The Public Buildings of the South Bank," in *London 2 South (The Buildings of England)*, ed. Bridget Cherry and Nikolaus Pevsner (London: Penguin, 1982), 350.
28. Cousins, "The Ugly (Part One)," 62.
29. Peter Moro in "Concert Halls," 1003.
30. The English translation of Quetelet's *A Treatise on Man and the Development of His Faculties* appeared in 1842. On the legal and philosophical history of the reasonable man, see Simon Stern, "R. v. Jones (1703): The Origins of the 'Reasonable Person,'" in *Landmark Cases in Criminal Law*, ed. Ian Williams, Phil Handler, and Henry Mares (Oxford: Hart, 2017), 59–79; J. R. Lucas, "The Philosophy of the Reasonable Man," *Philosophical Quarterly* 13, no. 51 (1963): 97–106; and R.K.L. Collins, "Language, History and the Legal Process: A Profile of the 'Reasonable Man,'" *Rutgers-Camden Law Journal*, no. 8 (1977): 311–24. The reasonable man standard has in recent decades been subjected to critique due to its projection of normative standards that reinforce nonegalitarian standards. The explicit

gendering of this legal fiction is the most obvious evidence of this tendency. For an overview of the critiques and the rethinking of the reasonable man standard, see Mayo Moran, *Rethinking the Reasonable Person: An Egalitarian Reconstruction of the Objective Standard* (Oxford: Oxford University Press, 2003).

31. Jencks, "Adhocism on the South Bank," 28.

32. For example, the 1967 performance of "Partita for an Unattended Computer" in the Queen Elizabeth Hall, the first concert of electronic music; or Theo Crosby's 1973 exhibition "How to Play the Environment Game" in the Hayward Gallery, his interactive imagining of a successor to the modernist city.

33. Antony Thorncroft, "The Pink Floyd," *Financial Times*, May 13, 1967; "Floyd Play Games," *International Times* 1, no. 13 (May 19–June 2, 1967): 14.

34. *Psycho Buildings: Artists Take on Architecture* (London: Hayward, 2008).

35. "Exhibition Guide" for *Psycho Buildings*.

36. Cedric Price, *Report on South Bank*, London Metropolitan Archives, GLC/DG/AR/07/023.

37. Commons Act 2006, http://www.legislation.gov.uk/ukpga/2006/26/section/15.

38. Pet Shop Boys, "Red Letter Day" (video), dir. Howard Greenhalgh (1997).

Chapter 4: Incongruity

1. John Summerson, "William Butterfield; or, The Glory of Ugliness," in *Heavenly Mansions and Other Essays on Architecture* (London: Cresset Press, 1949), 176.

2. Ibid., 159. Though Summerson's account was influential, later historians have disagreed with his depiction of Butterfield. More extensive accounts of Butterfield and his work can be found in Paul Thompson, *William Butterfield* (London: Routledge, 1971) and Peter Howell and Andrew Saint, eds., *Butterfield Revisited* (London: Victorian Society, 2017). In his contribution to the latter volume, Paul Thompson criticizes what he characterizes as Summerson's "vitriolic attack" for creating a "negative myth" of Butterfield. Summerson's view is indeed a polemic one, but it is, nevertheless, very much an appreciation of Butterfield, or of the difficulty of Butterfield. Its importance

in the present argument, of course, lies in its willingness to try to explore and understand the category of ugliness rather than to simply refute it. Also useful for its argument that the attention to Butterfield on the part of Summerson and his contemporaries influenced the New Brutalism is Elain Harwood, "Butterfield and Brutalism," *AA Files* 27 (1994): 39–46.

3. Summerson, "William Butterfield," 167.

4. Ibid., 166, 167.

5. Ibid., 173–74.

6. Ibid., 176.

7. John Summerson, *Georgian London* (London: Pleiades Books, 1945).

8. Christopher Wren, "The Auditory Church," letter reprinted as appendix 2 in G.W.O. Addleshaw and Frederick Etchells, *The Architectural Setting of Anglican Worship* (London: Faber and Faber, 1948), 249. The Addleshaw and Etchells book explains the physical transformations to church interiors that resulted from the Reformation and subsequent theological changes. (Frederick Etchells was also responsible for the first English translation of Le Corbusier's *Vers une Architecture*.)

9. Wren, "Auditory Church," 250.

10. Chad Varah, paraphrased by Peter Palumbo in memo of June 4, 1970, meeting as cited in *R v. St Stephen Walbrook*, 2 All England Law Reports 705, 709 (1986).

11. Chad Varah evidence as quoted in ibid., 709.

12. Chad Varah paraphrased by Peter Palumbo in memo of June 4, 1970, meeting, as cited in ibid., 709.

13. Memorandum note dated September 18, 1970, author unknown, "Materials pertaining to St Stephen Walbrook Altar," Henry Moore Archive, Henry Moore Foundation, Perry Green, Hertfordshire, UK.

14. In some cases, there is no opposition to the petition for the faculty, but if, as in this case, the change being proposed or the context is significant, the chancellor may then ask the archdeacon to enter appearance to put the petition to proof, in other words, to act as a formal opponent. For information on the faculty system, see Charles Mynors, *Changing Churches: A Practical Guide to the Faculty System* (London: Bloomsbury, 2016).

For an overview of ecclesiastical law, see Mark Hill, *Ecclesiastical Law*, 3rd ed. (Oxford: Oxford University Press, 2007).

15. *R v. St Stephen Walbrook* (1986), 711. The case was heard by Chancellor G. H. Newsom QC and argued by Peter Boydell QC and Charles George for the petitioners and Spencer G. Maurice for the archdeacon. A transcript of Newsom's trial notebook can be found in the London Metropolitan Archives, LMA/MS 31588/71.

16. *R v. St Stephen Walbrook* (1986), 711.

17. These are the words of Sir Roy Strong, director of the V&A Museum, presented at the Consistory Court hearing. See *R v. St Stephen Walbrook*, 2 All England Law Reports 578, 587 (1987).

18. From Downes's caption for the drawing in Downes, *Sir Christopher Wren* (London: Whitechapel Art Gallery, 1982), 65. The drawing, from 1674, is housed in the RIBA Drawings Collection, Victoria & Albert Museum, London. See Christopher Wren, "Designs for St Stephen Walbrook, City of London: Transverse Section."

19. See transcript of G. H. Newsom Trial Notebooks, London Metropolitan Archives, LMA/MS 31588/71.

20. *R v. St Stephen Walbrook* (1986), 711.

21. This point was made most forcefully by the witness John Arthur Newman, architectural historian and senior lecturer at the Courtauld Institute of Art and a member of the Georgian Group. Newman was also the one witness willing to declare the altar itself to be a "second-rate work." *R v. St Stephen Walbrook* (1987), 587.

22. Ibid., 586.

23. Ibid., 586.

24. Letter from Peter Palumbo to Henry Moore, dated April 16, 1971, "Materials pertaining to St Stephen Walbrook Altar," Henry Moore Archive.

25. *R v. St Stephen Walbrook* (1986), 712. Ashley Barker was referring here to a well-known assertion from Christopher Wren's *Tracts on Architecture*—well known if not entirely well understood. Wren is sometimes cited as having argued that there are two kinds of beauty, natural and customary, with natural beauty being an absolute quality of an object and customary beauty being relative to the conventions and tastes

of a given cultural context. Wren did indeed distinguish between the natural and the customary, but his argument was not that there are two "kinds" of beauty, but rather that there are two "causes" of beauty. Wren regarded beauty to be not so much a quality as a judgment. Natural beauty was not inherent in an object, but was a judgment formulated by the mind upon encountering the qualities of that object through the perceptions of the senses. Customary beauty was similarly a judgment of the mind, though one disoriented or deceived by social influence, as in an inordinate approbation of novelty, for example. Geometric perfection would indeed be a prompt of natural beauty, but would still have depended on the intercession of a faculty of judgment, and would also have required the overcoming of misleading judgments based upon fashion, habit, novelty, or other contingent influence. See J. A. Bennett, "Christopher Wren: The Natural Causes of Beauty," *Architectural History* 15 (1972): 5–22. On Wren, also see J. A. Bennett, *The Mathematical Science of Christopher Wren* (Cambridge: Cambridge University Press, 1982); Lydia M. Soo, *Wren's "Tracts" on Architecture and Other Writings* (Cambridge: Cambridge University Press, 1998); and John Summerson, "The Mind of Wren," in *Heavenly Mansions and Other Essays on Architecture* (London: Cresset Press, 1949), 51–86.

26. *R v. St Stephen Walbrook* (1986), 709. The theological distinction of altar and table had been put forward by the barrister in opposition as a possible point of law to be considered in the case, and his suggestion was taken up by the chancellor.

27. Ibid., 705.

28. John Henry Newman introduced the concept of development in a book published at the time of his conversion to Catholicism. See Newman, *An Essay on the Development of Christian Doctrine* (London: James Toovey, 1845).

29. Theoretical perspectives on postmodernism and postmodernity are extensive, but for the context of postmodernism as it is approached here, see Fredric Jameson, *Postmodernism; or, The Cultural Logic of Late Capitalism* (Durham, NC: Duke University Press,

1992) and Reinhold Martin, *Utopia's Ghost: Architecture and Postmodernism, Again* (Minneapolis: University of Minnesota Press, 2010). For a survey of British postmodern buildings contemporaneous with the St. Stephen Walbrook case, see Elain Harwood and Geraint Franklin, *Post-modern Buildings in Britain* (London: Batsford, 2017).

30. See James F. White, *The Cambridge Movement: The Ecclesiologists and the Gothic Revival* (Cambridge: Cambridge University Press, 1962) and Christopher Webster and John Elliott, eds., *"A Church as It Should Be": The Cambridge Camden Society and Its Influence* (Stamford: Shaun Tyas, 2000). Also see Michael Hall, "What Do Victorian Churches Mean? Symbolism and Sacramentalism in Anglican Church Architecture, 1850–1870," *Journal of the Society of Architectural Historians* 59, no. 1 (2000): 78–95.

31. In an account of Butterfield's design for All Saints', Margaret Street published in the *Ecclesiologist*, the society journal, the reviewer observed, not disapprovingly, a "dread of beauty" in the architect's work not far short of a "preference for ugliness." "All Saints', Margaret Street," *Ecclesiologist*, no. 130 (February 1859): 185.

32. The viewpoint of the Cambridge Camden Society is given in Thomas Thorp (Chairman of the Restoration Committee), *A Statement of Particulars Connected with the Restoration of the Round Church* (Cambridge: Deightons, Stevenson, and Walters, 1845). Reverend Faulkner conveyed his position in the circular R. R. Faulkner, "An Appeal to the Protestant Public Respecting the Popish Abominations of a Stone Altar and Credence Table, in St. Sepulchre's Church, Cambridge" (1844). For a historical account of the controversy, see Elliot Rose, "The Stone Table in the Round Church and the Crisis of the Cambridge Camden Society," *Victorian Studies* 10, no. 2 (1966): 119–44.

33. *Faulkner v. Litchfield and Stern*, 163 English Reports 1007 (1845): 1020.

34. Ibid., 1021.

35. The installation in the Round Church included a bead of mortar and a base recessed into the tiles of the floor, details that were interpreted as confirming the immobility of the altar.

36. *Faulkner v. Litchfield and Stern*, 1019.

37. Ibid., 1030.

38. Ibid., 1012.

39. Ibid., 1013.

40. Ibid., 1015.

41. The Court of Ecclesiastical Causes Reserved on its establishment was considered to be free of precedents set by the Privy Council. On the CECR, see Hill, *Ecclesiastical Law.*

42. *R v. St Stephen Walbrook* (1987), 580. In the implicit acceptance of development as an aspect of legal method, there is a parallel to the endorsement of development by some Ecclesiologists and gothic revival architects in the nineteenth century. See Hall, "What Do Victorian Churches Mean?" The five judges of the CECR were Sir Anthony Lloyd, the Bishop of Rochester, the Bishop of Chichester, the Right Reverend Kenneth Woollcombe, and Sir Ralph Gibson.

43. See *R v. St Mary's, Banbury*, 1 All England Law Reports 247 (1987).

44. *R v. St Stephen Walbrook* (1987), 594.

45. Kerry Downes as quoted in ibid., 589.

46. *R v. St Stephen Walbrook* (1986), 711, 710.

47. Ibid., 711.

48. *R v. St Stephen Walbrook* (1987), 581.

49. In Summerson's words, "If the value of a work of art is, for you, inseparable from its position in time, the ugliness in Butterfield becomes an essential part of a *situation* which must be evaluated as a whole." Summerson, "William Butterfield," 176.

Chapter 5: The Architect

1. Quoted in *European Magazine* 62 (November 1812): 384.

2. Ibid., 385.

3. Building Act, 14 George III, cap. 78, 1774.

4. *Sun*, October 15, 1812.

5. *Times*, November 19, 1812. The presence of Lord Ellenborough was only the consequence of his position as chief justice presiding over the Court of the King's Bench. But the account that follows will show his persistent involvement in the legal events that addressed questions of criticism and architecture. Lord Ellenborough was himself a fellow of the Society of Antiquaries of London, and evidently had concern for matters of art. He took advantage of the hearing regarding the

facade of Soane's House to quip that although the Building Act "might have benefited the construction of houses it was not itself a model of construction."

6. *Sun*, October 15, 1812.

7. John Henry Barrow, ed., *Mirror of Parliament (1st Session, 3 Will. IV)*, vol. 1 (1833): 773.

8. This discursive space is familiar as the public sphere theorized by Jürgen Habermas in *The Structural Transformation of the Public Sphere: An Inquiry into a Category of Bourgeois Society*, (1962; Cambridge, MA: MIT Press, 1991). Habermas's account privileges the nature of the public sphere at what he regards as its inception, in the late seventeenth century. By the time Soane began his career, the public condition was markedly different, as the invention of the word "publicity" demonstrates. The *Oxford English Dictionary* cites the first usage of the word in 1791, suggesting the perception at that moment of a new experience of public observation and notice, which was undoubtedly related to the proliferation of print media. The first daily newspaper, the *Daily Courant*, appeared in London in 1702, in editions of perhaps eight hundred copies; by 1821 there were several daily newspapers, and the leading daily, the *Times*, had a circulation of ten thousand. For the London press at the start of Soane's career, see Lucyle Werkmeister, *The London Daily Press, 1772–1792* (Lincoln: University of Nebraska Press, 1963). Habermas's argument is taken up critically in Joad Raymond, ed., *News, Newspapers, and Society in Early Modern Britain* (London: Frank Cass, 1999) and Hannah Barker, *Newspapers, Politics, and Public Opinion in Late Eighteenth-Century England* (Oxford: Clarendon, 1998).

9. Sir John Soane's Clippings Scrapbooks, Soane Museum, London. John Wood never "moved into the limelight of 18th-century gossip," as John Summerson put it, and so did not attain anything like Soane's rank of celebrity. But Soane knew of Wood and owned his treatise *The Origin of Building* and his account of Stonehenge, *Choir Gaure, Vulgarly Called Stonehenge, on Salisbury Plain, Described, Restored, and Explained*. Stonehenge was an artifact of considerable fascination for Soane.

10. *Observer*, October 16, 1796.

11. Arthur T. Bolton, *The Portrait of Sir John Soane, R.A.* (London: Butler & Tanner, 1927), 62. The text of the poem reprinted by Bolton, presumably a copy Soane possessed since Bolton was curator of the Soane Museum, differs slightly from that in the *Observer*, but the two versions are equally derisory.

12. Innuendo was the absence of any explicit referent, even if the imputation was obvious, as in the case of the elided "Sxxne." Only a statement that named or portrayed an individual in a manner that excluded any other identification could be libel. See C. R. Kropf, "Libel and Satire in the Eighteenth Century," *Eighteenth-Century Studies* 8, no. 2 (Winter 1974–75): 153–68. Francis Ludlow Holt's *The Law of Libel* (London: J. Butterworth, 1816) is an early nineteenth-century treatise on libel law, and an overview of English libel law is given in Peter Carter-Ruck, *Libel and Slander* (Hamden, CT: Archon Books, 1973).

13. Holt, *Law of Libel*, 72.

14. On the national significance of the architecture of the Bank of England and Soane's work for the bank, the authoritative study is Daniel M. Abramson, *Building the Bank of England: Money, Architecture, Society, 1694–1942* (New Haven, CT: Yale University Press, 2005).

15. Bolton, *Portrait of Sir John Soane*, 76.

16. Holt, *Law of Libel*, 187–88.

17. Bolton, *Portrait of Sir John Soane*, 76.

18. *Sun*, May 18, 1799 and *Morning Chronicle*, May 18, 1799. Reports also appeared in the *Herald*, the *Times*, and the *True Briton* on the same date.

19. *Times*, May 18, 1799.

20. The essays, signed only with initials, appeared in the *Guardian* of May 20, May 27, and June 3, 1821. They are excerpted in Bolton, *Portrait of Sir John Soane*, 340–43. Gillian Darley provides a compelling study of Soane's personality, and the effects of these events upon him, in her biography of Soane: Darley, *John Soane: An Accidental Romantic* (New Haven, CT: Yale University Press, 1999).

21. Bolton, *Portrait of Sir John Soane*, 341–42.

22. Ibid., 343–44. In theory, the criteria for "libels against a man in respect to his profession and calling" did support

action for an individual "disgraced or injured in his profession" by a defamatory publication. See Holt, *Law of Libel*, 210.

23. *Liberty of the Press! Sir John Carr against Hood and Sharpe. Report of the above Case*, Vernon, Hood, and Sharpe (London, 1808), 28.

24. Ibid., 27.

25. Ibid., 28.

26. *Sun*, May 18, 1799

27. Bolton, *Portrait of Sir John Soane*, 342–43.

28. Ibid., 343.

29. Ibid., 343.

30. *Sun*, June 5, 1821.

31. *Sun*, June 23, 1821.

32. Bolton, *Portrait of Sir John Soane*, 374–78.

33. *Times*, June 13, 1827.

34. *Times*, June 13, 1827. Perhaps the only legal strategy remaining to Soane was to argue that the libel constituted a "breach of the peace," meaning that it was deliberately calculated to cause deep offense and therefore likely to provoke a violent response. This interpretation of libel law was more common in the prosecution of criminal libels, which might be all the more antagonistic for being true. Soane's counsel in *Soane v. Knight* considered that this condition would be the only circumstance in which a court took notice of "personal feeling." Darley, *John Soane*, 279.

35. *Times*, June 13, 1827. The case of *Soane v. Knight* would be cited during the following decades, and into the twentieth century, as a precedent in the application of libel law to artistic works. See, for example, the Earl of Hansbury, *The Laws of England: Being a Complete Statement of the Whole Law of England*, vol. 18 (London: Butterworth, 1911), 704–5.

36. *Times*, June 13, 1827.

37. Bolton, *Portrait of Sir John Soane*, 148–49.

38. *Examiner*, February 11, 1810.

39. Sidney Hutchinson, *The History of the Royal Academy, 1768–1986* (1968; London: Robert Royce, 1986), 245. A nineteenth-century account of the Royal Academy is William Sandby, *The History of the Royal Academy of Arts* (London: Longman, Green, Longman, Roberts & Greene, 1862).

40. David Watkin, *Sir John Soane: Enlightenment Thought and the Royal Academy Lectures* (Cambridge: Cambridge University Press, 1996), 490, 491–92.

41. Good reputation was the public attribute of an academician, but inside the Royal Academy a reputation was subject to the numerous intrigues and rivalries that consumed its members. One of the most powerful and partisan academicians, painter Joseph Farington, disliked Soane intensely. See Kenneth Garlick, Angus Macintyre, et al., eds., *The Diary of Joseph Farington* (New Haven, CT: Yale University Press, 1998).

42. Watkin, *Sir John Soane*, 544.

43. Ibid., 544.

44. Bolton, *Portrait of Sir John Soane*, 148–49.

45. Illustrated newspapers did not appear until later in the nineteenth century; engravings were used sparingly in weekly journals. An interested reader could find architectural criticism in books like James Ralph's *A Critical Review of the Publick Buildings, Statues and Ornaments in, and about London and Westminster* of 1734, or James Elmes and Thomas Shepherd's *Metropolitan Improvements*, an illustrated volume published in 1827, but their circulation was not as extensive as that of the press, particularly among the general public. Mark Hallet has studied the reception of the Exhibition in the press, and confirms the likelihood that many more people read reviews of the Exhibition than actually paid a shilling to see it. See Mark Hallett, "'The Business of Criticism': The Press and the Royal Academy Exhibition in Eighteenth-Century London," in *Art on the Line*, ed. David Solkin (London: Yale University Press, 2001), 64–75.

46. *Examiner*, July 15, 1810. The letter is signed "A Humble Artist," and Soane likely had some role in its publication. Bolton suggests that it may have been written by Soane's friend, James Spiller. This adumbrates Soane's actions in the later *Guardian* episode, when supportive letters appeared in the *Sun*. The *Sun* was a Tory publication, while the *Examiner* was among the most radical of the London newspapers. Although this suggests some degree of disengagement between political partisanship and artistic criticism at the time, more likely it should be attributed to the influence of personal relationships upon the publications themselves. In this instance, the *Examiner*'s support for

Soane may well have been corollary to its politics, given the royal patronage of its target, the academy itself. Hallett addresses the relationship of "party-political" and "art-theoretical" criticism of the arts in "'Business of Criticism.'"

47. *Morning Chronicle*, May 18, 1799.

48. In the 1808 case of *Tabbert v. Tipper*, Lord Ellenborough directed the jury that the defendant's actions had deliberately brought harm to the plaintiff's business as a bookseller, and the jury therefore found the defendant guilty of libel. Lord Ellenborough nevertheless stated his view that criticism played a necessary social role. Quoted in Holt, *Law of Libel*, 215–16.

49. Watkin, *Sir John Soane*, 544.

50. Ibid., 666.

51. Ibid., 544.

52. *Times*, June 13, 1827.

53. *Times*, March 31, 1824.

54. For a full account of the trial proceedings, see Linda Merrill, *A Pot of Paint: Aesthetics on Trial in Whistler v. Ruskin* (Washington, DC: Smithsonian, 1992). Also see "The Trials of Beauty: Ruskin, Whistler, and a 'New Series of Truths,'" in Higgins, *Modernist Cult of Ugliness*.

55. *Botterill and Another v. Whytehead* in *The Law Times Reports*, vol. 41 (London: Horace Cox, 1880), 588.

56. Reyner Banham, "On Criticizing Architecture," *Listener*, January 4, 1962, 16.

57. J. M. Richards, "Architect, Critic and Public," *Royal Architectural Institute of Canada Journal* 27 (November 1950): 373.

58. "Architectural Criticism," *Architectural Review* (November 1950): 19.

59. Richards, "Architect, Critic and Public," 373.

60. Martin Filler, "The Insolence of Architecture," *New York Review of Books*, June 4, 2014, http://www.nybooks.com/articles/2014/06/05/insolence-architecture/. The essay was edited after the lawsuit was settled, with the modified version published on August 25, 2014, accompanied by a letter of apology from its author.

61. Though US libel law has been influenced by common law in Great Britain, particularly during the nineteenth century, the standards of libel are now distinct in the two legal contexts.

Because the case was filed in New York State, the relevant legal standards would have differed from those in Great Britain, though the broad categories of harm, as to professional reputation, for example, are the same.

62. "Complaint and Jury Demand," *Hadid v. NYREV d/b/a New York Review of Books, Martin Filler*, New York State Supreme Court, August 21, 2014. On the prevalence of explicitly gendered approaches to criticism of Zaha Hadid and her work, see Katie Lloyd Thomas, "On the Media Coverage of Zaha Hadid's Death," *arq* 20, no. 2 (June 2016): 99–103.

Chapter 6: The Profession

1. Ouida, "The Streets of London," in *The Woman's World*, ed. Oscar Wilde (London: Cassell & Company, 1888), 483.

2. Ibid., 482.

3. William Morris, "Ugly London," *Pall Mall Gazette*, September 4, 1888. Ouida's critical description of London's streets had also been published in the *Pall Mall Gazette*, and Morris was asked to give a response.

4. Ouida, "Streets of London," 484; Morris, "Ugly London."

5. Ouida, "Streets of London," 484.

6. Morris, "Ugly London."

7. RIBA Charter 1837, https://www.architecture.com/-/media/files/history-charter-and-byelaws/charterbyelaws2016.pdf.

8. The royal designation was granted by Queen Victoria in 1866. The more modern forms of legal incorporation followed in the middle of the century, with the Joint Stock Companies Acts passed in 1844 and 1856.

9. See R. Norman Shaw, "That an Artist Is Not Necessarily Impractical," in *Architecture: A Profession or an Art*, ed. R. Norman Shaw and T. G. Jackson (London: John Murray, 1892), 1–15, and John Wilton Ely, "The Rise of the Professional Architect in England," in *The Architect: Chapters in the History of a Profession*, ed. Spiro Kostof (Berkeley: University of California Press), 180–208. The 1931 act is the Architects (Registration) Act, 21 & 22 Geo. 5, Ch. 33.

10. *British Architect and Northern Engineer*, September 20, 1878, 115.

11. Ibid., 113.

12. John Summerson's essay "William

Butterfield" was one example of this process of acknowledgment and assessment of the Victorian architects within the exigencies of their historical period.

13. H. S. Goodhart-Rendel, "Victorian Conservanda," *Journal of the London Society*, no. 344 (1958): 40.

14. Ibid., 43.

15. Summerson, "William Butterfield," 172; John Summerson, *The Architecture of Victorian London* (Charlottesville: University of Virginia Press, 1976), 15, 89, 85.

16. Summerson, *Architecture of Victorian London*, 89.

17. Ibid., 88, 54.

18. John Summerson, *Victorian Architecture: Four Studies in Evaluation* (New York: Columbia University Press, 1970), 2.

19. Ibid., 4.

20. Roland Barthes, "The Death of the Author," in *Image-Music-Text* (New York: Macmillan, 1978).

21. See report by Inspector Stephen Marks, secs. 22.05–22.14, pp. 128–129, folder AT 41/411, National Archives, Kew, Surrey, UK. For the general history and current disposition of London conservation areas, see "Conservation Areas in the City of London: A General Introduction to Their Character," ed. Department of Planning and Transportation (City of London, 1994).

22. The Mansion House Square inquiry convened by Stephen Marks was held in the Livery Hall of Guildhall from May 1 to July 6, 1984. (see Figure 54) The inspector's final report, which contains summaries of the testimony and evidence, can be found in folder AT 41/411, National Archives.

23. Report by Inspector Stephen Marks, sec. 10.88, p. 47, folder AT 41/411, National Archives. Additional papers pertaining to the Mansion House Square inquiry are contained in the RIBA Archives, with John Summerson's testimony included in the John Summerson Papers. For an analysis of Summerson's testimony in relation to his concerns about preservation, see Michela Rosso, "An Open Space at the Constricted Centre of the City: Summerson and the Artificial Inflation of Victorian Values," in *Summerson and Hitchcock: Centenary Essays on Architectural Historiography*, ed.
Frank Salmon (New Haven, CT: Yale University Press, 2006), 155–69.

24. Summerson, *Architecture of Victorian London*, 88, 54.

25. Report by Inspector Stephen Marks, sec. 10.88, p. 56, folder AT 41/411, National Archives.

26. Ibid., 55, 57. Opponents also argued that the reputation Mies enjoyed was itself a fiction, forged largely by the sustained propaganda of Philip Johnson. Richard Rogers aimed to rebut this claim with an explication of the broad historical importance of Mies's work.

27. Ibid., 57.

28. John Harris, "Was the Design by Mies van der Rohe?," *Financial Times*, April 30, 1982. Harris was referring to the two public exhibitions of the Mansion House Square scheme. The 1968 exhibition is shown in Figure 52.

29. In a minor controversy during the inquiry, the inspector was told that Dr. Ludwig Glaeser, curator of the Mies archive and a supporter of the proposed tower, had suborned Hitchcock, attempting to induce him to recant this statement. The inspector did not pursue the accusation formally but surely took note of it.

30. Report by Inspector Stephen Marks, sec. 10.88, p. 46, folder AT 41/411, National Archives.

31. The secretary of state issued his decision on May 22, 1985. See Press Notice, "Patrick Jenkin Rejects Mansion House Proposal," folder AT 41/411, National Archives.

32. See Peter Carter, "The Design Was by Mies van der Rohe," *Financial Times*, May 5, 1982, and "Expert Witness: Peter Carter," *Architects' Journal*, August 22 and 29, 1984, 24–25.

33. Report by Inspector Stephen Marks, sec. 10.10, p. 40 and sec. 10.50, p. 48, folder AT 41/411, National Archives.

34. Ibid., 132–33

35. Ibid., 131.

36. Ibid., 17.

37. Inspector's report quoted in "Give These Vigorous Victorian Buildings a Chance" (SAVE Britain's Heritage), np. The architect is Frederick J. Ward, who also designed the Albert Buildings, which stood across the street. Noting the stylistic extremity of these architectural solutions, Summerson described

both buildings as "very disturbing solutions of the office block problem." Summerson, *Architecture of Victorian London*, 53.

38. The literary theorist Seán Burke has described this effect as a "structure of resummons whereby the author may be recalled to his or her text," proposing that the signature "offers itself to any tribunal which may be subsequently established upon the basis of the signatory's text in relation to as yet unrealized historical circumstances. The signature accedes to this tribunal." Burke, "The Ethics of Signature," in *Authorship: From Plato to the Postmodern: A Reader*, ed. Burke (Edinburgh: Edinburgh University Press, 1995), 289.

39. Ibid., 289.

40. Michel Foucault, in his essay "What Is an Author?," noted that with the modern notion of the author (or what he characterized as the "author-function"), the relation between author and text (or here between architect and building) was fixed by signature so that the circulation of illicit or transgressive discourses could be disciplined or curtailed. An author's signature was an acceptance of liability for the undersigned contents; in order to evade that discipline, the signature "Anonymous" appeared in its modern form. See Foucault, "What Is an Author?," in Burke, *Authorship*, 141–60.

41. Summerson, *Architecture of Victorian London*, 6.

42. "Palumbo to Commission New Scheme," *Architects' Journal*, May 29, 1985, 24.

43. Stirling Wilford and Associates became Michael Wilford & Partners in 1993.

44. "Foster and Rogers Add Weight to No. 1 Poultry Listing Bid," *Architects' Journal*, July 13, 2015, https://www.architectsjournal.co.uk/news/foster-and-rogers-add-weight-to-no1-poultry-listing-bid/8686170.article.

45. "James Stirling's Widow Hits Out at Poultry Plans," *Architects' Journal*, September 1, 2015, https://www.architectsjournal.co.uk/news/james-stirlings-widow-hits-out-at-poultry-plans/8688289.article.

46. "Wilford: 'Claims Stirling Was Unhappy with Poultry Are Wrong,'" *Architects' Journal*, July 27, 2015, https://www.architectsjournal.co.uk/news/

wilford-claims-stirling-was-unhappy-with-poultry-are-wrong/8686777.article.

47. Ibid.

48. The stated concern was that the several cultural communities that had come to reside in the neighborhood maintained different cultural practices and traditions, in some of which the presence of human remains would require avoidance of the building altogether.

49. "Case No. 15: Christ Church Spitalfields," April 12, 2004, Consistory Court of the Diocese of London, 3.

Chapter 7: The Monarch

1. "A speech by HRH The Prince of Wales at the 150th anniversary of the Royal Institute of British Architects (RIBA), Royal Gala Evening at Hampton Court Palace," May 30, 1984, https://www.princeofwales.gov.uk/media/speeches/speech-hrh-the-prince-of-wales-the-150th-anniversary-of-the-royal-institute-of.

2. This expansion of the National Gallery had been initiated decades earlier. The government purchased the site in 1958 to remove it from possible commercial development, and the following year the *Sunday Times* staged a competition soliciting ideas for the gallery's expansion. Several dozen entries were given recognition, but as no commitment of government funds was forthcoming, no action resulted from the competition. The later competition was announced by the government in 1981, and made use of a different format, in which both an architect and a developer would be selected, with the developer permitted to use some of the site for offices. Only a basic brief of information and requirements was provided to entrants, with the assumption being that further refinement to specify and satisfy the needs of the National Gallery would follow after the selection of an architect and developer. For an account of the history leading up to the extension of the National Gallery, see Colin Amery, *A Celebration of Art and Architecture: The National Gallery Sainsbury Wing* (London: National Gallery Publications, 1991).

3. In the informal public poll, the entry by Richard Rogers Partnership received 29 percent of the first-place votes

and 36 percent of the "least popular" votes. Seven schemes (out of seventy-nine entries) had been shortlisted and exhibited. In October 1982, the competition advisors announced that three firms would be asked to further develop their designs: Skidmore, Owings, and Merrill (SOM), Arup Associates, and the eventual winner Ahrends Burton and Koralek (ABK). At the end of the year, apparently after contentious deliberations, it was announced that none of the designs were satisfactory, but that ABK would be selected as architects and would be asked to prepare a new scheme based on revised requirements. Amery, *Celebration of Art and Architecture*, 43–49.

4. Quoted in ibid., 48.

5. See newspaper clipping reprinted in "RIBA President Rides into a Storm," *Building Design* 24 (August 2007): 36.

6. "A speech by HRH The Prince of Wales at the 150th anniversary of the Royal Institute of British Architects (RIBA), Royal Gala Evening at Hampton Court Palace," May 30, 1984, https://www.princeofwales.gov.uk/media/speeches/speech-hrh-the-prince-of-wales-the-150th-anniversary-of-the-royal-institute-of.

7. "The Prince of Wales' Speech," Andrew Allberry memorandum to the Secretary of State, May 31, 1984, folder 17/739, "National Gallery Extension, Public Inquiry: Discussions, Papers, and Correspondence," National Archives.

8. John Delafons memorandum to the Private Secretary for the Secretary of State, June 1, 1984, folder 17/739, "National Gallery Extension, Public Inquiry: Discussions, Papers, and Correspondence," National Archives.

9. "A speech by HRH The Prince of Wales at the Corporation of London Planning and Communication Committee's Annual Dinner, Mansion House, London," December 1, 1987, http://www.princeofwales.gov.uk/media/speeches/speech-hrh-the-prince-of-wales-the-corporation-of-london-planning-and-communication. Two useful sources on the participation of the Prince of Wales in these architectural debates are "Prince Charles and the Architectural Debate," *AD* 59, nos. 5/6 (1989), and Charles Jencks, *The Prince, the Architects,*

and the New Wave Monarchy (London: Academy Editions, 1988).

10. "A speech by HRH The Prince of Wales at the Corporation of London Planning and Communication Committee's Annual Dinner, Mansion House, London," December 1, 1987, http://www.princeofwales.gov.uk/media/speeches/speech-hrh-the-prince-of-wales-the-corporation-of-london-planning-and-communication.

11. Ibid.

12. See the Mass Observation archive, http://www.massobs.org.uk/.

13. Peter Collins, *Architectural Judgement* (Montreal: McGill-Queen's University Press, 1971), 192.

14. Ibid., 190.

15. Report by Inspector Stephen Marks, sec. 22.01, p. 128, folder AT 41/411, National Archives.

16. Collins was inspired to write *Architectural Judgement* after spending a year as a fellow at the Yale Law School. Intrigued by legal history and influenced by the concepts of precedent in legal reasoning, Collins argued for the possibility of revitalizing architectural judgment by adopting some of the perspectives to be found in jurisprudence. Collins also published brief reflections on ugliness in Peter Collins, "Uglification and Derision," *RAIC Journal* 36, no. 8 (1959): 282–83.

17. On the Town and Country Planning Act and town planning in Britain, see Gordon E. Cherry, *Town Planning in Britain since 1900: The Rise and Fall of the Planning Ideal* (Oxford: Blackwell, 1996); Cherry, *The Evolution of British Town Planning* (Leighton Buzzard: Leonard Hill Books, 1974); and Francis J. C. Amos, "The Town and Country Planning Act 1947," *Planning Outlook* 30 (1987): 12–14. For theoretical consideration of the space of the inquiry (from the perspective of sociology of science), see Stephen Yearley, "Bog Standards: Science and Conservation at a Public Inquiry," *Social Studies of Science* 19, no. 3 (1989): 421–38.

18. At present, this would be the secretary of state for community and local government. During the 1980s, it was the responsibility of the secretary of state for the environment. Planning procedures generally refer simply to the "secretary of state," so that

nomenclature is used here.

19. The two other national amenity societies concerned with architecture and monuments are the Ancient Monuments Society and the Council for British Archeology. There are also parallel societies in Scotland, and hundreds of local preservation societies as well as charities like SAVE Britain's Heritage. Within the national government, Historic England (formerly English Heritage) operates as an executive body in the Department for Culture, Media, and Sport. See the National Heritage Act of 1983. Sources on the emergence of the institutions of the heritage movement in Britain include Simon Thurley, *Men from the Ministry: How Britain Saved Its Heritage* (New Haven, CT: Yale University Press, 2013), and Michael Hunter, ed. *Preserving the Past* (Stroud: Alan Sutton, 1996).

20. The judiciary in Britain is independent of the sovereign, who is no longer the "fount of justice," and the sovereign is independent of the law. The monarch is immune from civil and criminal prosecution and cannot be compelled to give testimony in legal proceedings. Under constitutional practice, the monarch refrains from engaging in political matters, formally accepting the advice of ministers as the policy of the government she heads. On the Duchy of Cornwall, see http://duchyofcornwall. org/.

21. See chap. 4 in Vaughan Hart, *Inigo Jones: The Architect of Kings* (New Haven, CT: Yale University Press, 2011), and for the political theory of the king's two bodies, see Ernst H. Kantorowicz, *The King's Two Bodies: A Study in Medieval Political Theology* (Princeton, NJ: Princeton University Press, 1957). On the relation of monarch and architecture in the City of London, see Christine Stevenson, *The City and the King: Architecture and Politics in Restoration London* (New Haven, CT: Paul Mellon Centre for British Art, 2013).

22. See Michael Rustin, "Postmodernism and Antimodernism in Contemporary British Architecture," *Assemblage* 8 (1989): 88–104.

23. The Chelsea Society was a local organization. English Heritage (described in note 19 above) had been consulted because of the possible effect on a listed building; CABE, another

executive body under the authority of the Department of Culture, Media, and Sport, was responsible for advising the government on matters pertaining to architecture and the built environment.

24. Patrick Barkham and Bob Sharp, "Architects Clash on £20m Update for Wren's Historic Hospital," *Guardian*, May 12, 2005, https://www.theguardian. com/society/2005/may/12/urbandesign. arts; Neil Tweedie and Helen Johnstone, "Architects at War over Infirmary for Old Soldiers," *Telegraph*, May 23, 2005, www. telegraph.co.uk/news/uknews/1490570/ Architects-at-war-over-infirmary-for-old-soldiers.html.

25. Qatari Diar withdrew its application for planning permission, after the intervention from Prince Charles but prior to the actual hearing in front of the Kensington and Chelsea committee, leading the CPC Group to file suit against their partners on the grounds that they had a contractual obligation to try to obtain planning permission. *CPC Group Ltd v. Qatari Diar Real Estate Investment Co* [2010], EWHC 1535 (Ch) (June 25, 2010).

26. Robert Booth, "A Tale of Two Princes: How Prince Charles Altered the Landscape with a Word in the Emir of Qatar's Ear," *Guardian*, May 17, 2010, https://www. theguardian.com/uk/2010/may/17/ prince-charles-chelsea-barracks.

27. *Sunday Times*, April 19, 2009.

28. Jonathan Glancey, "The View from Highgrove," *Guardian*, April 23, 2009, https://www.theguardian. com/artanddesign/2009/apr/23/ prince-charles-richard-rogers-riba.

29. Robert Booth, "Prince Charles's Meddling in Planning 'Unconstitutional,' Says Richard Rogers," *Guardian*, June 15, 2009, https://www.theguardian.com/ uk/2009/jun/15/prince-charles-richard-rogers-architecture.

30. Walter Bagehot, *The English Constitution* (London: Chapman & Hall, 1867), 103.

31. In the British context, a constitutional convention is a rule or procedure that emerges from customary practice and, though not enacted into law, is agreed to regulate the conduct of relevant institutions of the state, and the Crown in particular.

32. This proposition had been asserted

speculatively by Rodney Brazier. See Brazier, "The Constitutional Position of the Prince of Wales," *Public Law*, Autumn 1995, 401–16. Also see Adam Perry, "Constitutional Conventions and the Prince of Wales," *Modern Law Review* 76, no. 6 (November 2013): 1119–28.

33. *Evans v. Information Commissioner* [2012], UKUT 313 (AAC) (September 18, 2012), para. 106, p. 33.

34. Ibid., para. 160, pp. 44–45.

35. Rob Evans and Robert Booth, "Attorney General Blocks Disclosure of Prince Charles Letters to Ministers," *Guardian*, October 16, 2012, https://www.theguardian.com/uk/2012/oct/16/attorney-general-blocks-prince-charles-letters.

36. The black spider memos are available online: "Prince of Wales Correspondence with Government Departments," https://www.gov.uk/government/collections/prince-of-wales-correspondence-with-government-departments. The decade-long case laid out the terms of argument, although it will not set a precedent because Parliament in 2010 passed a revision to the Freedom of Information Act exempting communications of the heir to the throne and the second in line to the throne.

37. See Jean-François Lyotard, *The Differend* (Minneapolis: University of Minnesota Press, 1988).

38. Jean-François Lyotard, *The Postmodern Condition: A Report on Knowledge* (Minneapolis: University of Minnesota Press, 1984), xxiv.

39. See *CPC Group Ltd v. Qatari Diar Real Estate Investment Co* [2010], EWHC 1535 (Ch) (June 25, 2010).

Conclusion

1. Edward Hollamby was the chief architect who commissioned John Outram, Richard Rogers, and Nicholas Grimshaw to each design one of the pumping stations. See the official listing for the Isle of Dogs Pumping Station by Historic England: "List Entry: Isle of Dogs Pumping Station," https://www.historicengland.org.uk/listing/the-list/list-entry/1447069.

2. See Grenfell Tower Regeneration Project Engagement Statement, October 2012, Royal Borough of Kensington and Chelsea, https://www.rbkc.gov.uk/idoxWAM/doc/Other-960662.pdf?extension=.pdf&id=960662&location=VOLUME2&contentType=application/pdf&pageCount=1.

3. As of this writing, official inquests and inquiries have not commenced, but the disaster has been intensely scrutinized in the general and professional media. Reports on the exact nature of causes at these different levels are thus provisional, but are more than speculation.

4. In her recent judgment on a petition for a faculty to approve, retroactively, the construction of a building on church grounds next to Christ Church Spitalfields, Chancellor June Rodgers of the Consistory Court of the Diocese of London bluntly cautioned that "the many advantages which the Church of England gains from being exempted from state listed building control can only be justified if the operation of this ecclesiastical system works competently and fairly. We operate as a Court of Law, within the legal system of this country, not a rather cosy club. To behave as such is always the risk in small specialised legal jurisdictions.... This present case highlights what happens when an outside spotlight, including Freedom of Information requests, is turned on this jurisdiction and its operation." See "Judgment in the matter of a building in the churchyard of Christ Church Spitalfields and in the matter of an application for a restoration order and a petition for a confirmatory faculty," December 17, 2017, Consistory Court of the Diocese of London, 9.

Photo and Illustration Credits

Figure 1: © Bath in Time www.bathintime. co.uk.

Figure 2: Brydges Family Papers, Stowe Collection, The Huntington Library, San Marino, California.

Figures 3–5: 386814, The Huntington Library, San Marino, California.

Figure 6: © Crown Copyright, UK Government Art Collection.

Figure 7: © J Marshall—Tribaleye Images / Alamy Stock Photo.

Figure 8: Reprinted in Edward Howell, ed., *Ye Ugly Face Clubb, Leverpoole, 1743–53* (Liverpool: Edward Howell, 1912).

Figure 9: © The Trustees of the British Museum.

Figure 10: *Metropolitan Grievances; or, A Serio-comic Glance at Minor Mischiefs in London and Its Vicinity* (London: Sherwood, Neely, and Jones, 1812).

Figure 11: © Royal Photographic Society/ National Science and Media Museum/ Science & Society Picture Library.

Figure 12: London Metropolitan Archives, City of London.

Figure 13: Author collection.

Figure 14: *The London Illustrated News*, 1844. Collage/London Metropolitan Archives, City of London.

Figure 15: London County Council Photographs Collection. Collage/ London Metropolitan Archives, City of London.

Figure 16: London Metropolitan Archives, City of London.

Figure 17: From *The Arup Journal* 1, no. 5 (July 1967).

Figures 18, 19: © John Donat / RIBApix.

Figure 20: Museum of Hartlepool © Frank Auerbach, courtesy Marlborough Fine Art.

Figure 21: © Terry Farrell.

Figure 22: Courtesy Rogers Stirk Harbour + Partners.

Figure 23: Courtesy FCB Studios.

Figure 24: Photo: Timothy Hyde, 2008.

Figure 25: © John Donat / RIBApix.

Figure 26: Photo by Nick Hale/Hulton Archive/Getty Images.

Figure 27: Courtesy the artists and Greene Naftali New York.

Figure 28: Courtesy the artists and Becker Brown.

Figure 29: © Architectural Press Archive / RIBA Collections.

Figure 30: © John Donat / RIBA Collections.

Figure 31: Collage/London Metropolitan Archives, City of London.

Figure 32: © Edwin Smith / RIBA Collections.

Figure 33: © Lucinda Douglas-Menzies / National Portrait Gallery, London.

Figure 34: Photo: Timothy Hyde.

Figure 35: © Richard Ingle / RIBA Collections.

Figure 36: Collage/London Metropolitan Archives, City of London.

Figure 37: From Thomas Thorp (Chairman of the Restoration Committee), *A Statement of Particulars Connected with the Restoration of the Round Church* (Cambridge: Deightons, Stevenson, and Walters, 1845).

Figure 38: From Cambridge Camden Society, *Illustrations of Monumental Brasses* (Cambridge: J.T. Walters, 1846).

Figure 39: Photo: Timothy Hyde.

Figure 40: *European Magazine* 62 (November 1812). The Huntington Library, San Marino, California.

Figure 41: Collage/London Metropolitan Archives, City of London.

Figure 42: © Sir John Soane's Museum, London.

Figure 43: London Metropolitan Archives, City of London.

Figure 44: © Sir John Soane's Museum, London. Photo: Ardon Bar Hama.

Figure 45: © Sir John Soane's Museum, London. Photo: Timothy Hyde.

Figure 46: © Sir John Soane's Museum, London. Photo: Ardon Bar Hama.

Figure 47: © Sir John Soane's Museum, London.

Figure 48: © Victoria and Albert Museum, London.

Figure 49: *Punch*, December 7, 1878. Reproduced with permission of Punch Ltd.

Figure 50: LCC Photograph Library. Collage/ London Metropolitan Archives, City of London.

Figures 51–54: © John Donat / RIBA Collections.

Figure 55: *Architects' Journal*, May 9, 1984. © Louis Hellman / RIBA Collections.

Photo and Illustration Credits

Index

Italic pages refer to figures

A

abstraction, 4, 8, 65, 97, 161, 179, 190n6
acid rain, 53, 58
Act for Rebuilding the City of London, 42
Acts of Uniformity, 105
Addison, Joseph, 128
Aesthetics of Ugliness (Rosenkranz), 5–7, 190n4
Ahrends, Burton, and Koralek (ABK), 156–57, *159*, 206n3
Alkali Act, 196n56
Allen, Ralph, 30–32
All Souls, Langham Place, 129–30
altars: aesthetics and, 11, 154, 177;
 incongruity and, 91–109, 154, 200n21,
 200n26, 201n32, 201n35; legal issues and,
 102–9; monarchy and, 177; Moore and, 11,
 91–95, 99, 105, 107; St. Stephen Walbrook
 and, 92–96, 99–109, 154, 177, 200n26;
 stone, 11, 91, 94–104, 107–9, 154, 201n32
ambiguity, 105–9
amenity societies, 164–65, 170, 208n19
Ancient Monuments Society, 208n19
Anglican Church, 11, 92–94, 96, 99, 101–2,
 105–6, 107, 155, 209n4
Anne, Queen of England, 16, 18
Anti-Ugly Action, 63–65, 81, 198n21
"Appeal to the Public, An: Occasioned by
 the Suspension of the Architectural
 Lectures in the Royal Academy"
 (Soane), 127
Arches Court, 102–6
Archigram, 70
Architect's Club, 116
Architect's Department (LCC), 67–71
architectural profession: aesthetic
 judgment and, 148–52; amenity societies
 and, 164–65, 170, 208n19; Anti-Ugly
 Action and, 63–65, 81, 198n21; Artingstall
 case and, 137–38; beauty and, 145–48,
 151–52; Building Acts and, 112, 135–36,
 201n5; civic appearance and, 22–29;
 civil society and, 136; codifications
 and, 3, 33, 42, 136–38, 194n4; concept
 of average and, 65–66; criticism and,
 124–33, 143 (*see also* criticism); death of
 the architect and, 139–48; Great Britain
 and, 137, 142; historical perspective on,
 148–52; institutions and, 136, 150, 155;
 legal issues and, 136–37, 142, 148, 151,
 154–55, 204n8; libel and, 115–24 (*see*

also libel); Lombard Street "funeral"
 and, 62–67; Lord Ellenborough and,
 114, 118, 120–22, 126, 201n5, 204n48;
 Mansion House and, 12, 140–52, 155,
 157–58, 163–64, 169, 205n22, 205n23;
 Mies van der Rohe and, 12, 94, 139–52;
 misconduct and, 137; No. 1 Poultry
 and, 151–53, 158, 177; normalization
 and, 136–39; postmodernism and, 152;
 postwar planning and, 11, 64, 66, 70, 91,
 142, 161, 176–77, 198n26; propriety and,
 137, 151; public opinion and, 162–69
 (*see also* public opinion); Registration
 Bill and, 137; regulations and, 136, 140;
 Royal Institute of British Architects
 (RIBA) and, 1, 53, 136–38, 144, 158, 173,
 188, 200n18, 205n23; social thought and,
 2; style and, 137–38, 142, 145, 152, 155;
 Summerson on, 138–39, 142–44, *145*,
 148, 150, 202n9, 205n12, 205n23, 205n37;
 symbolism and, 14, 23, 32–33, 79, 100–3,
 108, 144, 166–67; taste and, 145–49, 155;
 urban context and, 145; Wren's influence
 and, 169–76
Article 14, 170
Artingstall, George, 137–38
Assize of Nuisance, 40–44, 57, 193n1
Attenborough, John, 69
Auerbach, Frank, 73–74
average man, 65, 81, 87

B

Bacon, Francis, 69
Banham, Reyner, 70, 77–78, 131, 197n16
Bank of England, 116–19, 128, 202n9, 202n14
Banqueting Hall, 166
Barclays Bank Headquarters Building, 62, *63*
Barker, Ashley, 96, 98, 200n25
Barry, Charles, 45–50, 54, 194n16
Bartholomew, Alfred, 48–49, 195n25
Bath: aesthetics and, 10, 15–25, 29–37;
 beauty and, 15–16, 20, 25–28; Bladud
 and, 24; civic appearance and, 22–29;
 Corporation of, 16–19, 21; disorder of,
 15–22; Druids and, 24–25; *Essay towards
 a Description of Bath* and, 20, 24–25, 29,
 32–33, 193n35; improvement and, 10,
 15–25, 29–37, 48, 191n5, 192n11, 192n17,
 194n6; King's Circus, 19, 22, *33*; medieval,
 17, 24; neolithic past and, 22–29; Queen
 Square, *17*, 19, 22; regulations and, 20–21;
 Romans and, 16, 24; Royal Crescent, *17*,
 19; stones of, 15–16, 29–34, 48; Stukeley

Index

Rohe and, 12, 144, 151–52; No. 1 Poultry and, 151–53, 158, 177; plaque for, 154; postmodernism and, 100, 152; Venice Biennale pavilion and, 153; Wilford and, 153

Stirling, Mary, 152

Stirling, Wilford, and Associates, 153

stone, 192n30, 196n41, 196n43; acid rain and, 53, 58; aesthetics and, 10–11; Allen and, 30–32; altars and, 11, 91, 94–104, 107–9, 154, 201n32; Assize of Buildings and, 41–42; Bath and, 15–16, 29–34, 48; brutalism and, 11, 185; climate and, 46, 48, 134; cornerstones and, 62, 64, 167; decay and, 10, 34, 45–46, 48, 50, 53–61, 64, 109; Doulton Potteries and, 57–61; durability of, 45–52; effect of air upon, 50, 53–61; facades and, 16, 23, 112, 158, 184; foundation, 91, 167, 168; improvement and, 15–16, 21, 23–34, 37; limestone, 29, 46, 51–52, 54; marble, 29, 100; masonry and, 29–33, 42, 44, 54, 91, 158; Portland, 30, 68; proper selection of, 45–52; quality of, 15, 29–30, 45–46, 48, 56, 109; smoke and, 46, 48, 50, 53, 56–60; Soane and, 112; surveys and, 48, 50, 53, 60; tombstones and, 64; Wood and, 68, 192n30

Stonehenge, 10, 24–30, 34, 97, 107, 138, 202n9

Street, Margaret, 201n32

Stukeley, William, 15–16, 25–28

style: aesthetics and, 2–4, 7–8, 10, 13, 137–38, 142, 145, 152, 155; brutalism, 11, 70, 75–78, 83, 86, 185, 197n16, 198n26; classical, 23, 78, 116–17, 122, 181; classification and, 8–9; elegance and, 19, 21–22, 30, 45, 146, 156, 160–61; Elizabethan, 46, 167; functionalism and, 194n9; geometry, 23–28, 67, 72–73, 83, 96–98, 107, 200n25; Georgian, 19, 29, 89–90, 155, 164, 200n21; Gothic, 3, 45–46, 89, 123, 137, 194n9, 201n42; improvement and, 23, 37; incongruity and, 89, 91, 97, 100–2, 105; irritation and, 64, 72; materiality and, 10, 185; modernism, 3–4, 12, 64, 67, 70, 79, 89, 100–1, 106, 108–9, 131, 142, 145, 158, 169–71, 179–82, 194n9, 199n32, 200n29; monarchy and, 160, 168–69; neoclassical, 11–12, 19, 22, 64, 92, 123, 158, 169; New Brutalism, 70, 78, 83, 198n26, 199n2; New Classicism, 169; nuisance and, 45–46, 49, 60–61, 194n9; postmodernism, 4, 12, 92, 100–1, 106, 108–9, 152, 162, 169, 176–78, 181, 200n29; Soane and, 116, 119; symbolism and, 14, 23, 32–33, 79, 100–3, 108, 144, 166–67; taste and, 2, 4, 8, 13, 37, 89, 116, 145, 155, 168–69, 185; Victorian, 12, 59, 88–89, 136–45, 148, 150–51, 181,

196n60, 205n12

Summerson, Sir John: architectural profession and, 138–39, 142–44, 145, 148, 150, 202n9, 205n12, 205n23, 205n37; Butterfield and, 88–90, 108, 199n2, 205n12; incongruity and, 88–90, 108, 199n2, 201n49; Mansion House and, 148 surveys, 9, 156; aesthetics and, 190n13; air pollution, 195n22; Building Act and, 112, 135; Butterfield and, 89–90; Daily Mail, 68; engineers and, 195n15, 197n12; facades and, 112; Geological Survey of Great Britain and, 195n28; Great Fire and, 42–43; Jones and, 166; Kinnard and, 112–14; Norris and, 118–19; postmodern buildings and, 200n29; stench and, 135; stone and, 48, 50, 53, 60; Summerson and, 89–90, 138; ugliness, 68; Wood and, 25–28, 33–34, 107

symbolism, 14, 23, 32–33, 79, 100–3, 108, 144, 166–67

T

Tabbert v. Tipper, 204n48

taste: architectural profession and, 145–49, 155; discretion and, 8, 99, 107, 140, 159; improvement and, 15, 21–22, 37; incongruity and, 88–89; irritation and, 69, 88; monarchy and, 157, 161, 163, 168–70, 176, 179; nuisance and, 44; Soane and, 114, 116, 118, 121–31; style and, 2, 4, 8, 13, 37, 89, 116, 145, 155, 168–69, 185; ugliness and, 2–5, 8, 13, 15, 21–22, 37, 44, 81, 88–89, 114, 116, 118, 121–31, 145–49, 155, 157, 161, 163, 168–70, 176, 179, 185, 200n25; vulgarity and, 25, 27, 134, 138, 145–46, 148

Tate's Clore Gallery, 100

Taylor, John, 120–22

Temple of Solomon, 23–25

temporality, 89–90, 100–5

Terry, Francis, 172

Terry, Quinlan, 169–72

Terry Farrell and Partners, 100

Thirties Society, 164

Tite, William, 53

Town and Country Planning Act, 157, 159, 163–64, 172, 177–78, 207n17

Townscape movement, 66, 79, 198n26

Tracts on Architecture (Wren), 200n25

Tracy, Charles Hanbury, 45–46

TV-am building, 100

Twentieth Century Society, 164

U

Ugliest Building award, 1, 68

Ugliness: A Cultural History (Henderson), 6–7

"Ugly, The" (Cousins), 7, 77, 80

Published by Princeton University Press
41 William Street, Princeton, New Jersey 08540
6 Oxford Street, Woodstock, Oxfordshire OX20 1TR
press.princeton.edu

Jacket illustrations: (*front*) Royal Courts of Justice, Strand. Collage/London
Metropolitan Archives, City of London. (*back*) Hayward Gallery, South Bank Arts Centre,
London. © John Donat/RIBA Collections.

Some sections of chapters 2, 3, 5, and 6 appeared in earlier form in the following articles
or book chapters. I am grateful to the respective publishers for permission to include
this material. "London Particular: The City, Its Atmosphere, and the Visibility of Its
Objects," *Journal of Architecture* 21, no. 8 (December 2016): 1274–98; "Piles, Puddles,
and Other Architectural Irritants," *Log* 27 (Winter/Spring 2013): 67–79; "Some Evidence
of Libel, Criticism and Publicity in the Architectural Career of Sir John Soane,"
Perspecta 37: Famous (2005): 144–63; "Libel," in *The Printed and the Built: Architecture,
Print Culture, and Public Debate in the Nineteenth Century*, ed. Mari Hvattum and Anne
Hultzsch (London: Bloomsbury, 2018); "Signed, Anonymous," in *Terms of Appropriation*,
ed. Amanda Lawrence and Ana Miljački (London: Routledge, 2017).

ISBN 978-0-691-17916-2
Library of Congress Control Number: 2018958379
British Library Cataloging-in-Publication Data is available

Design: Luke Bulman Office, New York
This book has been composed in GT Sectra and MT Grotesque.

Printed on acid-free paper. ∞
Printed in the United States of America

10 9 8 7 6 5 4 3 2 1